DIGITAL PHOTOGRAPHY MADE EASY

From Camera to Computer

Julian Cremona

HOVE FOTO BOOKS

Digital Photography Made Easy
From Camera to Computer

Second Edition Hove Foto Books 2007

Publishers
Newpro UK Limited
Old Sawmills Road, Faringdon
Oxfordshire, SN7 7DS, United Kingdom
www.newprouk.co.uk

© Newpro UK Limited 2007

Text & Photographs
© Julian Cremona, unless otherwise stated

British Library Cataloguing-in-Publication Data.
A catalogue record for this book is available from the British Library

ISBN 10: 1 874031 28 2

ISBN 13: 978 1 874031 28 4

Worldwide Distribution
Newpro UK Limited
Old Sawmills Road, Faringdon
Oxfordshire, SN7 7DS, England
Telephone: (01367) 24211 Facsimile: (01367) 241124
E-mail: sales@newprouk.co.uk
www.newprouk.co.uk

Dedicated to my inspirational family who have never failed to be my perfect models over the years.

Taking better pictures

Scanners

Digital images

Digital or Film

Camera Choice

Camera Controls

Accessories

Taking Photographs

Scanning

Viewing/Organising

Improving Images

Creativity

Archiving/Printing

E-mail/Web/Video

Digital images

Digital or Film

Camera Choice

Camera Controls

Accessories

Taking Photographs

Scanning

Viewing/Organising

Improving Images

Creativity

Archiving/Printing

E-mail/Web/Video

Primary Sections

Introduction

A quick glance in any general photography magazine like Amateur Photography will introduce you to the argument which still goes on between the die-hard film users and the digital army, each slogging it out in their letters as to why their photography is best. One issue that cannot be argued is that nothing has done more to fire peoples' imagination and take up photography than the digital camera, whether through using a mobile phone or a simple compact camera. The many millions of units sold each year are testament to its success. Plummeting prices of digital and the almost eradication of film compacts has cast this in stone. Digital is so easy to use and superb in helping to improve your ability. Don't be afraid of it - take a shot, examine it, learn the mistakes, adjust and take it again. The learning curve is steep but quick. Compare that with film, wasting most of it, waiting days to see the results before trying again. A very slow method to learn improvement. This also shows the environmental benefits of digital as well. Delete an image rather than throwing valuable resources into land fill. For many years I was prepared to spend long hours in a darkroom, reeking of toxic chemicals, all in aid of achieving the images I wanted, but not any more. I sit in comfort with my laptop, wherever I wish.

This book is intended to "walk" you through the minefield that modern technology presents. It will guide you and support you and while it cannot possibly be expected to be up-to-date with the very latest state-of-the-art technology, it will tell you many things you wish to know about the digital image, help in using the camera and what you can do with software and computers. This book is all about it's title. Take a look at the pictures in this book and you will see that they are not "off-the-shelf" library specials that you may never aspire to, no, they are all pictures that I have taken to illustrate both the benefits and pitfalls of digital imaging. The book is particularly useful for those who are still wondering what camera to buy. Hopefully this will be the guide to give you the confidence you need. As a teacher of digital imaging I have great sympathy and understanding towards non-technology minded people trying to grapple with both the wonders of digital cameras and computers and that is the very reason for this book.

Julian Cremona, Pembrokeshire, England. July 2007

Digital images

Digital or Film

Camera Choice

Camera Controls

Accessories

Taking Photographs

Scanning

Viewing/Organising

Improving Images

Creativity

Archiving/Printing

E-mail/Web/Video

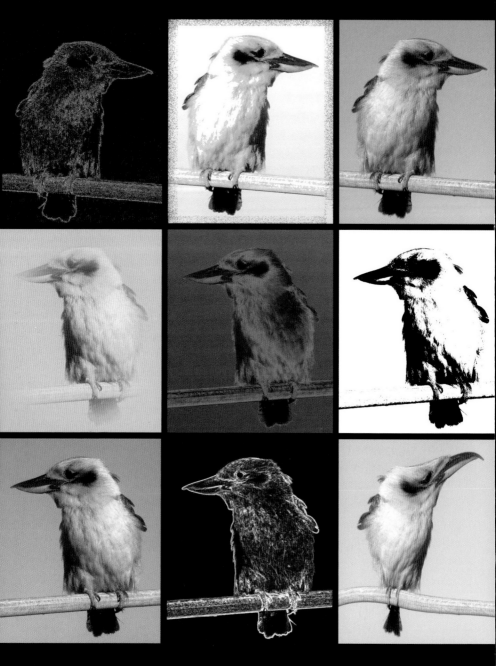

Spot the Original! Taken with a mid-range digital camera the Kookaburra picture has been changed using various filters on the computer.

Capturing Images

What is a digital image?

With all the current hype over the technology what exactly do we mean by digital photography? Initially, we must think of it as being an image on a computer with the option of printing it out after viewing on the screen. However, there is no real definition and it can be one or all of the following.

- Using a digital camera to take an image without film
- Scan an existing image, possibly on film, to create a computerised image
- Manipulating an image on the computer
- Printing out an image from the computer

It is a very flexible technology so much so that it can involve computers as much as you want or as little as possible. For example, it is quite possible for you to buy a digital camera but never use a computer and pick up your wad of photos from the printers just as with traditional photography. However, in this book we explore all of the above definitions for digital imaging and the first important concept to grasp is exactly what is the make-up of this image.

There are two types of graphic or image on your computer to think about. These are the *vectormap* and *bitmap*. It is the latter which is important to us but essential to understand the difference between the two, not least of all in ensuring that you use the correct graphics software. See Figure 1.

FIGURE 1. On the left is an example of a bit-map image made from an enlargement of part of an elipse in the background, showing the image is clearly made up of pixels. Pixels used in photographs. The vector-map image on the right taken from the same elipse shows it to be smooth as it is not made of pixels but defined mathmatically and made up of lines and curves. Used in drawings.

Digital or Film

Camera Choice

Camera Controls

Accessories

Taking Photographs

Scanning

Viewing/Organising

Improving Images

Creativity

Archiving/Printing

E-mail/Web/Video

Vector graphics are graphics created in drawing programs where shapes are represented as a series of lines, curves and circles called objects. In fact they are often referred to as object-based graphics or line art. Clip art, which is available in word processing packages like Microsoft Word are vectormaps. This contrasts with a bitmap graphic which is made up of pixels created in paint programs, by scanners or digital cameras. The first class software program, CorelDraw is a drawing package used to create and edit vectormaps. Part of the suite is a second super programme, CorelPhotopaint. This creates and edits bitmaps.

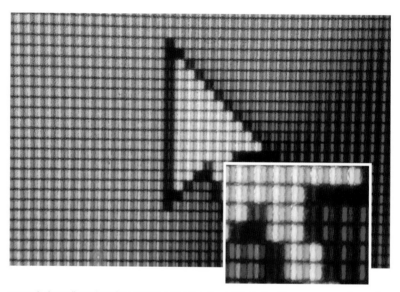

FIGURE 2. A small section of a computer screen enlarged, including the mouse arrow for scale. When enlarged the individual pixels making up the screen can clearly be seen. Note the three colours red, green and blue (RGB).

Bitmaps and resolution

So, digital images are bitmaps which are made up of pixels. These are tiny spots or rectangles of light and the name is short for picture element. A pixel is the smallest element that can be displayed and that software can manipulate to create letters, numbers, or graphics. Figure 2 above, is a section of a computer monitor highly enlarged. It is possible to see individual pixels. By comparison there is an enlargement of a small portion of an image printed on paper and here the individual dots making up the photo can be seen. Our digital image should not be confused with a printed image at this stage, see Figure 3 opposite, consider it only as an electronic "thing" stored on a computer and being displayed on it's monitor.

FIGURE 3. By contrast to a digital image, the printed image is made up of tiny dots with different intensities and size to create the final image. Dots enlarged.

Monitors have a *screen resolution* which is the setting that determines the amount of information that appears on the screen, measured in pixels. A low resolution, such as 640 x 480 pixels, makes items on the screen appear large, although the screen area is small. High resolution such as 1024 x 768, makes the overall screen area large, although individual items appear small. This is shown in Figure 4 on page 14. Monitors have limits on how high the resolution can be supported and you need to adjust the resolution to suit your own comfort. However, TFT or liquid crystal displays, typically found on laptops, have what is known as a native screen. This is the optimum of that monitor and performs best at that resolution. The usual way of changing resolution is to point the mouse at the desktop and right click. A small menu appears and then left click *Properties*. This produces a tab box and by clicking the *Settings* tab a display of the screen properties are given including a slider that can be moved to change the resolution, see Figure 5 on page 15. Keep a note of what screen resolution you use on your computer. What does this all mean for digital photography?

The quality of an image depends on the number of pixels present. This is resolution, measured in pixels per inch or ppi. When buying a digital camera this will more likely be expressed as the total number of pixels in the image, e.g. 1.3 million or mega pixels. You will

Digital Image

Digital or Film

Camera Choice

Camera Controls

Accessories

Taking Photographs

Scanning

Viewing/Organising

Improving Images

Creativity

Archiving/Printing

E-mail/Web/Video

FIGURE 4.1

FIGURE 4.2

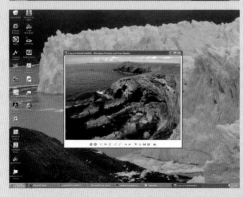

FIGURE 4.3

FIGURE 4. Computer monitors set at three different resolutions, **4.1**: 800 x 600, **4.2**: 1152 x 864 and **4.3**: 1280 x 1024 pixels. Note that the display of the photograph in the window of a coastal scene (itself a resolution of 640 x 480) varies in size. Most significantly, all the desktop icons and the task bar also change size, as each is made up of a fixed number of pixels, so that a high resolution reduces the space these will take up and increase space for the programmes

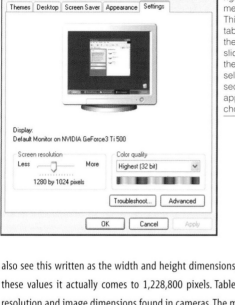

FIGURE 5. To change screen resolution right click the desktop. When the menu pops up left click Properties. This screen then appears. Click the tab Settings and the slider control for the resolution appears. If you drag the slider the small window shows what the desktop might look like. Once selected click Apply and after a few seconds of a blank screen the new appearance is displayed. If you choose to keep this click OK.

also see this written as the width and height dimensions, that is, 1280 x 960. If you multiply these values it actually comes to 1,228,800 pixels. Table 1 on page 17 displays a range of resolution and image dimensions found in cameras. The more pixels present the more data or information about the picture is available. Each pixel is a specific colour so that more pixels generate better quality colour. 640 x 480 is the lowest resolution found on cameras. Compare the images in Figure 6 on page 16. The one with lowest resolution is very "blocky" with pixels. For the same size photograph the highest resolution has many more pixels which are very small and creates an all round better image of good contrast and tonal range. If you were to enlarge the photo or, on the computer, zoom in, it will become blocky once more. The bigger the enlargement the more resolution (pixels) you need to maintain the quality.

Now let's go back to the computer monitor. If you are using a screen resolution of 800 x 600 pixels consider how the photos will be displayed. A 640 x 480 image will fit neatly in the middle, all visible and with space around it. 1280 x 960 images will only have two thirds displayed across and down the screen. For a very high resolution image only a small portion will be visible. Whilst this is not a major problem as software can usually be set to display an entire photo it is an important aspect to be considered, see Figure 4 on page 14.

One of the main reasons for considering the monitor at this stage is to help answer the key question: "what resolution is best for me?" If you are going to display your photos on the monitor or TV then high resolutions are unnecessary. If your screen is set at

Digital Image
Digital or Film
Camera Choice
Camera Controls
Accessories
Taking Photographs
Scanning
Viewing/Organising
Improving Images
Creativity
Archiving/Printing
E-mail/Web/Video

800 x 600 or even 1280 x 1024 a 1.3 megapixel image is ideal whilst 640 x 480 is too low. 4 megapixel images with a width of 2400 pixels is way over the top when the screen can only display 800 or 1280. A rule of thumb is to go for a resolution a little over the screen resolution.

Most significantly, the more pixels present in an image the more information or data has to be stored. High resolution results in huge, bloated files resulting in potentially megabytes of space taken up on the hard drive. A camera set to the highest resolution will be only able to take a few images as the storage medium will fill up fast. If you do not have a fast computer processor large files will be difficult to open and manipulate as more memory will be needed to deal with the image. Working with any graphics will be affected by your computers speed. Word processing requires miniscule amounts but start working with pixels and the more RAM and hard disk space you have the better.

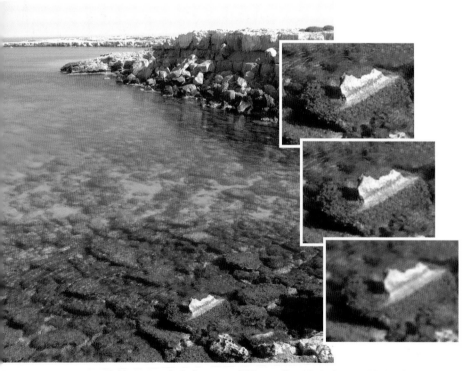

FIGURE 6. How many pixels do you need? The small rock in the bottom right has been cropped and enlarged. The three images differ by the number of pixels present. **6.1:** 600 was cropped from a picture of resolution 640 x 480, **6.2:** 1200 cropped from 1200 x 900 and **6.3:** 2400 from 2400 x 1800. To a point the more pixels present the clearer the image.

Once a digital image has been created pixels can always be taken away (called down-sampling) in the computer stage. Pixels can be added to increase resolution (up-sampling) but there is a degree of guesswork by the computer and the quality will never match that of a camera taking it at that resolution. The process of adding pixels to improve resolution is called *interpolation*. Found on some cameras and scanners it is to be avoided if possible. It is therefore always better to take a photograph on a medium/high resolution and then reduce quality rather than the other way. This is especially so if it is an important photograph.

Colour

By looking at the colour of the pixels in Figure 2 on page 12 one can see that the range of colours in a picture are made from just adding three components (also known as channels) together, red, green and blue. These pixels are at a microscopic level and when mixed in large numbers generate the wealth of colours we see. The range of colour found in each pixel has a value between 0, which is black, and 255, which is white. With three channels we see the 16 million possible colours, i.e. 256 x 256 x 256 = 16,777,216. This is dealt with in more detail in the section Colour Depth on page 20.

To summarise resolution and pixels

Low resolution photos (640 x 480 pixels) produce small file sizes and therefore are easily stored and quick to e-mail or use on a web site. However, the image quality will be very limited and unsuitable for printing out. Medium resolution such as 2 megapixel cameras generate bigger files but the quality printed at 6 x 4 inches will be good, ideal for viewing on computer screens. High resolutions of 4 or 6 megapixels can be enlarged to create super photographs of 10 x 8 inches but will occupy large space when stored in a camera or computer. Working with files of this dimension will require a higher specification computer than needed for the previous sizes.

Table 1. Digital Camera Resolutions and Uses

640 x 480	307,200 pixels	Web & E-mail
1280 x 960	1.3 mega pixel	Computer display — Prints 4 x 5in
1600 x 1200	2.0 mega pixel	Computer display — Prints 5 x 7in
2400 x 1800	4.3 mega pixel	Prints 10 x 8in

File Types, Size and Compression

All files have an extension which identifies that file as belonging to a particular type of software. This extension comes after the file name but is not always displayed. For example, .txt refers to a text file and can be opened by any text editor or word processor. This is the case in

Digital Image

Digital or Film

Camera Choice

Camera Controls

Accessories

Taking Photographs

Scanning

Viewing/Organising

Improving Images

Creativity

Archiving/Printing

E-mail/Web/Video

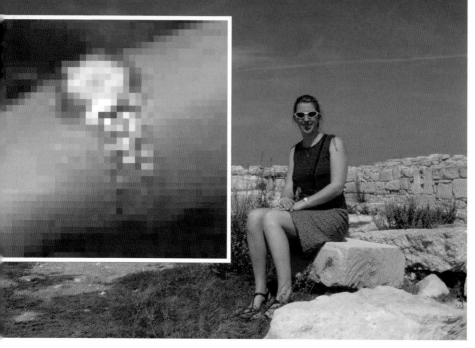

FIGURE 7. A bit map image: This 1.3 megapixel image has inset an enlargement of the wrist watch. Notice that at this magnification the pixels making up the watch are very obvious.

the Windows environment whilst in Macintosh systems there are four characters used. These extensions are used to associate the file with specific software on your computer and double clicking the file will fire up the programme.

Unfortunately, working with a bitmap there is a host of file types although here we will concentrate on just the two main ones.

Tagged Image File Format (TIFF or TIF) is a widely used type of high quality and can be recognised on either Windows or Mac computers. 1.3 megapixel images will have a file size of around 3 to 4 megabytes. This is chunky to say the least and for the majority of digital photography use out of the question. For example, if you took twenty four photographs with your camera, that would require almost one hundred megabytes of space to store them. Until recently that would have been impossible for digital cameras and that represents only 1.3m resolution. Table 2 opposite indicates the file sizes of different resolutions. The Joint Photographic Experts Group (JPEG or JPG) file format was developed and agreed to allow much smaller file sizes. This is the most commonly used file format for digital cameras. It too can be read by most computer systems and has the data compressed into a much smaller file size, e.g. 1.3 megapixel is 300 kilobytes, over a tenth the size of the uncompressed TIF. How do they do it? Essentially, in TIFs each pixel data is kept separate and distinct but in JPGs areas of

similar pixels has the information about them combined so less data is stored. This inevitably leads to a compromise and for reduced space read potential loss of quality. In most cases this can be an acceptable loss but there are levels of compression, so be aware!

The first place that you will come across compression is in the camera but you may not even realise this as it is usually simplified. One of the settings on digital cameras will be "quality" this may vary from camera to camera. This actually refers to the *level of compression*. Fine will be minimal compression, normal around medium and basic, high compression. In turn, going from fine to basic you will see the quality deteriorate. As Table 2 below shows, basic files produce small files whilst the better the quality the bigger the files.

Table 2. Examples of File Formats and file sizes (m is megapixel)

Resolution	Compression Levels			
	TIF	JIPG (fine)	JPG (normal)	JIPG (basic)
0.3m	900k	150k	50k	15k
1.3m	4mb	544k	240k	140k
2.0m	5.5mb	1.1mb	750k	290k
4.3m	12mb	2mb	890k	320k
6.2m	18mb	3mb	1.2mb	480k

Note: not all levels of compression will necessarily be available in the camera

Figure 8 on page 20 illustrates high and low compression showing an image with two levels of compression. With increased compression "blockiness" increases. This is where there is less contrast between pixels as compression removes data and they form similar blocks. Once the photos are downloaded to the computer bitmap editing software will also allow compression to occur but always be aware of over compression. For example, you will notice that if a JPG is opened up on the computer, altered in some way and then saved, the file size becomes smaller. Every time you save the file it keeps getting smaller. Each save compresses the file and the result is called *lossy*, losing data. It is something like photocopying a photocopy. Each time you do this it degrades the image. To work on an important JPG file first make a copy in TIF format. Use this to make and save your changes. As we will see later there are some software packages available which allow some simple changes that do not lose data by recompression, called *lossless*. Look out for this as for quick and often essential changes such as rotating photos it does not degrade the image.

JPG exists in two forms, standard and progressive. The former puts the photo on the screen in one go, meaning the computer waits until it has all the information before the first sign of the image appears. In the latter, the image appears progressively with an immediate

Digital Image

Digital or Film

Camera Choice

Camera Controls

Accessories

Taking Photographs

Scanning

Viewing/Organising

Improving Images

Creativity

Archiving/Printing

E-mail/Web/Video

FIGURE 8. JPG Compression: The degree of compression will affect the image quality. The image on the right has a low compression (10%) whilst the image on the left is highly compressed, by almost 80%. The latter has a much smaller file size but is very blocky.

rough outline followed by a gradual improvement in quality. This type is sometimes used on the internet as files often download slowly. It may be better to progressively show the image rather than viewers waiting half a minute for something to happen all at once.

Another file type occurring on the web is the GIF format. It was the forerunner of JPG but still has a use in keeping files small. Quality is not as good, supporting only 256 colours. This is because it is only 8-bit instead of the 24-bit found in the other formats. What does all this mean?

Colour Depth and other files

The acronym RGB turns up at intervals within the digital world, (see figure 2 page 12) referring to the red, green and blue colours (also called channels) encountered in the digital image. Colour information, like all digital information, is represented by binary digits (reduced to the word *bit*), either a one or a zero. The simplest image is a 1-bit form that is just black or white with no in between grey, shown in the image opposite and Figure 9 on page 21. 8-bit files have 8 binary digits per pixel, representing a maximum of 256 colours. 24-bit images have three channels producing enough information to yield more than 16 million colours. This is because

each of the three channels (RGB) can be 256 shades. So, 256 x 256 x 256. The latter will produce a more vibrant picture and hence most peoples' preference for a JPG rather than a GIF file. All this is referred to as *colour depth*. It is possible for software to work in a higher number of bits per channel, i.e. 12 or 16, creating bit depths of 36 and 48 respectively. Note that these produce huge files and is one of the reasons they are not generally used except, perhaps, when scanning images. Note that viewing software does not always support high bit depths.

At this point we should not exclude black & white or monochrome photography, which can produce a very different mood to that found in colour and should not be ignored. Rather than just black or white (a 1-bit image) there are usually a range of grey tones in between. This is a greyscale image and is typically 8-bit as illustrated in Figure 10 on page 23. Many cameras have the ability of taking or converting images to greyscale or sepia tone. Like most modifications this can be achieved later at the computer stage.

Other file formats include BMP, specific to Windows bitmaps whilst MAC is specific to the Apple Macintosh. A final consideration is the Raw Format found in more expensive digital cameras. This takes the data captured and stores every last bit of it, making no changes along

FIGURE 9. Example of 1 bit image. This is just black and white with no grays in between (tonal range). This is the simplest type of file as it contains a minimum of information.

Digital Image

Digital or Film

Camera Choice

Camera Controls

Accessories

Taking Photographs

Scanning

Viewing/Organising

Improving Images

Creativity

Archiving/Printing

E-mail/Web/Video

FIGURE 10. 8 bit image. Unlike the 1 bit image there is more information present, a full tonal range. A colour JPG image will typically be 24 bit as it has three channels of colour, red, green and blue (RGB).

The two images in Figures 9 and 10 are colour images taken with a digital camera and then converted into monochrome at the computer stage. At that time they can also be tinted, e.g. with sepia to simulate old photographs.

the way. The files will be big but no modification will be made by the camera. As a result the image may look low-key and lack-lustre. This is to allow the photographer to take this and make changes manually on the computer. In other formats cameras will make some automatic minor change before saving.

Different bitmap software have their own specific formats. For example, in Adobe Photoshop it is PSD while Corel PhotoPaint's format is CPT. These allow you to work on the file in that software only but will save information specific to that software such as changes you may have made and provide the opportunity to undo these even after saving. PNG, a commonly found format, is produced for the web in Adobe Flash.

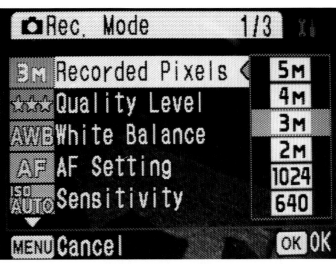

FIGURE 10 B

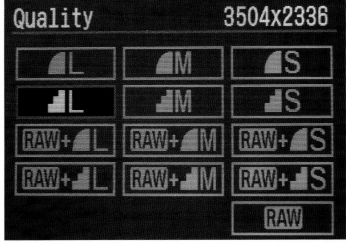

FIGURE 10 C

FIGURE 10 B PENTAX FIGURE 10 C CANON
"Confused? Two examples of camera menus. Top is one from a Pentax compact showing the resolution as the number of pixels with options between 5 megapixels down to just 640 pixels across. Quality Level is the level of compression, set at three stars, the best quality. The second menu is from a Canon DSLR where quality refers to both features. The highlighted L is showing 3504 pixels across with some compression. The L above has minimal compression. RAW+L is where the image is recorded as both JPG and RAW formats."

Digital Image

Scanning

Viewing/Organising

Improving Images

Creativity

Archiving/Printing

E-mail/Web/Video

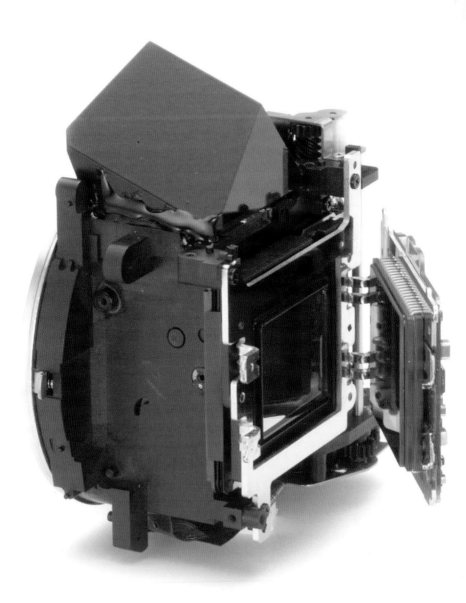

Photograph of a Canon D30 supplied by Canon UK

The Digital Camera

Digital Image

Digital or Film

Camera Choice

Camera Controls

Accessories

Taking Photographs

Scanning

Viewing/Organising

Improving Images

Creativity

Archiving/Printing

E-mail/Web/Video

What is the real difference between digital and film cameras?

Each year that passes sees the advantages of film eroded. They are close to being on a par but with digital, in many ways, surpassing film cameras. Essentially, a film camera has a light path that includes a mechanical shutter mechanism controlling the light passing on to a gelatine layer (film) containing crystals that become changed by that light. The layer is on a thin flexible backing that is moved along to provide a fresh layer of light sensitive chemical. At the end of the roll of film it is removed from the camera back in subdued light and processed with more chemicals. After this development it is enlarged on to a second gelatine layer but this time based on paper. This is the photographic print you receive.

By comparison creating a photo with the digital camera is much easier. The shutter may be electrical or mechanical and instead of film the light lands on a sensor. This converts it to a digital image that will be saved to a storage medium and then can be made to appear immediately on a small LCD panel on the back of the camera. No chemicals are used and in that respect is more environmentally friendly. Disposal of potentially hazardous photographic chemicals is a major concern which digital cameras eliminate. Upon viewing the image on the LCD the image can be easily deleted and taken again if necessary.

Camera Sensors

There are two different sensors used on cameras today

- **CCD (charged coupling device) sensors.** These have been around longest. In general, CCDs have more pixels and work better in low light. However, they tend to be more expensive and they use a lot of power. High-resolution cameras currently need a CCD sensor.
- **CMOS sensors.** These have a lower resolution, use less power and do not work well in low light. If you are looking for an inexpensive, low-resolution camera, and plan to use it outdoors, a CMOS sensor would be a good choice.

As prices continue to fall, more and more people are using digital cameras. One of the driving forces behind the falling prices has been the introduction of CMOS image sensors.

CMOS sensors are much less expensive to manufacture than CCD sensors. They are both similar in that they convert light into electrons. Like the retina at the back of our eye which has many thousands of light sensitive cells arranged in a 2-D array, the sensors have many thousands of solar cells called photo-sites, each of which transforms the light from one small portion of the image into electrons. The charge created is measured and, in the case of CCD, transported to a converter that turns this into a digital value relating to one pixel. In most CMOS devices, tiny transistors at each cell amplify and move the charge using traditional wires. This is a more flexible system. One problem here is that the transistors occupy space and some of the light strikes them instead of the photo-sites. Hence, CMOS have a lower resolution and more susceptible to "noise". This is a commonly found term in digital photography and essentially noise is where random pixels appear on the image, resembling static on a television screen. Most often this occurs in the form of pixels of the wrong colour appearing at random in the darker areas to generate an inferior image. CMOS chips are produced in the same way as most microprocessors whilst CCDs are manufactured specially to improve the transport of the information to the edge of the sensor without distortion.

Each photosite has one of three possible colour filters, red, green or blue. 25% of the photosites are red or blue and 50% green, all distributed evenly. Thus a pixel will have a colour derived from one of these filters. To improve colour and resolution we see CCDs like the Foveon chip, available in the Sigma DSLR, where a triple layer of filters, red, green and blue ensure that each pixel has the unique colour."

When buying a digital camera, whether it contains a CCD or a CMOS sensor is largely irrelevant. Some argue that the CCD gives a cleaner image than the CMOS although the latter has a clear advantage in its lower power consumption. Some CMOS DSLRs will take 1000 photos plus on one battery charge. Quality of the image is often down to in-camera treatment.

Film resolution is down to the number of silver grains and it was thought that an equivalent sensor would need to display 16 megapixels or more. Most people accept that it is, in fact, lower than this and with simple compacts coming out with 12 megapixel at least some parity with film is already available.

Where is the film? Memory Cards

Upon taking a photo the camera must save this electronic file in some form of memory so that upon switching off the camera it will not be lost. Many compact cameras have a limited built-in memory with all digital cameras having a slot to take a Flash memory card. Flash memory is a silicon-based technology like RAM, but the physical structure of the chip means that the electrical charge representing data can be retained almost indefinitely. It is fast, has no moving parts and is therefore very durable. The built-in memory and cards store the images until they can be copied to a computer hard disk for storage. Once transferred the images on the memory can be deleted to store new ones. Cards, or internal memory, can be used again and again.

Cards vary enormously in storage capacity and the number of images stored is limited by the resolution used. The better the quality the fewer can be stored. See table 003. Built-in memory will be severely limited and so should not be relied upon. Extra cards can be purchased and it is strongly recommended that you have at least one spare card. It is also debatable that one large capacity one are better than several medium capacity cards. Prices continue to drop and the price of large capacity cards is now quite low, especially when purchased over the internet. Cameras are limited to a specific type of flash memory which look and sometimes behave differently but essentially do the same thing: store the images.

Types of Storage media – memory cards

Smartmedia: now obsolete it was used by Fuji and Olympus, but had limited capacity (around 125Mb) and so was replaced by the significantly smaller xD cards.

xD: Fuji and Olympus joined forces in 2002 to create this tiny card, with the name coming from the phrase "extreme digital" with the potential to reach 8Gb. It is one of the more expensive cards to buy and comes in two types, H and M, where H offers the fastest transfer rate. Also there are cards that support panorama modes and special effects. Unlike most cards xD cards do not have a write protect mechanism although it has been shown that very few people actually use this function.

Compactflash is widely used. Physically the largest memory card available it is very robust. I have actually had mine go through a washing machine (by mistake!). In the early days of compact digital cameras the majority of manufacturers used Compactflash. Now the smaller compacts use SD cards leaving this solid flash memory in larger cameras like DSLRs. Card capacity stands at 16 Gb but this continues to rise. Most significantly, Compactflash exists in different read-write speeds. Using the "motordrive" facility on a camera takes multiple shots in quick succession. The buffer in the camera will soon fill up and data needs to be written to the

Digital Image

Digital or Film

Camera Choice

Camera Controls

Accessories

Taking Photographs

Scanning

Viewing/Organising

Improving Images

Creativity

Archiving/Printing

E-mail/Web/Video

card quickly. In many cases if the transfer is not fast enough no more photos can be taken until the buffer is empty. Hence the need for faster cards. They are marketed in different ways according to the manufacturer. *Sandisk* have a range of Standard, Ultra (66x) and Extreme (133 – 266x). *Lexar* have 80x and 133x cards whilst *Kingston* cards have the Elite (50x) and Ultimate (133x) range. 66x represents a typical transfer rate of 10 Mb/second. So 133x is 19.85 Mb/second.

Secure Digital (SD/SDHC) started out later than other cards but are now the cheapest as they have been utilised by the majority of camera manufacturers. The MMC standard is backed by the MultiMediaCard Association, which is made up of more than 80 members. MMC Flash memory cards are the size of a large postage stamp (24 x 32 mm). Their size is kept down by the use of a serial interface which requires just seven pins. Secure Digital (SD) is the latest standard to appear on the market, and is a superset of MMC. It has become the most popular card and although the capacities are not as high as Compactflash it is also available in variable read-write speeds. SD cards are almost identical in size and shape to MMC cards, and are backward compatible with them. Devices Fitted with SD slots can also accept MMC cards, but an SD card cannot be used in an MMC slot. The main difference between SD and MMC lies in SD's built-in support for the Content Rights Management (CRM) system, an industry standard for preventing piracy. SDHC are high capacity cards but are not compatible with older cameras. Check before buying! *Sandisk* also produce an excellent Ultra card which is hinged in the centre so that it can plug directly into a USB slot without the need for an adapter or reader.

Memory Stick Duo is exclusive to Sony which in the original form is like a stick of chewing gum, measuring 21x50x2.8mm. In recent years Sony has introduced a smaller version (20x31xl.6mm)

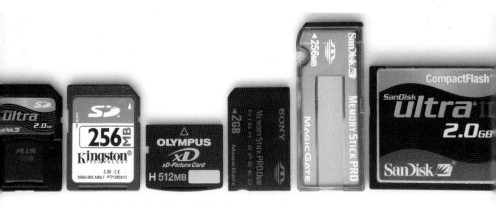

"Left to Right: Ultra SD, basic SD, xD, Sony Duo, Memory Stick Pro, Ultra Compactflash"

called the Memory Stick Duo which has now replaced all camera cards. The Duo is similar to the SD card in size and shape but is usually more expensive. Pro versions have a faster write speed and are essential for high quality video capture.

There are few advantages or disadvantages between the different card types and just because you may already have one type of medium should not affect the choice of a new device. Buy the camera which is best for you rather than basing a decision on the same medium. You may find that you rarely take the card out of the device and cards are cheap enough. Also, some cameras will have slots for more than one type of card and wait a year and probably a new flash memory will come along. Already we are seeing Mini versions of SD and Duo for phones and MP3 players.

One further device worth mentioning is the IBM/Hitachi Microdrive. A very compact hard drive, with a one inch sized disk, they are cheaper than flash memory. They have between 4 – 8 Gb capacities and are popular with some photographers. Used in cameras which have a Compactflash slot type 11 it can be a valuable asset to store large numbers of images when access to downloading to a computer is difficult. Despite this they require more care than Compactflash cards, which are solid state and more durable; the Microdrive has the workings and vulnerability of a hard drive.

Table 003 Approximate number of images that can be stored on various capacity memory cards. NB. This is only a guide as cameras vary and so does compression.

Megapixels JPGs	256Mb	512Mb	1Gb	4Gb
1	850	1700	3400	13600
2	420	840	1680	6720
3	295	590	1180	4720
4	210	420	840	3360
5	170	340	680	2720
6	140	280	560	2240
8	100	200	400	1600
10	80	160	320	1280

Caring for your memory cards.

They are not indestructible and should be treated carefully if removed from the camera. Avoid touching the gold contacts and keep the card in the provided storage box if not in the camera.

Digital Image

Digital or Film

Camera Choice

Camera Controls

Accessories

Taking Photographs

Scanning

Viewing/Organising

Improving Images

Creativity

Archiving/Printing

E-mail/Web/Video

Occasionally, if the card is used in another device (equipment) and then put back in the camera it may give an error message. This can usually be overcome by reformatting the card in the camera or on the computer. Formatting the card will also extend the life of the card and should be done regularly. The ideal is to always reformat the card in the camera after downloading and saving the pictures on the computer. To find the **Format** command work your way through the menus. It may be in the Setup section or even under the Playback menu. Use format rather than the "Delete All" command. After a while cards which have had files deleted rather than formatted may lose capacity. Regularly formatted they should last for many years (I have Compactflash cards more than 8 years old). Large static charges can harm cards so handle them carefully in dry, low humid areas (Australia outback?), especially avoiding the gold contacts. X-Ray machines at airports are fine but avoid strong magnetic fields.

If problems occur during downloads or you have deleted images by mistake there maybe ways of retrieving the files even if corrupted. Software is available (some free with the cards, some on the internet) which allows the computer to go in and find what is on the card. If the card has been used numerous times since the file was deleted the file will probably be over written but it is worth trying. The software can be remarkably effective. Unfortunately it does not seem to work with xD cards.

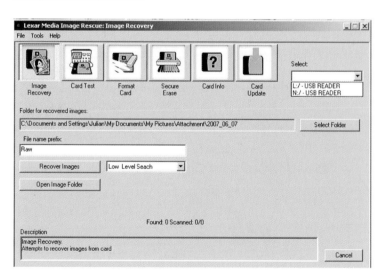

FIGURE 11. The software Lexar Media Image Rescue showing the Image Recovery screen. Available free with their Professional cards or as a download from www.lexarmedia.com"

Digital Image

Digital or Film

Camera Choice

Camera Controls

Accessories

Taking Photographs

Scanning

Viewing/Organising

Improving Images

Creativity

Archiving/Printing

E-mail/Web/Video

Getting Photos on to the Computer

The images contained on the camera memory need to be downloaded on to the computer so that they can be viewed on a bigger screen or printed. This is in two parts: First, attach the flash card to the computer and, second, use software to transfer the files. There are several possibilities for attaching the flash media to the computer:

1. Connect the camera to the computer

Recently produced cameras will come with a lead to connect it to a USB 2 socket on the computer. The first time you connect your camera lead to the computer and switch on the camera the operating system of the computer may ask for a driver. If it does this will be on the CD which came with the camera. Drivers are small piece of software the computer needs so that it can recognise the camera. Most compacts will connect without this and using Windows XP, Vista or a Mac the operating system should recognise the camera. Once the camera and computer are linked and both switched on the image files can be transferred. One disadvantage of this method is the camera battery must be in good condition and well charged. If there is insufficient charge it may refuse to transfer files. Alternatively, files start transferring and part

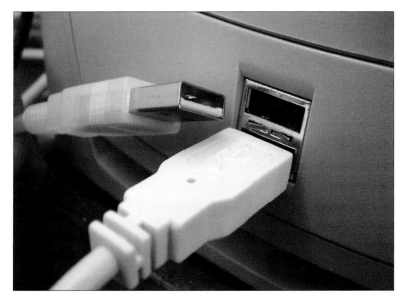

FIGURE 12. USB connections are the most typical way that cameras and scanners are connected to the computer.

way through the battery fails and the transfer stops, possibly causing corruption of the data. This is the bit where inexperienced computer users panic.

2. Use a memory card reader

In this case the memory card is removed from the camera and inserted into a special drive, called a Card Reader that can be left attached to the computer. The connection is via USB and there are many readers on the market. They are small and variable in cost from a few pounds upwards. A good reader is capable of faster data downloading than others. Card readers are often fitted into computers, both desktops and laptops. It is possible to get a reader specific to a card type or a multi-card reader able to read all types of flash cards.

It may seem an irrelevance to purchase a reader when connecting the camera works fine and to use the reader media has to be removed. In most cases the reader is quicker but most importantly there is no concern that the battery will suddenly fail as readers draw power from the computer. Also if your camera is set up for action, say on a tripod, it is more convenient to remove the card, download the images and then put the media back ready for more shots.

I use my reader to move any large files, not necessarily photographs, between computers. Place

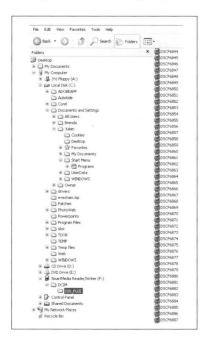

FIGURE 13. Windows Explorer view with a Smartmedia card reader connected. This appears as a separate drive, here F:,under the DVD and CD drive. This would be the same if it was a camera connected. The drive has been expanded to display the DCIM folder which contains one called Fuji 100. This is highlighted in blue when clicked and the files it contains shown in the area to the right as a list. The files can be selected and then dragged and dropped elsewhere in the computer. Although this is Windows XP all Windows use a similar screen.

Digital Image

Digital or Film

Camera Choice

Camera Controls

Accessories

Taking Photographs

Scanning

Viewing/Organising

Improving Images

Creativity

Archiving/Printing

E-mail/Web/Video

a card in the reader and copy files on to the card and then connect the reader to another computer to copy the files on to that one. Nothing to do with photographs!

3. Use a specific adapter

Adapters are made for PC slots (PCMCIA) found on the side of laptops. These are normally specific to a particular card and can be very fast. See Figure 15.

The camera may have come with special software on a CD. A common one is Exif. If this is installed this should appear on the screen the instant the media is connected. These are similar to Windows Explorer with the folders of the computer on the left side and the camera files on the right. Then by selected the files they can be dragged across and dropped on to the folder you are using on your computer. It is not essential to use the specific software. Fig 006 shows how Windows Explorer would show the camera as a removable drive. If you use this software to transfer files remember that the camera's memory card has a specific folder in which it stores the files. You need to keep clicking on the folders to move down the "tree" to find them. Once you have checked the files are on the computer the camera memory can be cleared.

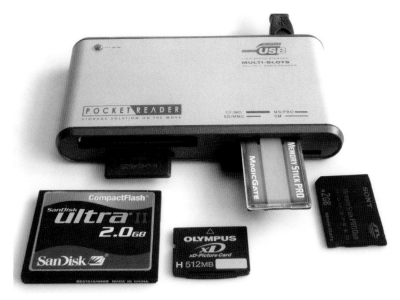

FIGURE 14. Flash Card Reader: These are a useful and quick way to download images to the computer from flash cards. They draw power from the computer via the USB port and save the camera battery. Most significant is that they can be used as any other drive for moving large files from computer to computer.

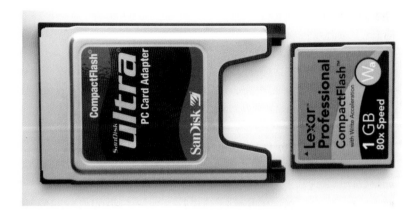

FIGURE 15. PC card adapter which fits into the side slot on a laptop. This one will read Compactflash cards.
Below: This SD has a built in card where the card "snaps-in-half" to reveal contacts which fit into a USB port.

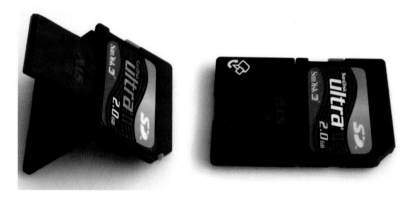

This is best done on the camera but can be done by the computer. If so make sure you delete only the files not the folder on the card as future storage may be a problem when it searches for the specified folder. If that happens, reformat the card.

USB has being superceded with the faster USB2 and likewise Firewire 2 is here. Although a wired connection is normal cameras are now appearing, e.g. Sony, that use wireless methods such as Bluetooth. These allow transfer at similar speeds to USB but the camera does not even have to be in the same room as the computer!

Choosing a digital camera

For most manufacturers film cameras have become a niche market. The emphasis is digital. It can be very difficult in some quarters to buy a compact film camera. This is not surprising as the cost of digital cameras is at an all-time low where they have flooded the market and the boom has collapsed. Most importantly film compact cameras have little or no advantage over digital ones. Everything you might want to do with film can be done better with digital. To start with, a memory card will hold hundreds of shots whilst film is limited to just 36. The card will not have a date limit or be affected by x-rays when passing through the airport security. Possibly the only slight advantage of film cameras is their ability to use less battery power. For those not wishing to embrace digital technology it can be daunting, thinking that a digital camera is all about computing. Well, it does not have to be at all. Take as many photos as you wish then take the camera to your usual high street shop to have the photographs printed. They will do everything and pass you a wad of photographs. They will even let you check them on a screen before you select which ones to print. It could not be easier. If you want to get more out of your photography then you could start thinking about computers.

So what are your options? Like all things it comes down to you and your personal preferences but here are some ideas based on cost. Cheapest first

- Basic digital compact with full automatic functions and 3x optical zoom. This is the typical point and shoot, fit in a pocket, lightweight camera. 50-200 pounds/$300

- Digital compact with automatic functions as well as manual control, e.g. aperture priority, 3x optical zoom or more. A point and shoot type camera but one where more options can be controlled like exposure. More features, possibly better quality lens but overall may be a bit heavier than the basic and so would need a larger pocket. 150 – 350 pounds/$600.

- Digital Bridge camera, with automatic but full manual controls, optical zoom range from 3x up to 18x. These can be bulky cameras like the previous type but pretending to be close to a DSLR (next option). Hence the term "bridge" as they span the gap between them. There are not many examples (see Olympus SP550 and Fuji 9600) but they will be a very flexible option with a good zoom range, close-up facilities and quality. The lens is fixed and therefore will not let in dust like the DSLR as long as they are handled with care. 250 – 350 pounds/$600.

- Digital Single Lens Reflex Camera (DSLR). At the top end of the scale you have a sophisticated SLR camera with all the lenses and attachments you could ever want. You get full control of the photograph if you wish and it will give the best image quality.

Digital Image

Digital or Film

Camera Choice

Camera Controls

Accessories

Taking Photographs

Scanning

Viewing/Organising

Improving Images

Creativity

Archiving/Printing

E-mail/Web/Video

Film SLR. If you already have plenty of photographic gear there is the option of just buying a good scanner and scan the film. See page 123. A high quality scanner is essential as getting a good result is not easy. If a shot taken on a DSLR is compared with one taken on film and scanned, most people would choose the first. However, quality is affected by many variables not least the ability of the person doing the scans. When print film is processed there is an option of having the images on a CD as well.

Before looking at specific camera choices further features to consider are as follows.

The Sensor. Sensors in DSLRs are larger than those in compact cameras and will produce a better quality image. The larger sensor provides a cleaner image with less noise or interference between the photosites for the same resolution. See below more on DSLRs.

Resolution. In recent years there have been "pixel wars" between manufacturers trying to squeeze more photosites into the sensor to create better quality. Generally, a compact with around 6 or 7 megapixels will be more than adequate for the job of producing top quality print blow-ups. Increasing the size much above this in a compact may end up creating more noise. See page 40

Lens quality. The better the quality the better the image produced. The centre of the lens, which has the best quality, deteriorates toward the edge. Inexpensive lenses may have a reasonable centre but the fall off to the edge can be dramatic resulting in distortion around the periphery of the photo. Look in the four corners of the picture and see how it compares with the centre. When camera magazines carry out reviews on equipment this is one of the tests they make and so consulting these before you buy can be a useful tool to help you choose. Manufacturing a good, low distortion edge costs money and will affect the cost of the camera.

Zoom lens. If you need to get closer or further away for better composition it may not always be possible. This is when a zoom lens is useful but you should only consider optical zooms. Digital zooms are really just a gimmick and effectively crop the image. This can be done later on the computer. The greater the zoom range the more expensive the camera but is more versatile. Telephoto lenses will increase the chance of camera shake and so those cameras with some form of **optical image stabilisation** will be most useful. This anti-shake device will help if you do not have a tripod. Some cameras without the feature increase the ISO level to compensate but is not so good and could degrade the image.

Level of controls. Simple point and shoot models will just have an automatic mode with the possibility of some minor manual over-ride. If you really want to take control of the exposure

FIGURE 16: Rear view of a basic compact. Note that there is only an LCD screen present (no optical viewfinder). The dial surrounding the OK button is a typical 4-way switch to control the menu. The rocker switch for the zoom as at the top."

FIGURE 17: Rear view of a bridge camera. Compare this view to Figure 16. There is an electronic viewfinder above the large LCD. The dial is still around the OK switch but there is now a large dial on the top plate allowing changes to exposure with Shutter and Aperture Priority as well as full Manual control. NB. The LCD has a plastic shield added to prevent being scratched."

look for options called Aperture and/or Shutter Priority, even Manual written as A, S and M respectively on the camera.

Flash. Most digital cameras will have a flash, ideally located off centre to reduce red-eye. The power of the flash produced effects the distance that it will reach, typically a maximum of three metres. If it is important for you to illuminate areas further than this consider a more expensive camera and having the option of attaching an external flashgun. This needs a hot-shoe accessorie attachment on the top of the camera although other options are available. See page 85

Viewfinder. Whilst the optical viewfinder was the usual way of composing the picture it has largely been replaced by the LCD screen, especially the inexpensive range of cameras. A separate viewfinder, as well as the LCD screen on the back, may increase the cost but is well worth considering. It can be more effective in bright light. The top end of the compact and bridge camera range may use an electronic viewfinder (EVF) which means that what the lens is

Digital Image

Digital or Film

Camera Choice

Camera Controls

Accessories

Taking Photographs

Scanning

Viewing/Organising

Improving Images

Creativity

Archiving/Printing

E-mail/Web/Video

seeing is what you see. This is approaching the SLR (single lens reflex) camera found in traditional photography and can be very useful, particular for natural history photography. However, the view you get is a relatively low quality picture to an optical viewfinder and can take some getting use to. They can tend to be slow to react to changes in the subject and the camera needs to be switched on before the scene can be viewed. Personally, I believe the disadvantages are outweighed by the advantages, once you become experienced at using them. For example, it gives a better indication of the exposure, whether it is too bright or too dark. It is then possible to make adjustments. Also, images can be played back through the viewfinder, especially useful in very bright sunshine. Any camera's viewfinder will only show a percentage of what you eventually get. More will appear in the final image and often things appear in the shot that you were not expecting. Practice with your camera to see what extra will appear as it is usually biased to one side, by up to 10%. If you know this in advance it can be allowed for and even used to your advantage. See page 55

LCD panel. Located on the back of the camera this is primarily for viewing images once they have been taken. If you have a number of images saved you can scroll through them one a time. Pictures may look good on this small panel but this can be deceptive. An out of focus image viewed four centimetres across will appear in focus. Use the zoom control to enlarge sections of the photo and see if it is distorted or out of focus rather than relying on the entire image on the screen. If you do not like the image you can delete it and retake it. The LCD panel is an important component and should not be under-rated. A large, clear (one with good contrast) panel will add slightly to the cost so make sure you are happy with this screen when you buy. Viewing an LCD panel in bright sunshine is near impossible although it does vary between.manufacturers. Find some shade or put a coat over the top. It is possible to buy a shield to put over the panel if you use it a great deal in the sun. Due to its position, the surface of the panel can be easy to scratch; check out the quality of the surface material and if in any doubt buy one of the special clear plastic shield which will stick on the screen and protect it.

Batteries. Digital cameras are notorious consumers of batteries. The first camera I owned in 1997 would barely take five shots before the four AA batteries died. Great advances have been made since those days but it is an important factor. Rechargeable batteries are best and lithium ion types last the longest but are most expensive. Consider the need to buy additional batteries when costing out your new equipment. The less the LCD panel is used the longer the battery will last. See page 89

Recovery Time: Once the photo has been taken you would think that as there is no film to transport there would be a minimum delay before a second shot could be taken. Wrong! Upon

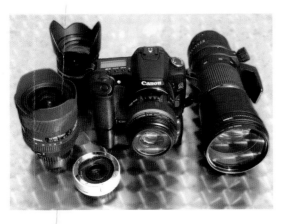

FIGURE 18: Digital SLR with a selection of lenses. This is a very bulky camera compared to compacts and bridge cameras but you are buying into a system. Here there are lenses from independent makes like Sigma and Tamron. The lens on the camera body is a macro lens".

pushing the button down the image has to be captured on the photosites, extra "noise" eliminated and then saved to a medium. The higher the resolution the bigger the file size. The delay could be easily measured in seconds and this does vary between camera. If this is an important consideration for you check when you buy the camera. Normally, a light will change colour during the saving process and so you can get an indication of the time. Some cameras have a multiple frame facility that while the button is held down it keeps taking photos, a bit like a motordrive on film cameras.

Stills or Movies? Most compacts and bridge cameras will have a movie mode. Pressing the shutter starts recording whilst another press stops and saves the videoclip as a file. It will store this either as an AVI file or MPEG. Both of these can be shown on a computer and clips can be joined together without too much fuss using a Moviemaker software found in Windows or iMovie on the Mac. Two considerations are the length of the movie clip and the quality. Older and cheaper cameras will have a limited time, around 30 seconds to a minute. Most compacts now allow the recording to continue until the memory card is full. If you use this mode regularly consider large capacity cards as file sizes will be significantly larger than stills. The file size is affected by the quality. The basic resolution of 320 pixel across is usually the lowest whilst 640 x 480 pixels is the highest. On top of this is the frame rate with the lowest of 15 frames per second and the highest 30 fps. Setting 640 at 30fps will create a clip of very good quality but large size. For example, a three minute AVI file will be around 150 megabytes. The fast writing speed may need a fast card and for Sony compacts the Pro stick is essential.

If taking video is more important than stills you may need to look at camcorders as an alternative. Those by Sony, Canon, Panasonic and JVC produce a much better control of the

Digital Image

Digital or Film

Camera Choice

Camera Controls

Accessories

Taking Photographs

Scanning

Viewing/Organising

Improving Images

Creativity

Archiving/Printing

E-mail/Web/Video

filming with pauses, special effects and up to an hour recording. In addition they will take digital still photos. The resolution of these may appear good but the small sensors tend to generate high levels of noise and are rarely of a good quality.

The DSLR

The film Single Lens Reflex has for many decades been the choice of enthusiastic amateurs and professionals. Many of the latter have already switched to the digital version but the top flight ones are still very expensive. In the last few years the boom in affordable DSLRs have opened up this section to the amateur and has squeezed the Bridge Camera market. The DSLR gives the ultimate control over the shooting of all subjects as you buy into a system. To begin with you purchase a camera body and then lenses to fit and remove. They may come with a "kit" lens which may seem alright but can be inferior to others. The sensor size of the majority is 24 x 16mm and called the APS-C. This is smaller than the traditional cameras taking 35mm. As a consequence placing a 200mm focal length lens on the digital camera will increase it to around 300mm. In other words, it is 1.5x the magnification. This is amazing if you want to get a more powerful telephoto but is a disadvantage for wide-angle users. Using the typical 28mm lens it becomes 42mm; not much of a wide angle. This has bred a new range of zoom lens between 12-24mm. The alternative to the APS-C format are the full size sensor DSLRs but they tend to be expensive. Olympus went their own route by producing their own Four Thirds system with a sensor 18x13mm. There are possible concerns with this even smaller sensor in having a potentially limited resolution without creating noise, although there have been some excellent results recently with these cameras. Many of the lenses produced for DSLRs now come in a digital enhanced form. Essentially this changes the way light leaves the back of the lens to enter the sensor.

Buying the DSLR opens up a wealth of accessories including specialised flash, cable releases and any number of gadgets. But there are disadvantages. They can be heavy, especially once you start buying many lenses. The major problem is dirt and dust getting on the sensor, primarily, when the lens is removed to fit a different one. Pictures taken with dirt on the sensor will have variable number of out-of-focus dark blobs on them. Some cameras reduce dust and dirt by rapidly vibrating the sensor before taking the photo, shaking off the problem. All cameras have a cleaning mode to leave the sensor exposed. Make sure the battery is well charged. You can then reach in with cleaning kits. Various brushes and vacuum cleaners are available and, for stubborn dirt, wet swabs. These are all specialist items and not particularly cheap.

So, which digital camera is best for you? Only you can say. If you want large prints of

A4 size and beyond then more pixels are good. But for most people you do not need huge numbers. Think about weight: do you want it to sit in a pocket or are you happy to carry a large bag with lots of accessories. A bridge camera saves having to carry different lenses. The Olympus 550 has an 18x zoom equivalent to a range of 28 – 510mm. This would save a tremendous weight of lenses but the quality will not be as high as a DSLR with separate lenses. Compromise maybe necessary.

A selection of digital cameras

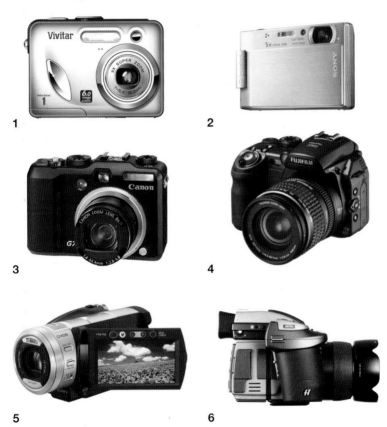

FIGURE 19: 1. Basic, expensive compact. 2. A Slim-line model. 3. Advanced compact with DSLR capability. 4. Bridge camera: fixed lens but SLR style. 5. Digital camcorder with hard disk/memory card, capable of stills as well as video 6. Seriously expensive and professional 22-megapixel digital camera.

Digital Image

Digital or Film

Camera Choice

Camera Controls

Accessories

Taking Photographs

Scanning

Viewing/Organising

Improving Images

Creativity

Archiving/Printing

E-mail/Web/Video

Basic camera controls

People talk about point and shoot cameras. Most digital cameras can be classified as such. Point the lens in the direction of the subject and press the button. The camera does it all without you having to think. This is the way the least sophisticated entry level compact digital cameras operate and for the majority of people that is all they want. No controls, push the button. Yet there are still things to think about. Ways to control the quality of the final image. Composition and how to improve the way a photograph looks will be discussed later but in terms of controls there are essential ones that must be considered even with a point and shoot camera if you are to maintain good quality.

Focus and **exposure**.

When you press the button or shutter release to take the photograph (whether this is a digital compact or a traditional film camera) there are *two* important stages. Press down a little, not enough to take the picture, just sufficient to get the camera ready. In most cases there is a light, usually green, which flickers in or near the viewfinder when you first touch the button. During this stage the camera is focusing the lens (and makes some noise while it is doing so) and setting the correct exposure for the light available. The green light flickers for an instant

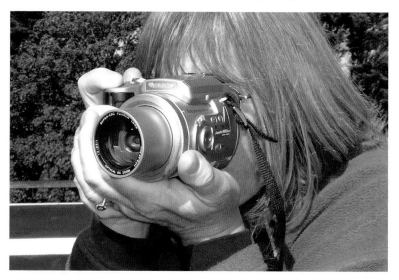

FIGURE 20. Whatever the camera it is essential to give it good support. Place the left hand underneath the main body to give most support and compliment this by grasping the side with the right hand. The forefinger and thumb of the right hand then operate the controls.

FIGURE 21. Locking Focus and Face Detection Technology. The image on the left has the faces slightly blurred. The camera has focused behind them. When photographing two people focus on one first, lock the focus and then recompose to take the picture. Cameras are available with *Face Detection* software which identifies where the faces are and locks on to them without the need for you to do this.

and then remains on telling you that these two have been set. If you take your finger off the button the light goes out. Touch the button again and it flickers again as it refocuses and sets the new exposure. Fixed focus lens will not make any noise and this does not apply to those cameras. If you push your finger all the way down after the green light has remained on, the photo is taken.

This first stage of creating the correct focus and exposure is the most basic of functions but must be clearly understood to achieve good results. If you ignore the first phase and just press down in one movement the photo may be taken without the correct focus or exposure. Your camera may even refuse to take the picture at all. Practice lightly touching the button to achieve this without taking a picture. Most importantly practice *holding* the first stage without taking the picture but keeping the green light on. See Figure 20 opposite. What you have done here is to *lock* the controls on the subject on which you first looked. This is how you can affect the focusing and exposure of even the most basic camera. Even if your camera has adjustments for focus and exposure this is a quick and simple way to lock these controls when operating in fully auto mode. But why would you want to control focus and exposure?

In the centre of the viewfinder there is usually a marked area, often as a circle. This is the zone or area used by the camera to make the focus and exposure when you take the photo. Whatever is contained in the circle should be in focus. In Figure 21 above there is a classic

Image
Digital
Digital or Film
Camera Choice
Camera Controls
Accessories
Taking Photographs
Scanning
Viewing/Organising
Improving Images
Creativity
Archiving/Printing
E-mail/Web/Video

FIGURE 22. Fill in flash. A quick snap would result in either the person being dark and the outside correctly exposed or the reverse. To get both correctly exposed the photo was taken with the flash switched on but by first locking the exposure on the scene outside.

photo of two people. Upon framing them the circle will be between the heads and therefore focus behind them. If the area was very pale or dark this would also upset the exposure. In this circumstance lock the focus on the head of one person and then move the camera to compose the shot before pushing the button to take the photo.

Photographing someone against the light invariably results in them being dark. If you focus up close on the person the flash will probably switch on automatically to exposed them correctly. Unfortunately the rest of the shot will be underexposed. This is typical of taking photos of people against windows. See Figure 22 above. To avoid this happening it is simple to overcome by first manually switching on the flash and then locking the focus and exposure on the window area. The exposure inside should equal that outside. Lets see how the flash works

Using the built in Flash

Most people leave the flash to auto so that when there is insufficient light the flash comes on. This happens even when photographing a landscape if the camera considers that there is not enough light although the flash will not be able to illuminate much further than 3 metres in front. Learn to switch the flash on and off when required. Consult the manual for your camera

as there may be a button to push or a menu to scroll through. Either way they will normally have the following settings:

Flash Setting	Result
Auto	Only flashes when there is insufficient light on subject
Red Eye	Flashes several times, the first trying to reduce the effect of red eye
No flash	Switches off the flash
Force Flash	The flash always fires upon squeezing the shutter release

If a person or pet is in low light the pupil of the eye is wide open and a flash reflects off the back of the retina to create an image with red eye. By the flash going off twice the first time will make the pupil constrict a little and reduce the effect of red eye. This can be eliminated in the computer stage. See page 155.

Forcing the flash to be used is good in several situations, one of which was above. Fill in flash could be used to illuminate someone's face in the shade when in strong sunlight. The exposure is made for the landscape but by switching on the flash the harsh shadow is eliminated. This is called fill-in flash and may need a few attempts to get it right but with a digital camera it is easy enough to delete unwanted shots. When the background is getting dark in the early evening try filling in the foreground with a flash. Remember that a flash will not reach very far, just a few metres or so. Figure23 and 24 below.

FIGURE 23 AND 24. Fill in Flash. Flash can be used to expose the forground outdoors. This is useful at night or the early evening when the background has some light but the people would be underexposed in the foreground. Use the exposure from the background but use the flash to illuminate the forground.

Digital Image

Digital or Film

Camera Choice

Camera Controls

Accessories

Taking Photographs

Scanning

Viewing/Organising

Improving Images

Creativity

Archiving/Printing

E-mail/Web/Video

FIGURE 25. Need for Support: This macro photo of mosses uses natural light but to hand-hold the camera with a small aperture would give a blurred image unless it was carefully supported with a tripod which was able to position the camera low to the ground

Why would you want to switch off the flash? Flash can be a strong, even harsh, light and for some subjects a softer approach may be better. The moss in Figure 25 opposite was taken without a flash otherwise it would have had cast a strong shadow and the soft detail lost. The bluish background would have been black. As it is the image is soft and delicate like the moss itself. Without a flash the camera has to take a longer exposure, meaning that it takes longer for the light to be picked up on the sensor. In turn, camera shake could occur and so some sort of support is necessary.

Camera Support

A tripod is the preferred means of support for any camera and if you do use a tripod make sure it is a good one. Cheap tripods are not much better than using a fence post as a support. Make sure that when extended they do not flex. In fact, do not feel the need to always extend them; keep them low and the tripod will be more rigid and stable. Figure 26 below shows several types, all of which are rigid, stable, lightweight and easily carried when hiking. Consider

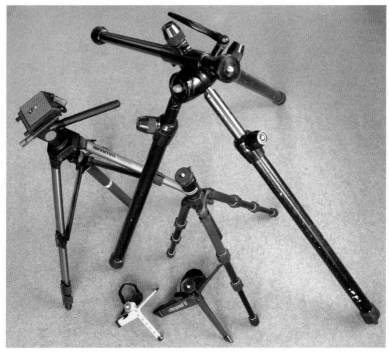

FIGURE 26. A selection of tripods and ultrapods.

Digital Image

Digital or Film

Camera Choice

Camera Controls

Accessories

Taking Photographs

Scanning

Viewing/Organising

Improving Images

Creativity

Archiving/Printing

E-mail/Web/Video

FIGURE 27. The Ultrapod strapped to a balcony to take a slow exposure inside a hotel. Result is FIGURE 28, 1/4 second using a self timer to stop camera shake.

buying a bag if the tripod does not come with one or an Op/Tech tripod strap that allows you to carry it easily over your shoulder. Those with a built-in spirit level may help to keep a level horizon when composing the image. Despite owning three tripods I am the world's worst at carrying one. I even have an ancient, but still working Cullmann table top/shoulder support sitting in my camera bag but will always try to get away without it. I am more likely to lie down on the ground and use a natural support.

I like tripods that will go into strange positions. That way you can take more unusual photos. For natural history subjects, like flowers close to the ground, it is essential to buy one which gives the opportunity to easily collapse to ground level. Benbo, Unilock and some Manfrotto and Cullmann models are very good. The former two have a bolt through the centre allowing the legs and central pole to go "limp". Then the legs can be pushed and pulled into any position. Unfortunately the one aspect which gives the great flexibility, the bolt, is also its weak point. It is easy to over tighten and then snap the bolt and getting replacement ones is not that easy. Some Manfrotto and Cullmann tripods have legs which can fold out side ways and so bring the camera closer to the ground. In turn the central column can either be reversed or fitted sideways to create the greatest flexibility although it may be a bit more fiddly than the previous two. Manfrotto also make carbon fibre tripods which are very lightweight and strong but expensive. Cullmann produce a good range including excellent solid tripods which are ultraportable. Also, there is a desktop collection that includes several lightweight and tough

plastic Ultrapods suitable for digital cameras. Ultrapods are easy to carry and strap to other supports such as tree branches, railings, gate posts, walking poles etc. See Figure 27opposite.

There are tripods which can be reversed so that the pole through the centre is repositioned with the camera underneath it. Setting up a shot near to the ground takes long enough and if your tripod requires work to achieve this you may not be keen to use it. You should also consider getting a quick-release mechanism – almost a must! – so that you do not spend time screwing the camera on to the top of the tripod. A plate attaches to the base of the camera and then it quickly slots into place on the tripod head.

Sometimes a tripod head does not come with the tripod. This gives you the choice of what to fit. If you are buying a tripod for even the slightest specialist job, think carefully before buying and be prepared to spend up to £100/$190 or more. This may seem excessive for something which just holds a camera steady but a good tripod opens up many new and exciting opportunities. To start with, if you have bought a relatively expensive camera with manual control of shutter speeds you will not be able to use the potential of your investment as half of the shutter speeds will not be practical without a tripod. Use a tripod if:

- light is low, e.g. sunset, and the shutter speed is likely to be lower than one thirtieth of a second
- for close-ups
- for panoramas of landscapes (see page164)
- when using the telephoto (zoomed in)

Digital cameras are generally small and light and it is tempting to get away with a minimum of support. In many cases leaning against a wall or resting it on top of a fence post will give you the chance of using the camera in low light without a flash. Sunsets especially need a camera support. A small bean bag placed down first with the camera on top will often work when using the self-timer to take your own photo or to improve the support on a post or table.

The act of taking the photograph will in itself cause shake even if it is being supported. Use the self-timer. Although this is primarily to allow you to take photos with you in the shot it is ideal to take photos without having to touch the camera. For this, many cameras have two settings – one with a delay of 9 to 12 seconds to give you the chance to get in front of the lens, the other with a delay of just 2 seconds. This latter one is for use on a support. Set the delay time required, and then push the shutter release followed by removing your hands from the camera so that you cannot jog it.

There are a whole host of different remote shutter release mechanisms for film

Digital Image

Digital or Film

Camera Choice

Camera Controls

Accessories

Taking Photographs

Scanning

Viewing/Organising

Improving Images

Creativity

Archiving/Printing

E-mail/Web/Video

cameras but few for digital, hence the need to use the self-timer. Some manufacturers, e.g. Olympus, Sony, do produce wireless remotes which come with their cameras. This will be a small, flat box with buttons to control various functions. The camera can be set up on a tripod and then operated from some distance away.

Auto Exposure and Compensation

What do we mean exactly about exposure? Light passes through the lens of the camera and on to the sensor but the light level varies considerably in the environment and like the iris of our eye needs to be controlled so that the exposure to the sensor is not too bright or too dark. Typically, this is achieved by two methods. First a diaphragm which like the iris is a variable sized hole and then by a shutter. This may be a physical device that opens to let the light on to the sensor for a specified time (usually in fractions of seconds) or an electronic switch in some digital cameras. The diaphragm or apertures and shutter speeds are discussed in more detail under Advance Controls See page 59. In all cameras there will be an automatic exposure control which upon pushing the shutter release will measure the light present and set the controls appropriately. There are different methods for achieving this. The most commonly found is *Centre-weighted metering*, which as the names states, concentrates on the light from the centre of the frame but, essentially, averages the light measurement before it sets the controls. For much of the time this works well and each image is perfect. Sometimes it can be fooled into thinking there is too much or too little light. This happens when photographing extremes, such as black or white.

FIGURE 29. Difficult exposures: this female polar bear is walking across brightly lit fresh snow and the exposure meter will be fooled on auto to create a grey rather than white bear. An exposure reading off the nearby bushes will help.

Considering monochrome photography for a moment, rarely is an image made up of black and white but various shades of grey. Nine in fact. From white these greys start as being very pale to gradually a mid-tone and then dark until black. These tones represent colours so that green is mid-tone whilst red is dark and blue, pale grey. Photographing mid-tone grey or green produces perfect exposure as it is between the extremes. When it comes to black no light is being reflected from the subject, it has been absorbed. The metering detects little light and so it changes the controls so that they allow more light to enter the camera. Instead of getting black the result is a greyish exposure as the black is brightened by over-exposure. When it comes to white a considerable amount of light is reflected back at the camera. This time the metering believes that there is so much light available that it overcompensates, the controls reducing the amount of light entering the camera. The result, grey again, as it is now under-exposed.

So, it is the extremes that mess up photography. But, now you know, you can do something about it.

Zooming in on a bride in her pure white dress in bright sunshine is the perfect recipe for turning grey. If there is grass to one side of her, take the exposure here, lock the exposure, recompose on the bride and snap. Green, remember, is mid-tone and will produce the correct exposure. So important is this mid-tone you can buy a mid-tone grey card from your camera shop from which to take the exposure. Useful if there is no grass nearby. The same is true for photographing anything black. With care this works fine but the locking process also locks the focus and so this must be done at the same distance from the subject, unless your camera has a separate automatic exposure locking button (called AEL) which you can use. See Figure 29 opposite. When you take the exposure reading off the grass push and hold the button in until you have recomposed and taken the photo. If your camera has full manual override see the next section on Advanced Controls.

Your camera may state that it has manual control but this may be limited to AE Compensation. This allows you to override the auto setting but does not give full control. The worst aspect of it is remembering to reset it afterwards, although some cameras do reset when you switch them off. See Figure 31 on page 53.

A good time to use this function is when snow is lying on the ground in sunshine. The highly reflective surface will go a dull grey if you do not compensate. The way the manual override usually works is to move along a sliding scale of exposure values, e.g. -9, -6, -3, 0, 3, 6, 9.

Normally, the setting will be zero. In snow the camera lets less light through so by resetting at 3 the light entering will be doubled. Moving to 6 it will double again and would

Digital Image

Digital or Film

Camera Choice

Camera Controls

Accessories

Taking Photographs

Scanning

Viewing/Organising

Improving Images

Creativity

Archiving/Printing

E-mail/Web/Video

be a typical setting for snow. Try a test shot and check this on the LCD panel to see if this is OK. If not reset to a different value and test again. If you are taking a large number of shots, check at intervals that the exposure is still fine, especially if the sun goes in and the scene darkens. The reverse is true for naturally dark images and removal of light is required by using minus values. The beauty of digital photography is the speed you can check the exposure and delete the images if they are not correct. See Figure 30 below.

In critical shots where you really do not have time to check the exposure as there is just one chance of getting the shot there may be another function to help – auto exposure bracketing. Upon taking a photo in the normal way more shots are automatically taken using different exposure values above and below the first one Afterwards delete the shots you do not want.

Other methods of metering may be present on your camera, e.g. spot metering. As the name suggests, there is a limited, small area of the viewfinder in the centre where the exposure is made rather than using information from across the entire field. By placing the spot on the ideal tone or colour the exposure for that area can be locked, the shot reframed and taken.

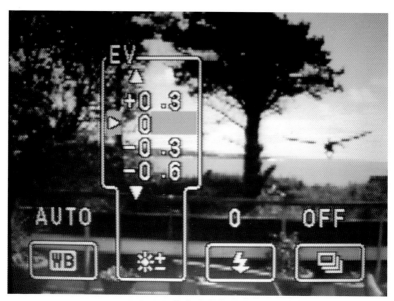

FIGURE 30. Menu Setup – Exposure. This is the LCD screen of a typical point-and-shoot camera. This EV (exposure value) scale should be at zero but if the images come out dark scroll up the scale to a +3 or more. Alternatively, over-exposed results can have the EV adjusted to -3 or more. Don't forget to reset later.

FIGURE 31. Increased sensitivity: Taken after sunset when there is a minimum of light, a flash would be useless because of the distance involved. Here the camera flash has been switched off, the ISO increased to 400 and placed on a window ledge for stability.

Sensitivity to light – ISO rating

Resolution in film cameras is down to the size of the silver halide crystals in the gelatine coating and how many are present in an area. The more that can be crammed in the better the resolution. However, small crystals will be less sensitive to light and so the image will have to be bright to expose the film. A way around this has been to produce larger crystals and therefore more area over the surface to pick up the light. Sensitivity of film has been measured or rated as the ISO value. For example, ISO 50 is slow to react to light but will produce a fine quality image. By contrast, ISO 400 will be faster to react to light but, due to the larger crystals, it will be grainy and not such a fine image.

Although digital cameras do not have film they have a setting called ISO that can be changed to allow a greater sensitivity to light just as if you have put a roll of faster film in the camera. The beauty is the ISO rating can be changed at any time, for just one photograph rather than having to change films.

Compacts have an Auto ISO control where the camera adjusts the ISO with the light.

Digital Image

Digital or Film

Camera Choice

Camera Controls

Accessories

Taking Photographs

Scanning

Viewing/Organising

Improving Images

Creativity

Archiving/Printing

E-mail/Web/Video

However, the best quality will always be if it is manually set on the lowest number, e.g. 100. In low light a warning of camera shake may appear. If the scene is a distant one a flash will be of little use as it will only be suitable for up to 3-4 metres. Also, flash can produce a harsh light to faces or objects and in some public places such as museums flash is often banned along with tripods. The latter is ideal in low light. If a tripod is unavailable and flash is impossible change the ISO setting to a higher one, usually 400. Maximum ISO settings may reach 3200, even in compacts, but only use in emergencies as the image will be grainy. The "grain" is actually interference or noise. Some of this might be eliminated later on the computer. For the shot in Figure 31 on page 53 the camera was rested on a window sill to steady it because the light was still fairly low for even the high ISO setting. Always look for support as low light invariable means a slow shutter speed. A much slower shutter speed would have occurred at ISO 125 and a much better support would have been needed. Having the ability to switch the level of sensitivity provides a great flexibility, allowing some otherwise difficult shots to be taken. If possible try a sensitivity less than 400 to avoid camera shake but always remember to switch back to the lower ISO level when you have finished.

LCD Panel

This has two functions: to view and check your images and, second, to use it under certain conditions as a viewfinder. Either way, keep its use to a minimum as this is the single most energy consuming component of the camera. By default keep it switched off, using it sparingly. For many cameras however, it is the only way of finding out how many more images you can take and how much battery power there is left. Some cameras fill the panel with an incredible amount of information so that it is almost impossible to see the image. Typically, there will be a display button to press that will switch the panel off and on, as well as to restrict what written information will be shown. In some pressing this repeatedly will scroll through various displays from clear screen, data displays and even guides for composition. The latter consists of a grid dividing the screen into nine equal segments. It is of particular use when there is a clear, flat horizon, such as a view of the sea. Invariably, people hold the camera at a slight angle producing a result with a sloping horizon. The camera can be held so that the horizon is next to one of the lines on the grid to keep it straight. See page 109 for more detail on composition. Parallax problems occur with optical viewfinders on non-SLR cameras and at times, such as close-ups, the LCD screen gives a truer picture. See page 115 under macro.

Viewing images on the screen can be deceptive. Remember that it is tiny compared to the eventual size of the print or view on a computer monitor. This means that even an out of

focus shot will appear to be sharp on the small screen. If the photo is important to you and can be taken again check on the panel by zooming in close to a critical area on the picture. Practice this before the critical time when you need it. By zooming in close it is possible to see the relative sharpness and whether to take it again.

Erasing pictures held on the memory card is just one feature whilst in viewing mode. Other options may be available such as playback controls. This is primarily for when showing them on a TV direct from the camera and allows fancy transitions between images such as swirling and dissolve. The camera is connected by a suitable cable (normally supplied with the camera) to the AV or video socket on the television.

Another option on the camera, in LCD panel view, will be the option to change the resolution of the image by reducing the number of pixels and in turn making the image size smaller. For example if the image is 1600 pixels across it could be reduced to 1280 pixels. The advantage of this is if you are running out of space on the memory card but do not want to delete the image. You down grade it instead so that it frees up memory for more pictures. Important in an emergency. Note that usually the camera generates a new file so that it will need deletion of the original.

Files can also be protected by locking them so that they cannot be accidentally erased. Finally there may be a DPOF (Digital Print Order Format) facility. This is an option for allowing you to record information on the memory card if the images are to be printed commercially. It sets the conditions for which prints and how many to print. It may also allow you to specify how you want the prints cropped.

The LCD panel is strongly affected by bright sunshine and some are worse than others. Do not delete images unless you can see them clearly, by going into shade or diving under a coat. Shades designed for specific models can be purchased but are rather bulky.

Viewfinders

As mentioned before, it is very important to understand the viewfinder to achieve good results, especially to realise its limitations and what it does not show you rather than what it does.

First off the optical viewfinder (OVF) may appear to be better than the electronic (EVF) form. This is because you do not have to switch the camera on to look through and it does not use batteries. The OVF will zoom as you zoom the lens and so it appears to frame your photo well. However, the lens which you are looking through is not the lens taking the photo, unless this is an expensive digital SLR. See Figure 32 on page 56. For distant shots the difference between OVF and EVF is negligible but the closer your subject is to the lens

Digital Image

Digital or Film

Camera Choice

Camera Controls

Accessories

Taking Photographs

Scanning

Viewing/Organising

Improving Images

Creativity

Archiving/Printing

E-mail/Web/Video

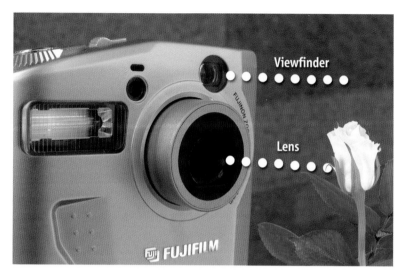

FIGURE 32. Parallax problems: The viewfinder is above the lens in a point-and-shoot camera. What you see is not exactly what the lens photographs. With the subject at a great distance from the camera there is negligible difference but the closer to the camera the more noticeable this becomes. For close-ups it is a major problem and needs to have the LCD panel switched on on to see what the lens sees.

the more likely that what you see is not what the lens will take. This is especially so for macro use but also for close-ups of people where you might chop the top of a head off. In this case switch on the LCD panel and use this to focus and frame your photo. This does show what the lens is looking at. In most cases switching to macro on the camera will automatically switch the panel on. For long term use it will soon drain the battery so be careful. Another problem is that the OVF is not sensitive to light and so gives no hint as to the exposure of the photo. The only thing to do is keep taking the shots and then check afterwards on the LCD panel. In this respect an EVF is great.

The EVF is a small version of the LCD panel, meaning it uses battery power but less so, and being shielded by the eye is not affected by bright sunshine. EVF is found on the higher end of digital cameras and can have a number of benefits. If the camera is used in preview mode rather than immediately storing the photograph the shot appears in the EVF so focus, framing and exposure can be checked. Two buttons are located near where your thumb is likely to be, One saves the image, the second deletes it and all without taking your eye from the viewfinder. Even if the camera is not set to preview it would be possible to switch it into viewing mode and peruse the stored images in the EVF. In bright light it may be difficult to view images on the LCD panel but easy with a EVF.

The EVF allows a good indication of whether the image is overcompensating for an extra dark or light subject which the OVF could not do. If the image on the screen is very pale this acts like a warning that something needs to be done or the image will be overexposed.

Other Camera Settings

There are a number of fundamental set-up procedures you should understand which are common to most digital cameras. Typically, there is one control that places the camera into set-up mode and adjustments are made by looking at the LCD panel. A list of options is then presented and by using the up and down arrows near the panel they can be selected. *Resolution* is one that has been already discussed. Depending on the sensor and the cameras ability depends on what will be available but this is usually present under *file size* such as 2400 or 3M, 1280 or 1M. Choose the number of pixels required across the top of the image. Either as part of this or another option within Set-up is *quality*. This controls the degree of compression required. The *Fine* setting will produce the least compression and best quality but the largest file size the opposite of *Basic*. See Table 2 page 19

Frame Number: There are two options, either to *renew* or *continue*. In the first case all file numbers return to zero every time you erase all the files or fit an empty memory card. As the name suggests, continue just carries on the numbering sequence until it gets to 9,999 at which point it restarts at zero. In most cases leave it on continue. When the files are downloaded to the computer there will be files present already. If you renew the file number it is quite likely that the files could have the same name. This is especially likely if you have more than one memory card and try to download them at the same time. You will have to generate a different folder to download the files into as the files will have the same names on the two cards. This is avoided by having it set to continue. The files will all download into the same folder and be in the correct chronological order.

Date & Time: by setting this correctly ensures that when the files are transferred to your computer this information will be saved along with other information.

Auto Power Save: This may be an option available to you, especially if the camera has an electronic viewfinder. To save power the camera can be set to switch itself off after a period of time in which no controls are touched. This is a good default so that you do not leave it on by mistake. If an important event is to happen, then switch the auto power save off.

Digital Image

Digital or Film

Camera Choice

Camera Controls

Accessories

Taking Photographs

Scanning

Viewing/Organising

Improving Images

Creativity

Archiving/Printing

E-mail/Web/Video

Beep: unlike traditional film cameras that make a noise when taking photos (shutter followed by the film transport) it is quite possible to take a photo with a digital camera in total silence. The beep is there to let you know that something has indeed occurred! For some this may be highly annoying and so switching it off may be essential. In that instance there is probably a light which changes colour when the photo is being stored to memory card so you can still be aware that photos have been taken. You may be able to reduce the volume of the beep. Loud beeps can be obtrusive when you want to take candid photos of people as well as being a major problem photographing wild animals.

Preview mentioned under viewfinders above. Useful facility to preview a photo before saving.

White balance: Film is very sensitive to subtle variations in the colour of lighting and daylight film is balanced for mid-day. As the sun moves across the sky so different wavelengths reach the earth and generate brilliant red sunsets or bluish light before dawn. These can enhance pictures but there are times, like indoor lighting with light bulbs, when colour shifts to one of yellow or brown. The eye adjusts to this but film creates a photo dominated by yellow. Digital cameras however have the ability to adjust automatically to these changes. It is called white balance and ensures that all whites in the picture do come out white rather than yellow or brown. In fluorescent light it would be a greenish tinge. By default this is automatic and no adjustment is necessary to the controls.

Sometimes the camera will not always be able to cope with the extremes. Try taking a photo indoors with just tungsten lighting (normal light bulbs), switching the flash off. It may well need a support to avoid camera shake. The image will have a soft effect and will contain a strong hint of yellow which gives a warmth not found when using the flash. Different light sources can generate different tints and they may be unwanted. If this is the case and white is appearing in a tint you do not want then over-ride the auto white balance. Options will be available for different types of lighting or can be adjusted manually. To do this point the camera lens at a sheet of white paper or something you know to be pure white. Once set the camera will automatically adjust the colour. Remember to switch the white balance back to auto once you have finished shooting under those lighting conditions.

Continuous Shooting: When taking a photo a delay occurs before you can take another as the camera saves the image to its memory. This could be a second or two or more. If the likelihood is that a number of shots need to be taken in rapid succession then the continuous shooting

mode (sometimes referred to as motor-drive facility) could be switched on. Whilst the finger is holding down the shutter release the camera keeps taking the pictures. Different digital cameras have differing capacities to temporarily store the images until you release your finger, and then save them to the memory card as required. The camera may even give the option of choosing which images you want saved. Some cameras may limit this facility to certain lower resolutions as high resolutions will require a greater degree of temporary storage.

This is a great feature when taking sport, action or moving natural history subjects. It is not always possible to snap the one shot you want as the subject flies past. Hold the button down for the duration and after the sequence has been taken view the shots on the LCD panel and delete any that you do not want. With any luck one will be just right. Bear in mind that if your exposure and focusing is set to auto all of the photos will be determined by the first shot you took.

Advanced Camera Controls – Beyond Point & Shoot

This section looks at creating better photos by understanding the more advanced controls and putting them to better use.

Focusing

Auto-Focus is standard on digital cameras but on some can be switched off so that focusing can be done manually. A commonly used method to auto-focus is for the camera to compare contrast in the subject and if this is missing the lens fails to focus correctly. This will usually be indicated by a warning light flashing near the viewfinder. It may be possible to find a contrasting subject at a similar distance to where you want to photograph. Lock the auto-focus on that before reframing on the subject you do want. A clear blue sky is a common problem with poor contrast. In this case bring the camera down to focus on the horizon which usually gives the camera something to fix on. Beware of odd subjects like fence posts in the field of view. The camera may focus on this rather than the wider picture. When focusing is difficult and there is the option of manual override this may give a sharper image.

Manual focus is useful in sport or nature photography when a subject is moving fast towards you. Auto-focus is rarely that quick in digital cameras. Switch into manual and pre-focus on a point where you want to take the photograph. If you cannot manually do this try to lock the auto-focus on this point. Then it is a case of placing the subject in the viewfinder and following it until it reaches this pre-focused point so that you can click the shutter release.

Rendering different parts of the picture out of focus can give emphasis to certain

Digital Image

Digital or Film

Camera Choice

Camera Controls

Accessories

Taking Photographs

Scanning

Viewing/Organising

Improving Images

Creativity

Archiving/Printing

E-mail/Web/Video

subjects. This is "differential focus" and can give you the opportunity to separate elements of your picture by placing important parts in focus clear of less important parts which are made less sharp. See Figure 33 below. Although selective focusing is useful another control is very important, aperture.

Exposure - Apertures and Shutter Speeds

Typically, when the camera takes a photo it will first measure the amount of light present (called metering) and then control the exposure of the CCD or CMOS with the correct amount of light to give an image, not too bright or too dark. The control is done in two ways:

- The *aperture* of the lens, which opens and closes like the iris of the eye, produces a hole of varying size to allow different amounts of light through.
- A *shutter* over the film or pixel sensor to expose it with a varying time burst of light.

Usually both of these controls are present but on some more basic point and shoot models only one. Before we will look at the potential of these to improve picture quality it is important to understand them.

FIGURE 33. Differential focus for emphasis. The depth of field is limited so focus on the important place the face and make sure this is in focus.

Apertures and diaphragm

| f2 | f4 | f8 | f16 |

FIGURE 34. Diagram to show four different lens apertures when the diaphragm closes down. f2 is wide open allowing the most light through whilst f16 is at its smallest.

The aperture is the size of the opening in the camera's diaphragm located behind the lens. On a bright sunny day, the light reflected off your image may be very intense, and it doesn't take very much of it to create a good picture. In this situation, you want a small aperture to let less light through. But on a dull, cloudy day, or in twilight, the light is not so intense and the camera will need to let in more light to create an image. The aperture must be enlarged to let more light on to the sensor or film. See Figure 34 above.

A diaphragm allows a speedy way of changing the aperture and as the camera measures the light precisely it must open or shut the apertures to a set size to allow a known amount of light through. A scale of aperture sizes or *F stops* are numbered in a seemingly weird way but has been agreed internationally as F numbers, F 22 16 11 8 5.6 4 2.8 2. This is actually a progression such that 16 has a diameter one sixteenth the lens focal length. The larger the number the smaller the aperture and conversely the smaller the number the greater the amount of light let in to the camera. Moving from the maximum size, each setting exactly halves the amount of light allowed through. For example, f8 allows half the light through as f5.6. The apertures shown in Figure 34 above are whole ones although the camera may well display half values.

The second control of light is the shutter. Think of this as a window blind. It is placed across the back of the aperture to block out the light. Then, for a fixed amount of time, it opens and closes. The amount of time it is open is the shutter speed. One way of getting more light into the camera is to decrease the shutter speed. In other words, leave the shutter open for a longer period of time. Just like the aperture it too needs to be calibrated to open for set periods expressed in fractions of a second. Again, these work on halving the amount of light. An eighth of a second shutter lets in half the light of a shutter one quarter of a second. Film-based cameras have a mechanical shutter, either made from cloth or metal. These make a

Digital Image

Digital or Film

Camera Choice

Camera Controls

Accessories

Taking Photographs

Scanning

Viewing/Organising

Improving Images

Creativity

Archiving/Printing

E-mail/Web/Video

distinct noise when released. Once you expose the film to the light, the shutter mechanism has to be reset in a way that no light is allowed through or the film will be exposed again. This is not the case with digital cameras as this can be reset electronically as the mechanism is usually a combination of electrical and mechanical shutters - a digital shutter.

Check your camera specification for the range of apertures, e.g. f2 – f16, and range of shutter speeds, e.g. 2 seconds – 1/1000th.

Table 6 an example of an exposure range to produce the same exposure of an image

Aperture:	2	2.8	4	5.6	8	11	16
Shutter:	1000	500	250	125	60	30	15

Apertures and shutter speeds work together to capture the proper amount of light needed to make a good image. In photographic terms, they set the exposure of the sensor. When the light is metered the camera will express the exposure with both values, e.g. f8 at 1/60th . In the lower-end of the range of point and shoot cameras this information may not be available, being expressed as an exposure value, See page 50 for more on metering. Whilst it may be possible to adjust the exposure with this it does not give the flexibility we are about to talk about now. In addition, there may be a limit to how the metering is achieved. So what does all this mean?

If we use the example of the exposure reading f8 at 1/60th. As both the apertures and shutters are all about halving or doubling the light available they can be said to be *reciprocal*. Table 6 above shows this reciprocal nature. Moving up one aperture from f8 to f11 halves the light entering the camera and so the image will be darker. However, notice that moving the shutter speed to one thirtieth from one sixtieth compensates for this as it doubles the amount of light through to the sensor.

This means that although the meter reading may have given an exposure of f8 at 1/60th you could just as easily change it to f2 at 1/1000th and the photograph will be illuminated in the same way: the exposure is the same. Once the exposure for a particular scene has been taken the option of which aperture or shutter speed to use is up to you. But why would you want to change these?

Choosing Apertures

Changing the aperture determines what will be in focus. The rule of thumb is: a wide aperture (small number) produces the least in focus and, conversely, the smaller the aperture (greater the number) the more has the potential to come into focus. This is due to *depth of field*. Try

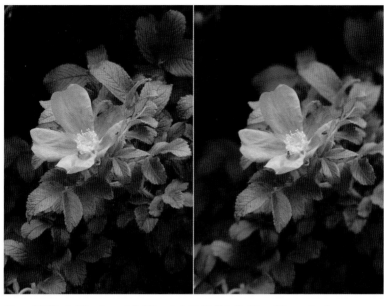

FIGURE 35 Effect of Apertures: left, f16 and, right, f2. Note that the wide aperture has very littlein focus except the rose itself whilst the smaller one has created much more in focus, i.e. good depth of field.

getting close to an object, such as a flower, setting the aperture at f2 (or the lowest number your camera goes to) and taking a photo. Then set a larger number, say, f11. After taking the second shot compare the two photos suitably enlarged. The second will have more in focus (sharp) behind and in front of the object. Play around with your camera to learn about the depth of field. At least with the digital camera you can do this easily and then delete the images if you don't want to keep any.

The zone of what is sharp can be found on both sides of the point where you focus. If you focus on a person a few metres away with an aperture at f2 the chances are that the area in the background will be out of focus. Even at a smaller aperture of f8 the horizon can be out of focus. By changing the point of focus to being a little behind the person the depth of field for f8 now extends to the horizon but because there is an area in focus on both sides of the point the person will still be within the zone of focus. This suggests that you should not always focus on the horizon but somewhere just in front. That way by using depth of field more of the foreground can be brought into focus. Digital cameras have a better depth of field than typical film cameras but it does vary with the lens.

Digital Image

Digital or Film

Camera Choice

Camera Controls

Accessories

Taking Photographs

Scanning

Viewing/Organising

Improving Images

Creativity

Archiving/Printing

E-mail/Web/Video

FIGURE 36. All in focus. By contrast to FIGURE 40 this is a scene where we want everything in focus from the glass through to the horizon. For this a wide angle is used and the smallest aperture to gain a maximum depth of field.

Remember that when you look through the viewfinder the camera is showing you the view as if the aperture is wide open, on its maximum aperture. Once the photo is taken you may be surprised how much will come into focus. This may not always be what you want.

Portraits of individuals can often look better if the background is blurred. Although this can be achieved latter on in the computer by using a wide aperture on the camera the background will go out of focus and help to isolate the person, making them stand out. This will emphasise the individual rather than the back ground. Conversely, a landscape will often require a maximum amount in focus and so a small aperture would be better. Now we see a potential problem. Using the exposure f8 at 1/60th we could go to f16 to get as much as possible into focus but the reciprocal shutter speed is 1/15th. That is too slow to hold the camera and will lead to camera shake. Despite using the best aperture the picture will be out of focus caused by the inability to hold the camera still enough. To be able to use the full range of apertures often means the need for a tripod or another suitable method to support the camera.

FIGURE 37. Slow shutter: With a tripod slow shutter speeds are possible and movement can be blurred. Rather than freeze the action a shutter speed of just one second will give a sense of movement. If the scene is too bright a neutral density filter is needed to reduce the light so that slow shutter speeds can be used.

Choosing Shutter Speeds

The degree of blurring in any photograph will depend on the how much the image moves while the shutter is open. This includes moving the camera during the taking of the image, referred to as camera shake. Be careful to squeeze the shutter release rather than creating sudden movement. To avoid camera shake try not to take photos using less than 1/60th of a second. If the wind is buffeting your body or you are moving in a vehicle use a much faster speed. The way the camera is held is also crucial to eliminate camera shake. Make it part of your body grasping it tightly in your right hand with your arm tucked in well to the side of your body. Use the left hand to support the camera underneath. The bizarre array of different shapes and sizes of digital cameras will influence the way you hold it with some more difficult than others.

Selection of shutter speed will also depend on the focal length of the lens used. With a wide angle of view you can get away with slower speeds but zooming in on a subject requires a faster speed. Many cameras have a shaking hand signal to appear in the viewfinder or a special sound emitted if the shutter speed is too slow and camera shake is likely. If in

Digital Image

Digital or Film

Camera Choice

Camera Controls

Tak

Scanning

Viewing/Organising

Improving Images

Creativity

Archiving/Printing

E-mail/Web/Video

doubt consider using some form of support whether leaning against a wall or a tripod to produce a sharper image. When releasing the shutter be careful not to move the camera even if it is on a tripod. Using the self-timer will reduce shake as you can get well clear of the camera before it fires the shutter. Reviewing images on the cameras LCD panel will rarely show up camera shake unless it is really bad or greatly magnified.

Although we might be able to produce a rule of thumb over eliminating camera shake it is not so easy when considering the subject. Any parts of a scene that are moving may require a fast speed to sharpen up the image and avoid blurring. Freezing action can take speeds of 1/500, 1/1000 or faster. Practice on different subjects and just delete the photos afterwards if they are no good. See Figures 36, 37 on pages 64 and 65 and 38 below. For some moving shots fast shutter speeds may freeze the action so that the main subject looks static. To create movement within a scene may require slow speeds to produce some blur. As we will see this can be added at the computer stage. Panning is a technique where the photo is taken moving the camera with the moving subject. Try setting a shutter speed of 1/30th or 1/60th

FIGURE 38. Fast Shutter speed: Male polar bears wrestling in the snow photographed with 500mm telephoto needed the action freezing. Two thousandths of a second with ISO rated at 400

FIGURE 39. Panning: To capture this road train in the Outback the camera was pre-focused on a point in front where the road was closest. Then by holding the focus the camera was moved to where the vehicle was charging towards me. It was held in the viewfinder, moving the camera until it was in the prefocused spot and the shutter fired, still moving with the vehicle. The road train is sharp but the fore and background are blurred.

and photograph a car or person running past you. As the subject, approaches move the camera to hold them as static as possible in the viewfinder. As they come side-on to you keep the camera moving with the subject but click the shutter release. If you kept the subject reasonably still in the viewfinder the medium to slow shutter speed should capture them in focus but the background was moving too fast and it will be blurred, emphasising the subject. Beforehand, pre-focus on the point in front of you to ensure that the subject is in focus. See Figure 39 above. You do not have to have a moving subject. Try taking a photo with a slow shutter speed and deliberately move the camera during the exposure. Better still, take the photo from a moving car but keeping the camera still. These can generate interesting abstract pictures with contrasting subjects such as foliage and street lights at night.

When adjusting the exposure for a photo there maybe something of a compromise. Unless there is plenty of light it may not be possible to freeze the action of a moving subject and get every part of the picture clear and in sharp. Alternatively, there may be too much light to use a slow shutter speed. There are ways round these problems. See Accessories page 76.

Digital Image

Digital or Film

Camera Choice

Camera Controls

Accessories

otographs

Ta

Scanning

Viewing/Organising

Improving Images

Creativity

Archiving/Printing

E-mail/Web/Video

FIGURE 40. Limited Depth of Field for Emphasis: In contrast with FIGURE 36, here the main subject is in focus and stands out because the background is out of focus. This is achieved by zooming in with a telephoto lens and a wide aperture.

Photographic Modes

If you thought choosing apertures and shutters were complex, manufacturers have tried to make it simpler by having different modes on many cameras. For example, sports mode for freezing action, landscape mode to concentrate on a wide depth of field and portrait mode for one which is shallower. Others may be present including close-ups.

Alternatively there is a wealth of metering modes. Auto mode, as the name suggests, is completely automatic. Program mode is similar but does allow you to intervene. For example, if the displayed exposure is f8 at 1/60th in this mode it is possible to shift along the range, for example, to f2 at 1/1000th.

Aperture and shutter priority are two partial automatic modes. In the first you set the aperture you want, say f11, and the camera's metering decides what is the correct shutter speed to set. You set the priority on what the depth of field will be for the picture. In the case of shutter priority you set the speed required and the camera decides on the appropriate aperture.

Full manual mode means you set both controls. Potentially dangerous if you do not take heed of the correct exposure. However, this is very useful on digital cameras and one which I use far more than a film camera. Once the ideal exposure has been determined in, say, aperture priority, by switching to manual the controls can be set. Then just because a very bright area in the view reflects a great deal of light the exposure will not be adversely affected. This was discussed in more detail on page 60. This is especially suitable if you have the camera set on manual preview, meaning the image is displayed first before saving. Then if the picture is no good it can be discarded and taken again by slightly adjusting the shutter or aperture. This is ideal for great areas of brightness, e.g. snow, or dark.

Lens & Zooms

All compact or bridge camera have a lens permanently attached whilst the lens is removable in the DSLRs.

The lens is measured by its focal length and this will be a number written on the edge of the lens. If there is a range, e.g. 8 – 24, then this is a zoom lens meaning that it can change continuously from one focal length to another. In the case of 35mm cameras the range is well known amongst photographers but in "digicams" the numbers vary considerably due to the different sizes of sensors used. As a consequence the lens usually has the 35mm equivalent written into the specification. Due to the sensor being smaller than 35mm film the focal length numbers will be much smaller. For example, a typical 6x zoom will show the focal lengths as 7.8 – 46. This is the equivalent of 35 – 200mm for 35mm film.

Another way of looking at focal length is viewing angle. A 50 mm lens (called a standard lens) is considered to be equivalent to taking a scene exactly as you see it with nothing enlarged or made smaller. 35mm is a moderately wide angle and will mean that the image will contain more scene than the 50mm. As you increase the focal length so the angle of view gets less with 200mm moderately narrow. The effect of this on the image is to make it appear larger.

As well as these numbers there will be a maximum aperture (f number) to consider in more expensive cameras and lenses for DSLRs. f2.8 is a moderately large (wide) aperture for a digital camera and will let twice the amount of light into the lens than f4. These values are typical of a *fast* lens meaning that this will be good in low light. f4 lets in half the light of f2.8 and a lens with this as the maximum aperture will be *slow*, as it will not be so good in low light. This may be a consideration when buying a camera or separate lens. Faster lenses will be more expensive. These maximum values will be written on the side or end of the lens next to the focal length. With a zoom lens the maximum aperture will change as you zoom. With the lens in wide angle it will have a smaller f number than when it is zoomed in to telephoto. Zooming in on a subject will therefore have less light passing into the camera then when the lens was in wide angle.

The lenses discussed here are optical zooms. This means that it is the lens which determines the size of the final image. If the camera has a digital zoom the resultant quality is poor as the image is determined by the camera taking the wide image and then cropping away a section and enlarging it by adding pixels. If you can, avoid using digital zooms.

Camera Shake: this is a subject discussed in many areas of this book and here it should be mentioned that shake will vary according to the focal length of the lens. The longer the focal

Digital Image

Digital or Film

Camera Choice

Camera Controls

Accessories

Taking Photographs

Scanning

Viewing/Organising

Improving Images

Creativity

Archiving/Printing

E-mail/Web/Video

length the greater the chance of getting blur on the image as this enlarges the subject and will accentuate the shake. To eliminate shake keep an eye on the shutter speed. As a rough guide use a similar or faster shutter number than the focal length number. For example, a 200mm lens should have 1/200th second or faster, whilst a 35mm lens should use beteen 1/30th to 1/60th second or faster. A camera on Auto will be programmed to do this and compensate for the amount of light available. *Optical Image Stabilisation* is becoming a common feature on medium range cameras. This is an anti-shake device. In most cases this is where the sensor is moved to compensate for the camera movement. Used with care it will allow slower shutter speeds to be used than those given above. The manufacturers, Canon and Nikon, employ anti-shake devices in some lenses by moving glass elements. They will be bulkier and heavier then normal lenses but will reduce the vibration caused by shake.

What is the advantage of a zoom? With such a variety of focal lengths the camera becomes a more flexible tool. Best of all is the ability to quickly re-frame an image without having to move. Clutter can be removed from the image, cropping in tight to the image you want rather than having to do this later on and reducing the number of pixels. When setting up a shot you should always consider moving positions to check your composition but there are times when you are stuck and cannot move closer or further away. A zoom gives you better control over composition.

What makes a good photo is something different to that which the eye normally sees. The 50 mm or standard lens faithfully reproduces the scene as your eyes see it but as you move towards the extremes of wide angle and telephoto the image can become more interesting. The zoom does not just reframe the image. As you zoom in or out subtle changes to the image occur. One of these differences is depth of field, discussed

FIGURE 41 Wide angle: these are used to achieve a good depth of field but objects up close tend to be enlarged. Here the paws are large compared to the rest of the body and look distorted.

Digital Image

Digital or Film

Camera Choice

Camera Controls

Accessories

Taking Photographs

Scanning

Viewing/Organising

Improving Images

Creativity

Archiving/Printing

E-mail/Web/Video

above. This is the zone of sharpness either side of the point on which you focus and varies with aperture. It also varies with the lens. The greater the wide angle the greater the depth of field. If you want the maximum amount in your photo to be sharp and in focus go for the smallest aperture on the camera, e.g. F16, and the widest angle the zoom will go. Conversely, the greater the telephoto the more difficult it is to get the image in focus as the depth of field will be very shallow even with F16. See Figure 40 on page 68

The second change which zooming performs is in perspective that different focal lengths will produce. A simple rule: wide angle lenses make near objects appear large whilst distant objects appear smaller. The wide angle shot in Figure 41 opposite distorts the head to be larger in proportion to the legs. Unless for fun taking a close-up of a friends head with a wide angle may not guarantee that they remain a friend as the nose (being the nearest object) will appear unusually large compared to the back of the head, which being furthest away will appear small. Wide angles are not flattering for portrait photography but cn be useful for some landscapes although this does need care in its use. For example, it gives the opportunity to

frame a view by getting down low and incorporating vegetation or other interest along the bottom of the image. Ensure the maximum depth of field is achieved by using a small aperture. See Figure 52 on page 78 and Figure 84 on page 111. However, the wide angle will end up flattening the horizon by making it appear more distant. Here is another drawback to wide angles, the potential flattening of a scene. If you are in a mountainous region taking photos there is often a temptation to use a wide angle to try to get as much of the view into the photo. The results can sometimes be disappointing.

In man-made environments the wide angle has advantages but some problems. With many buildings together it is not so easy to move so that one building can be photographed on its

FIGURE 42. Converging verticals: The wide angle problem of enlarging what is closest is seen in buildings like this mosque where the base is closest to the camera. The minarets are furthest away and converge towards a distant vanishing point.

FIGURE 43. Zoom Telephoto: Even a slight increase in focal length will help to compress the background to help exagerate the landscape. See also FIGURE 45.

own. A wide angle means that you can be relatively close and yet fit the entire structure into the photo but changes perspectives of any vertical lines. Figure 42 on page 71 shows the effect with converging verticals. Instead of being parallel sided the building has the appearance of falling over. Wide angle lens will bend and shape straight lines. Although we know that the horizon of a sea view is slightly curved, photographed with the wide angle will accentuated it.

Most cameras when switched on go to the default setting of wide angle and this is how you may be tempted to take pictures. Likewise some start with the standard lens, a better option. Be careful not to automatically use a wide angle but consider what elements you have in the scene and the affect different focal lengths might have.

The telephoto reduces the angle of view and gets in tighter to an image. The immediate advantage is that this gets rid of clutter. Look around the edges of what you want to photograph and zoom in to avoid anything which is surplus to requirements. By doing this now means minimising the need to crop later on at the computer stage. In terms of changing perspectives the telephoto is the reverse of the wide angle. Distant objects appear closer and near objects smaller when compared together. This is the way to take portraits as the front of the face will not be accentuated and the background may not be sharp. Zooming into to a section of mountainous scenery, will give emphasis and actually enlarge it to make the height even more spectacular. See Figure 43 above. Avoid the temptation to try and fit everything in one shot; telephotos make you more selective. The degree of perspective distortion all

Digital Image

Digital or Film

Camera Choice

Camera Controls

Accessories

Taking Photographs

Scanning

Viewing/Organising

Improving Images

Creativity

Archiving/Printing

E-mail/Web/Video

depends on the extremes of focal length. The greater the focal length (or smaller in the case of wide angle) the greater the effect. Advertisers, when trying to create an illusion of size difference between two objects, e.g. a person against a towering truck descending on them, use these tricks of focal length. The huge truck looks as if it is about to run the person down but is probably half a mile away. A very long focal length will compress the subjects together and the furthest appears large. Telephotos are great for emphasis and tight framing.

A potential drawback is that if the lens is focused on a subject many miles away the telephoto will emphasise mist or anything in the atmosphere, causing a drop in contrast in the resulting image. Reflection on the glass elements of a zoom may cause flare, particularly when pointing the camera towards the light. This manifests itself as a series of coloured patches in a line across the photo. See Figure 44 below. It may not be seen in the viewfinder so check the image after taking if you suspect flare. Sometimes it is difficult to avoid and may be eliminated later in the computer if it is not too bad. Shooting into the sun may not always give flare but it will reduce contrast in the image. Any reflection will do this so where possible consider using a lens hood attached to the lens. This should stop stray light coming in from the side but check that it does not give vignetting (darken the corners of the image). See Figure 50 on page 77.

FIGURE 44 low contrast into sun. Photographing into the sun can be difficult but gives shape and sun pattern but also reduces colour. Shooting into the sun can also result in flare and reduced contrast.

FIGURE 45, 46, 47 AND 48. Emphasising Landscapes: Zoom into interesting areas of landscape to create more drama. The wide angle shots are at the top of these two pages and although good at setting the scene, they tend to flatten the land. The telephoto exaggerates slopes and peaks.

Digital Image

Digital Origin

Camera Choice

Camera Controls

Accessories

Taking Photographs

Scanning

Viewing/Organising

Improving Images

Creativity

Archiving/Printing

E-mail/Web/Video

Digital Photography Made Easy 75

Supplementary lenses

Point and shoot compact cameras may well have a small optical zoom, typically 3x. The flexibility of the digital compact is the LCD panel which displays what the lens actually sees. As a result, unlike the film-based compact camera, the digital form can have any amount of extras attached to the fixed lens and you can see the result on the LCD.

This has generated a market in extra lenses that can be attached to the camera lens to produce a greater range of focal lengths. These supplementary lenses are attached either directly to the filter thread on the front of the lens or via an adapter. There are also nifty little magnetic rings that attach to the front of the lens and these then hold a small lens on the magnet. See Fig 49 below. Made by a range of manufacturers the cheaper ones will be those made by independent companies but caution, some will be of an inferior quality. The centre of most lenses are reasonable quality but if the aperture of the camera lens is wide open then the light will pass through the edge of the lens. Edges are more difficult to produce to a high quality and so expensive lens will tend to have better edges, cheap lenses poor. If you are thinking of buying one of these lenses try it in the shop with a wide aperture. Then enlarge the edge of the

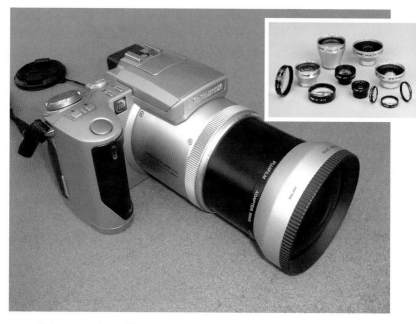

FIGURE 49. A camera with a wide angle converter lens attached to an adapter ring. Inset are a selection of supplementary lenses.

FIGURE 50. Vignetting and Flare: the lens is circular and so a cylinder of light passes to the sensor at the back of the camera. This is rectangular and needs to fit within the circle or parts of the image will be black. This blackening is vignetting and in this case is very severe due to an extra lens being added to the front of the camera lens. The sun is also reflecting on the lens and causing flare spots on the picture.

FIGURE 51. Digiscope Photo of Moon. If you have a telescope you already have a powerful telephoto lens. Here a telescope is set up on a tripod and a very simple, cheap 1.3 megapixel camera has its lens placed up close to the eyepiece of the telescope. By switching on the LCD panel the image can be seen and then photographed. If you do this regularly buy an adapter to attach the camera to the telescope.

picture and compare with the middle. In many cases the edge will be flat or distorted whilst the centre is clear.

Supplementary lenses are rated by their magnification and are sometimes referred to as converters. A wide-angle will have a value of less than one, normally 0.5x. This will actually halve the focal length and increase the width of the image. A telephoto will have a value greater than one. For example, 2x will double the magnification of the camera lens. Another reason for checking the lens on your camera first is the problem of *vignetting*. This is where the corners of the photo go black or are slightly darkened. The problem is that light passing through the lens is circular but the sensor just picks out a rectangle from the middle. If the lens is not wide enough darkening of the corners will occur.

Another type of supplementary lens useful for some cameras is a close-up lens. These are not specific for digital cameras but can be purchased for any camera with an ability to attach it to the camera lens, usually a screw thread. The strength of magnification on these lenses is measured in dioptres, the higher the number the greater the magnification. They can be purchased in packs of four and several lenses can be stacked on top of each other to create even higher magnification.

Digital Image

Digital or Film

Camera Choice

Camera Controls

Accessories

Taking Photographs

Scanning

Viewing/Organising

Improving Images

Creativity

Archiving/Printing

E-mail/Web/Video

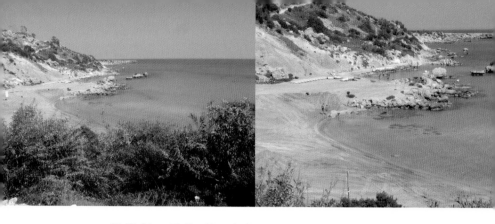

FIGURE 52, 53, 54 AND 55. Focal Length of the Lens: A zoom lens gives a variety of angles of view. The best wide angle a digital camera can display is the equivalent of a 28mm lens. As the zoom is moved to a tighter angle less is visible. 200mm is the typical maximum and to achieve more supplementary lenses have to be added.

In conclusion, supplementary lens are a very useful addition to change the size of the image but be aware that they will reduce the quality even if this is of a very mild nature. Adding extra glass for the light to pass through always does.

Filters

If adding extra glass can degrade an image the same occurs when placing filters on the front of the camera lens although this is in a minor way, especially if the filter quality is good. They can improve certain qualities within the image but treat them sparingly as some of the effects they can make could be done later on the computer. However, it is always best to start with as good an image as possible on the computer and so some filters are useful especially if they can boost contrast. A polarising filter, for example, is very useful. Fit it to the lens if the sky is pale blue with clouds. Contrast is put into the sky by darkening the blue and making the cloud stand out. This is achieved by rotating the filter so that polarised light is gradually eliminated. To see the full effect before you click the shutter, the LCD panel will have to be switched on (unless you have an electronic viewfinder). In Figure 56 opposite and 57 on page 80 not only is there more contrast in the sky but also in the water. Even the vegetation has improved as reflected light which lightens the foliage is removed by the filter.

The polariser works by reducing polarised light reaching the sensor. This is how filters work, by modifying the light. Many are special effects and need a minimum of explanation here. Some are non-effects filters and are useful like the polariser to achieve an improved image. Neutral Density filters reduce the intensity of light. They are neutral to colour and will not alter the image but being dense they absorb some of the light. As we saw in the shutter speed section there are times when you might like to use a slow shutter but if the scene is well

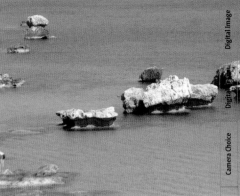

lit and you are already on the minimum aperture it is impossible to leave the shutter open for fear of over-exposing the image. Effectively, you want to get rid of some of the light and polariser will do this, reducing this by several F stops of light. However, the neutral density filter, which comes in different strengths, will reduce the light by up to four stops.

Times to use a ND filter: when photographing a building in a busy street all the people walking by will get in the way; set the camera on a tripod and use a shutter speed of one second or slower and the people will be so blurred they should disappear from the photo completely; photographing waterfalls with a slow shutter speed of just a second to get a blurring of the water; panning a moving object and using 1/30th second.

FIGURE 56. Polariser enhanced: The strongly sunlit scene, white rock and deep blue sea has been intensified by using a polarising filter in manual mode.

Digital Image

Digital ...

Camera Choice

Camera Controls

Accessories

Taking Photographs

Scanning

Viewing/Organising

Improving Images

Creativity

Archiving/Printing

E-mail/Web/Video

FIGURE 57 Polarising filter: By using a polarising filter the sky is a deeper blue and the water has contrast. This produces a sharper, cleaner picture with more saturated colour. Some trial and error may be needed as the camera will tend to compensate for the filter and the best results are achieved in manual.

A landscape with bright sky and a dark foreground is difficult to get a good exposure. Exposing for the land will burn out the sky to nothing. This where a graduated ND filter is useful. One side is of the glass is dense and this would be put in the sky area to reduce the intensity. The other side of the filter is graduated to clear and this goes over the land.

Filters for effect are varied and diverse but are less important for digital cameras as many of the effects can be added later. For example, filters have been used for many years to soften or diffuse areas of the image. This is an effect very easily done on the computer. Even changing colour can be achieved later on. Graduated colour is not so easily achieved and this type of filter is useful. Used carefully and occasionally they can add contrast and colour to a scene. Like the graduated ND above a graduated blue could be used to brighten up a non-descript sky.

When using filters you will need to check the result on the LCD screen. Being able to see the result so quickly means that many different abstract ideas can be tried. It is just down to your imagination. Coloured, clear cellophane from sweet wrappers could be your starting point. Scrunched up, the defracted light produces a variety of effects. Clear Perspex, coloured

or patterned, can be tried. These abstract patterns can be used at the computer stage to add to existing bland images as we will see.

In film photography filters are used to adjust the colour of light under different conditions such as fluorescent tubes. However, in digital cameras the setting for white balance can be adjusted to accommodate this. See page 58. Even the UV filter used to reduce the violet colour of sky, sea and snow on film has little need in digital cameras.

Filters can be purchased in several formats. There are round, screw thread filters which screw into the filter mount of some lenses. Those lenses which do not have a thread usually have an adapter to fit them to the camera. The greatest range of filters will be found in the different systems using 6cm x 6cm square plastic or gelatine filters, e.g. Cokin, Hoya. They require a special adaptor and holder to be fitted to the camera lens and then the squares are slid into this holder. Watch out for vignetting, especially if using more than one filter on the lens, and be aware that not all systems will be compatible with all digital cameras.

FIGURE 58. Ultra Violet light: on the right is a patch of bluebells taken with film. The result is violet colouration rather than true blue. This is due to film being sensitive to UV. On the left a digital camera has photographed the bluebells with little violet affect as sensors are not so sensitive to UV.

Digital Image
Digital or Film
Camera Choice
Camera Controls
Accessories
Taking Photographs
Scanning
Viewing/Organising
Improving Images
Creativity
Archiving/Printing
E-mail/Web/Video

FIGURE 59. Using an Infra Red filter: Above is an infra red shot of vegetation in close-up and it reflects IR, showing up white. FIGURE 60. In the photograph opposite the sea and sky by contrast does not reflect IR and so becomes black.

Infra Red (IR)

Our world is viewed within a narrow band of electromagnetic wavelengths between 400 and 700 nm. This is what the human eye is able to see. However, there are plenty more wavelengths out there which cannot be seen. Film is designed to expose between 400 and 700 nm but will also pick up ultra violet which is just below the 400nm. This is why one should use a UV filter on a film camera so that when photographing landscapes and sea there is not a violet cast. We do not see it but film is sensitive to it. Digital sensors are not particularly sensitive to UV and so we do not recommend the need for a UV filter. Just beyond 700nm, the red end of the visible spectrum, there is infra red. We cannot see it but digital sensors do. Manufacturers are aware of IR contaminating the digital image and so filters are normally set over the sensor to minimise

Digital Image

Digital or Film

Camera Choice

Camera Controls

Accessories

Taking Photographs

Scanning

Viewing/Organising

Improving Images

Creativity

Archiving/Printing

E-mail/Web/Video

the problems. BUT, some near infra red (NIR) between 700-1200nm does reach the sensors of the general consumer digital cameras as it is too expensive to filter all of the NIR out.

The fact that some IR comes through can be actively explored. For many years specialist IR film can be purchased but it has been complex to have developed.

Expensive cameras like DSLRs are well filtered and so for once we can see a possible advantage to "cheap" cameras. By using the correct filter it is possible to stop most of the visible spectrum passing through and allow just the NIR to reach the sensor. In other words, unlike the UV filter which stops UV light an infra red filter allows just that light to pass through. The best to use is the Hoya R72 (where the 72 stands for 720 nm wavelength). Looking at the filter it appears black and fixing it to the camera immediately dims the LCD panel. The exposure can be difficult as it has very little light to work with.

As you can see from Figure 59 opposite the effect is to produce a rather false colour although the predominate image is in monochrome. It is almost impossible to tell what the result is likely to be as NIR cannot be seen. Typically, infra red is given off by living cells. Bright green foliage will reflect considerable NIR and this appears white (over-exposing the sensor). If the vegetation is green but comes out dark it indicates the vegetation is dead or dying. Traditionally, infra red photography has been used in medicine and forestry. In the latter case aerial photographs of large expanses of forest can tell if an area of trees are diseased. Clouds are pure white whilst brilliant blue sky will be black. Bright sunshine is best but trial and error will show unexpected results. See Figure 60 above. Fluorescent tubes do

not give off infra red but tungsten (light bulbs) do. Some flash guns may but most do not. The surreal effects of the IR filter generates fascinating images. Reflections in glass will disappear and so will water. It can be a very bizarre medium.

If you like the examples you see here try it for your self. All you need is a Hoya R72 filter. However, there are some considerations. Some digital cameras are better than others at picking up the IR. The quickest way of checking is to point a TV remote at the camera lens with the filter fitted. There will be a negligible image as there is not NIR. Push one of the buttons on the remote and although you see nothing with the naked eye through the camera there will be a bright beam of light. Try this in the shop before you buy the filter. If there is no bright light the internal filtration of the CCD or CMOS is too good. Fuji, Olympus and Sony compacts give good results but investigate and see.

Another important problem to overcome is the lack of light for a good exposure and this will vary between different cameras. The Fuji cameras will loose the equivalent of 6 or 7 stops of light, Olympus less. Instead of 1/125th at F5.6 the exposure may be closer to half a second at F2.8. The view will be difficult to see on the LCD screen and start by using auto exposure. With these slow shutter speeds a tripod is very important, in fact a must. You might be able to change the ISO setting to a more sensitive one but this will increase the graininess of the image. Vegetation blowing in the wind will be blurred although this can generate interesting effects. Having taken some test shots, view them and if need change to manual exposure and take several more using different shutter speeds. The useless ones can be deleted later on the computer. This is where digital beats film hands down. The exposure can be changed at the time to suite the conditions as the meter does not accurately measure NIR. It is difficult however to predict results.

Focusing can also be a problem. Film cameras have a different focusing point on the lens for IR but with the better depth of field found in digital cameras the focal distance is not so crucial. Do use a small aperture. However, auto focus may not work if the light coming through to the camera is very low. Overcome this by focusing without the filter then switch into manual focus (if possible), fit the filter and take the photograph. With the slow shutter speed use the self-timer.

Initially the photos will not look great. Once downloaded use Levels and Tone Curves to add contrast. It is also best to split the photo into the three channels and then save the best as a grayscale image. See page 152.

If you want to get serious about infra-red, take a good look at 'Infra-Red Photography' a superb book by Fountain Press.

Flash

The basics of flash have been covered and for many point and shoot cameras that is the limit. However, there are situations when you could do with extending the flash ability yet further. Several additional features may be found on your camera. Slow Sync is one. One occasional drawback to auto flash is that when switched on it always sets a medium shutter speed, the synchronisation speed. On film cameras this is to coincide with the opening of the shutter mechanism. Too slow and the shutter speed will create blur, too fast and the flash will end up catching the shutter and not illuminate the film. Hence, a speed like 1/60th. This has been retained in digital cameras for similar reasons. Slow sync allows the flash to be used with different shutter speeds, especially slow ones. Often the only way to get the flash to work with slow shutters is to switch to manual and set everything yourself. By switching on the Slow Sync the exposure for the scene is first determined in automatic and, if this is early evening, it could be a slow shutter speed. Once the shutter release is made the background, e.g. the sunset, will be correctly exposed and the flash will correctly expose the foreground. An electronic flash has a very short duration, often thousandths of a second. This is sufficient to freeze any movement

FIGURE 61. External Flash: An external flash is at its most useful when it is detached from the camera's hotshoe and connected by cable. Inset shows a slave unit which, when connected to a flash gun, senses when an exposure is made and activates the flash gun to provide instant extra light.

Digital Image

Digital or Film

Camera Choice

Camera Controls

Accessories

Taking Photographs

Scanning

Viewing/Organising

Improving Images

Creativity

Archiving/Printing

E-mail/Web/Video

in the foreground. Obviously if the background is moving it will be blurred. This can create exciting shots at fairgrounds and firework displays.

The distance a built-in camera flash will reach can be seriously limited. This is why we see increasing numbers of digital cameras with a hot shoe connection sited on the top. Sometimes known as an accessory shoe it allows an external flash gun to be attached. These can be purchased for a wide range of prices but one which is many times more powerful than the one in the camera need not be expensive. The chances are this could be an independent make, maybe one which specialises in flash rather than cameras. There has been a small debate on attaching flash guns and what is the required power needed to discharge the flash. This is the power sent out by the camera to the flash to trigger the device. A particular heavy duty flash may require a substantial power surge and the debate is whether this is safe as it could overheat the camera. The best bet is to check with the manufacturer of the camera (or from where you purchase the camera) as to whether a flash is suitable. Be aware of the potential danger and watch out for any initial signs of problems.

The most important issue is that an external flash has many advantages, not least the increased power. The flash in Figure 61 on page 85 can fill a medium sized hall 20 metres across, something a built in flash is never designed to do. If you do decide to use an external flash purchase a cable so that it can be used away from the top of the camera. It seems obvious to attach the flash directly to the hotshoe. One of the reasons red-eye is so prevalent with the built in flash is the fact that the flash is along the same axis as the lens. The flash goes straight into the eye and, if the iris is wide open, illuminates the blood vessels at the back of the eye. The light comes out of the eye and is picked up by the lens. If the flash is not on the same axis as the lens but held to one side of the camera the light enters and leaves the eye at an angle. Red eye is eliminated. Additionally, a flash directed straight on to a subject whether human or otherwise has the effect of blasting away all the shadow to produce a very flat image. However, if you want to use flash on camera and eliminate "red-eye" and get some nice soft images, use a "Sto-Fen" softie diffuser or a "Lumiquest" flash modifier. Alternatively, create a more 3-dimensional image by using the flash from the side to cast some shadow. This is looked at in more detail under the sections covering photographing specific subjects, portraits.

Immediately we can see the main advantage of an external flash if you intend to get good, well lit photographs of people. Also, for good close-ups it is often the only way to illuminate dark subjects sufficiently to be able to use a small aperture and achieve maximum depth of field. See macro section.

But what if you do not have a hot shoe or even want two flashes rather than one? It is

not about being greedy just that sometimes it is useful to illuminate a subject from both sides, one being stronger than the other to give the feeling of depth. A **slave unit** may sound like something a bit on the dodgy side but is actually a very useful piece of photographic kit. It contains a tiny photoelectric cell which is sensitive to a sudden flash of light. The device is not connected to the camera but to a flash gun. If it detects a flash (from the camera's flash) it fires the flash to which it is attached. You can have as many flash guns as you like attached in this way. The technique can be used to photographing the inside of large buildings such as churches, with a number of flashes strategically placed around the building. Especially for compact digital cameras there are now a number of different small and lightweight digital flash guns with built-in slave units. Check the web and adverts in magazines. See Figure 61 on page 85.

Camera Care

Most consumer cameras are not expected to have the intense use found in professional equipment. My camera gear, ranging from simple compacts to DSLRs, gets a regular hammering and so it is important to do what you can to keep it functioning. With trips to hot and cold, dusty and windy, dry and humid climes I have been impressed how well relatively cheap cameras can perform. Despite using a lens cap dust can still reach the lens surface and even inside between the glass. I use both disposable lens tissue and a lens cloth. A blower brush removes most of the loose dust first and then a fine mist of breath to help the tissue or cloth to remove any film on the lens surface. The case which may come with the camera is rarely that good but there is an amazing array of bags to suit every situation possible. I use a backpack that even has a section at the back for a laptop.

The weak point in DSLRs is that upon changing lenses dust and dirt can enter and attach to the sensor forming dark spots on the picture, showing up particularly in the sky or other uniform areas. Olympus was the first to have a shaking sensor but some others have followed suit to attempt to remove the dirt. Cleaning the sensor is well within the bounds of the individual and there are any amount of vacuum devices and wet swabs to wipe over the surface. None are cheap. The Green Clean system is good as is the SensorKlear pen or SensorKlear 'Pro Kit'. On the camera menu system there will be a cleaning sensor mode. Make sure the battery is well charged before you attempt the operation. Note that wet swabbing is the last thing to try. Blow or suck the dust off first with the correct sensor tool.

There are times when the environment gets just a bit too dangerous for electronic gear. Rain, traveling in a powerboat or walking close to a large waterfall are all asking for

Digital Image

Digital or Film

Camera Choice

Camera Controls

Accessories

Taking Photographs

Scanning

Viewing/Organising

Improving Images

Creativity

Archiving/Printing

E-mail/Web/Video

FIGURE 62 Aquapac Protection: The Devil's Throat at the Iguacu Falls would have been impossible to photograph unless the Aquapac, inset, had been protecting the camera from the spray.

trouble. Even sunbathing on a sandy beach is bad news for cameras. In these situations the waterproof models from Pentax (WP series) and Olympus (750 series) are very good. For other models the wind can easily drive the finest of sand grains into the workings of the camera and produce severe problems. Aquapacs are special plastic bags with a guaranteed seal to keep out water and sand. Fit the camera inside the bag and seal it tight. Do this in a safe place before water or sand are confronted. Photographs can be taken with the camera sealed inside as they have clear windows to shoot through. They come with a strap to carry them. It is vital you are not tempted to open the seal until you are back in a safe area where the opening is carefully controlled. Water does get caught around the seal. Some Aquapacs are waterproof down to depths of several metres and I have used them immersed in rock pools. Spray collecting on the outside of the plastic can mess up the camera's autofocus. If you take pictures often enough under water (maximum depth 3 metres), in rain, sand and spray seriously consider the Pentax (see figure 16) or Olympus waterproof models, they are brilliant.

Batteries

Typically, people may change the battery on their film camera once a year if that. Digital cameras may be once a day! They are power-hungry beasts and rechargeable batteries are essential. The size and type of battery varies between models and some makes have proprietary ones. If your camera comes with single use batteries they are likely to be AA size alkaline, lasting a few hundred shots before they die. They should be replaced by rechargeable ones. Check, however, as Sony often provide rechargeable AA batteries.

In recent years rechargeable AA size batteries are made from Nickel Metal Hydride (Ni-MH). Manufactured by many companies the important specification to look for is the capacity level, measured in milliamp hours (mAh). 2500 mAh is a good capacity to go for but anything in this region should give a respectable number of shots. Make sure that different capacities are not mixed, both when charging and using in the camera. AA chargers do not occupy too much space and they can be provided with two leads, one for mains charging and one from a cigarette lighter socket in a car.

Some cameras may have a unique battery size specific to the make of camera. They may not be cheap but they store considerably more power than the others. These proprietary packs are Lithium Ion (LiON) the most efficient and long lasting of the batteries although more expensive than AAs. Some manufactures, e.g. Sony, produce LiON batteries which are "intelligent" so they can inform the camera of the exact power left to the nearest minute. Usually cameras have some indication to the nearest 25% of how much power is left. Bear in mind that if you grab the camera every few weeks to take photos the batteries are likely to discharge themselves although this does not tend to happen with LiON. Sanyo produce a new type of AA battery which will not self-discharge over time. Over a year they may only lose one or two percent. Ansmann produce a wide range of batteries and chargers to suit most extreme conditions particularly for heavy duty users. Solar chargers for remote use are available but they are only really of use for topping up rather than charging from empty.

Most DSLR cameras have the option of a Battery Grip. This may take several of the specific lithium batteries required by the camera or six or eight AA batteries. Due to the size it doubles as a grip so that when the camera is turned ninety degrees for portraiture a second shutter release is available in the correct place for your finger. Canon have particularly good battery usage and a mid-range DSLR such as the 30D will take several thousand pictures with the battery grip attached. See page Figure 18 where a battery grip is fitted.

Digital Image

Digital or Film

Camera Choice

Camera Controls

Accessories

Taking Photographs

Scanning

Viewing/Organising

Improving Images

Creativity

Archiving/Printing

E-mail/Web/Video

Problems on holiday? Storage.

Extra memory cards are necessity when going on holiday otherwise you could run out of storage space. They are cheap enough but with digital technology today you can do more. What about viewing them and backing them up in case you lose the card? Portable media players are good value. Once upon a time the specification was all about capacity and quality of screens. Now they do much more than keep your photos safe. Why not watch a full-length movie, listen to the radio or MP3 music files? Cheaper ones like the JOBO Giga series will store 30 gigabytes of files. The memory card is inserted and following the LCD screen the files are downloaded to the JOBO. This one does not allow you to see the images but at least they are backed up. More expensive ones by Archos or Epson store three or four times the amount of files. The colour

screens are great for viewing.

Prices of the media players may not be far off the price of a laptop although these will be large models weighing in excess of several kilograms. Secondhand, ultra-portable laptops may be an option and at least then you could do some editing on the trip. New ones may run beyond people's budgets but end of line or refurbished ones are available from specialised dealers.

FIGURE 63: Epson p5000 portable media player and the Archos 504

FIGURE 63 AND 64. Looking for Colour and Shape: Bright colours will lift an otherwise simple image. Using a telephoto in this holiday photo has helped to crop the image to dominate the photo with colour and shapes but not being intrusive. The photographer is away from the setting out on the street. If there is a dominant splash of colour in the landscape, like this section of a field, be careful to fill the shot with colour.

Digital Image

Digital or Film

Camera Choice

Camera Controls

Accessories

Taking Photographs

Scanning

Viewing/Organising

Improving Images

Creativity

Archiving/Printing

E-mail/Web/Video

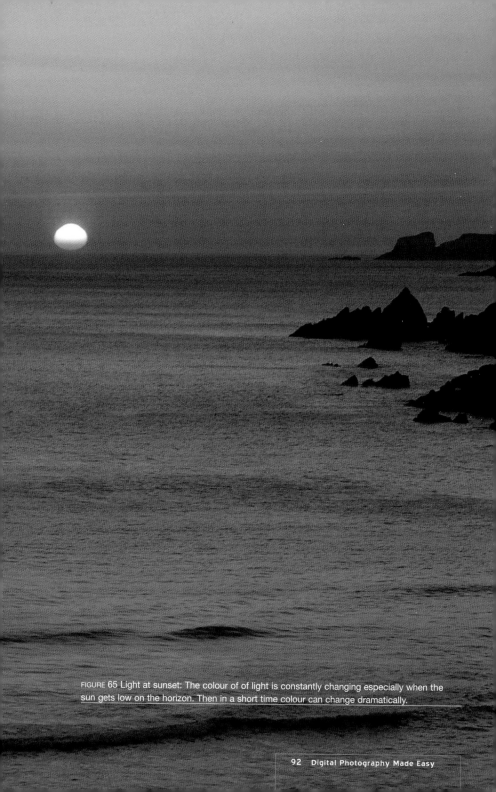

FIGURE 65 Light at sunset: The colour of of light is constantly changing especially when the sun gets low on the horizon. Then in a short time colour can change dramatically.

Taking Better Pictures

Correct focus and exposure help but there are a number of other factors which go together to create a good picture. It is a very subjective area and at the end of the day the good picture is the one *you* want. What one person sees as a good image others will see it as something ordinary and not worth a second glance. Often an interesting picture, one to catch the eye is that which people do not typically see. We all tend to look at the world at a similar height above the ground and in a way equivalent to a standard 50mm lens. In this way the extremes of the camera may improve the image. Wide angle or telephoto; slow shutter speed to deliberately blur or fast shutter speed to freeze action; shooting low to the ground or high above it.

Composition is all about considering where to place the key elements of your picture in the frame to make it work. But, first, the whole meaning of photography is light. We will therefore look at these three topics in the order light, the picture elements and then composition.

Light

As the day progresses, from before dawn until after dark, light is constantly changing. The direction, quality and colour of the light is rarely the same. As weather and seasons change so these and other aspects like contrast will also change. If you are aware of these so you can use them to your advantage. Many people are just fine weather, summer photographers. An image people like is often the one they never see. How many are up to see the dawn? At this time the colour and quality of light is very different to mid-day. See Figure 65 opposite.

Direction of light: A good time for landscape photography is early or late in the day as the sun is low in the sky. This casts long shadows that increase the relief of the land creating a three dimensional aspect. See Figure 66 on page 94. As the day progresses so the sun rises higher in the sky and the shadow becomes less until at mid-day shadow may disappear completely as the sun is overhead. This principle can be applied to any photography. The bark of a tree can have a superb texture to it. If the light is striking it full on from the front of the camera, such as you would get with a flash on top of the camera, the texture will be minimal as the shadow is minimal. If the light source is the sun, move to the side so that the suns rays are glancing off

Digital Image

Digital or Film

Camera Choice

Camera Controls

Accessories

Taking Photographs

Scanning

Viewing/Organising

Improving Images

Creativity

Archiving/Printing

E-mail/Web/Video

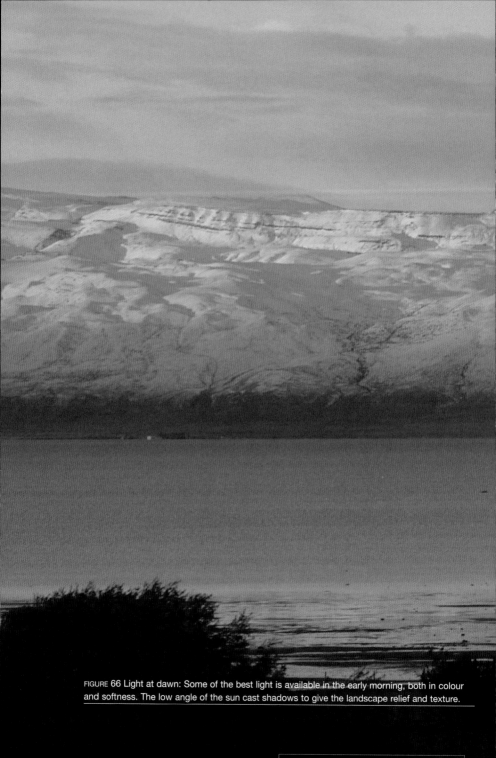

FIGURE 66 Light at dawn: Some of the best light is available in the early morning, both in colour and softness. The low angle of the sun cast shadows to give the landscape relief and texture.

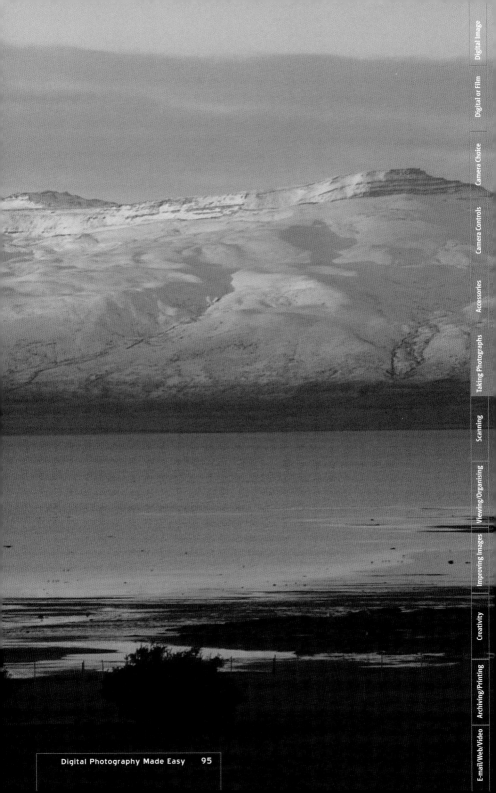

Digital Image

Digital or Film

Camera Choice

Camera Controls

Accessories

Taking Photographs

Scanning

Viewing/Organising

Improving Images

Creativity

Archiving/Printing

E-mail/Web/Video

the side of the bark from an angle ninety degrees to the camera. Now the roughness of the bark creates shadow. The texture of the bark is revealed. If you want a flat image with no texture hit the subject full on with light from the direction of the camera. Side lighting adds depth. This is the same for showing the texture of skin on a person's face or the relief on a close-up of a coin.

If the light comes from behind the subject expect a silhouette effect. Against a sunset this can be especially good and the more complex the subject such as trees in winter the more interesting it becomes. The brighter this back light becomes the more the edge of the subject can be illuminated. For a person, the hair will brighten around the top edge to produce a rim-light effect. In many cases the light source cannot be changed and you will have to wait for, say, the sun to move around to create the effect you want. See Figures 67 and 68 opposite.

Consider changing you viewpoint. Lie down on the ground and shoot up through vegetation, rocks and buildings to provide the rim-lit silhouette against the sky. Alternatively, if the subject is a building the sun striking it is fixed and so by changing your position the effect of the sidelight will vary.

Shooting into the light, referred to by photographers as *contre jour*, will reduce the depth of colour of the light. Bright colours become washed out and in some cases, such as photos across water, will become almost monochrome. See Figures 70 on page 99. Exposures can be tricky and there is no right or wrong technique here. Underexposure is normal with the light coming straight towards the exposure meter of the camera. It is quite possible to turn round and meter the area behind you, using this reading to take your contre jour photos. With a digital camera it is relatively simple to take an approximate reading, take the photo and check the result. Then, using manual controls, change the exposure to make the view brighter or darker. I tend to retain all shots until I can look at them on the computer. The general rule is to expose for the highlight areas. Figure 69 on page 98 shows a scene shooting into the light and getting an almost inevitable problem of flare. This is where internal reflection of all the lens elements occurs. Lens hoods can sometimes help but shooting into the sun typically shows flare. If the viewfinder is electronic you should be able to see this happening. Sometimes it is possible to put one of your hands up above the lens, out of sight, but sufficiently to reduce the reflection. Alternatively, try to keep the sun just out of sight behind an object.

FIGURE 67 AND 68. Changing light: Both these photos were taken from the same spot at the same time in the evening. Aiming into the sun has reduced the colour but created drama whereas away from the sun there is the evening glow on the buildings and the flamingoes.

Digital Image

Digital or Film

Camera Choice

Camera Controls

Accessories

Taking Photographs

Scanning

Viewing/Organising

Improving Images

Creativity

Archiving/Printing

E-mail/Web/Video

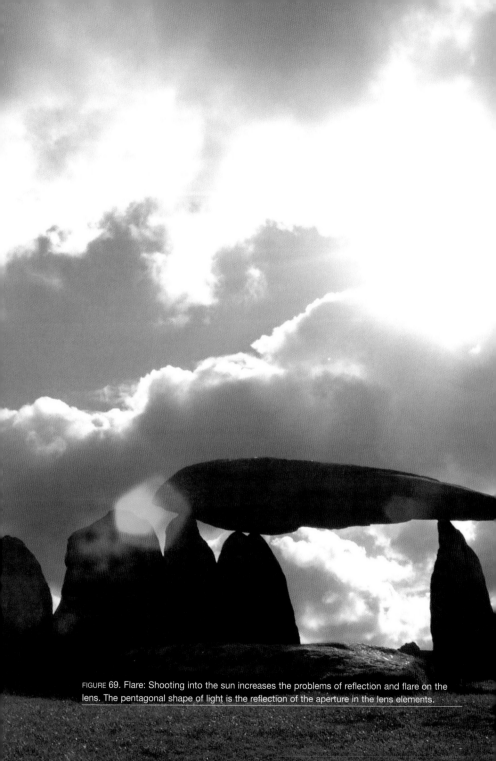

FIGURE 69. Flare: Shooting into the sun increases the problems of reflection and flare on the lens. The pentagonal shape of light is the reflection of the aperture in the lens elements.

FIGURE 70. Contre Jour: Look for interesting shapes silhoueted against the light. Shooting into the bright areas tends to reduce colour unless this is around dawn or dusk. The effect can be virtually monochrome.

Colour of light: Strong sunlight falling on bright, reflective colours will generate wonderful images of maximum brilliance. Try to dominate the frame with over-powering colour. By contrast subtle pastel colours in diffuse light create a softer image. The white balance of the camera is usually set to automatic. Typically, like film this is balanced to correspond with the colour of mid-day. The amazing thing is that our eyes easily adjust to tiny changes in the colour of light and we do not notice it but during the day the colour is changing. When the sun is low in the sky the visible spectrum of light rays strike the earths atmosphere so that different wavelengths penetrate in differing quantities. Red predominates. This is why we see warm light (orange, red and yellow) at dawn and dusk. In the middle of the day the wavelengths are more even. After the sun has set the dominant wavelength is blue. Any long exposures taken at night will have a strong hint of blue. Likewise in the middle of winter photographs taken in the day have a tendency to be bluish, a cold light to suit the season. As well as the time of day the state of the weather will influence the colour of light. A sudden storm may clear the atmosphere of particles which would otherwise break up the light and while the dark sky is still there emerging sunshine will produce very striking and dramatic lighting. Mist and haze will reduce the impact of colour, especially around dawn and dusk.

Digital Image

Digital or Film

Camera Choice

Camera Controls

Accessories

Taking Photographs

Scanning

Viewing/Organising

Improving Images

Creativity

Archiving/Printing

E-mail/Web/Video

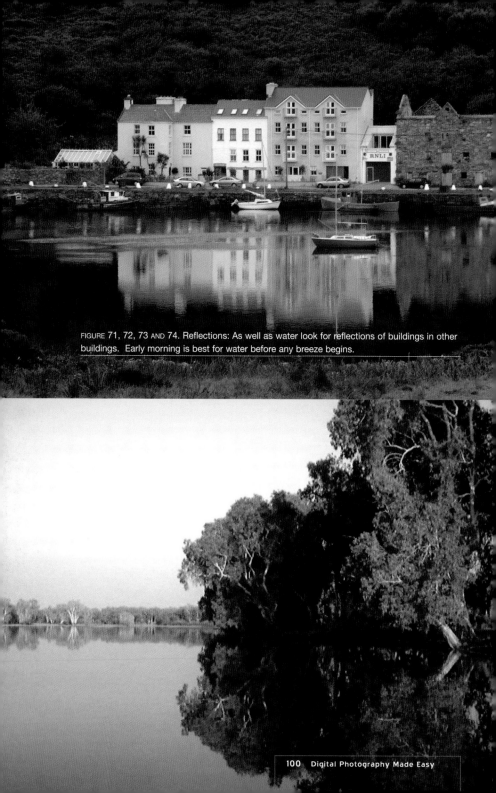

FIGURE 71, 72, 73 AND 74. Reflections: As well as water look for reflections of buildings in other buildings. Early morning is best for water before any breeze begins.

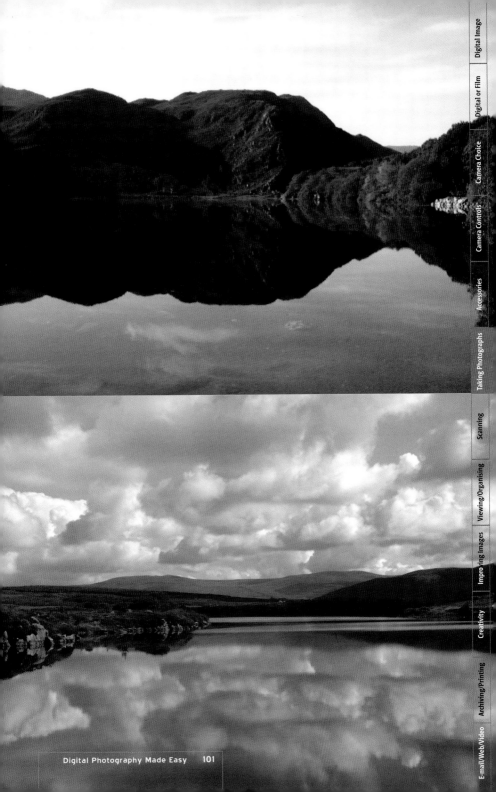

Digital Image

Digital or Film

Camera Choice

Camera Controls

Accessories

Taking Photographs

Scanning

Viewing/Organising

Improving Images

Creativity

Archiving/Printing

E-mail/Web/Video

FIGURE 75. Low Key: the image is dominated by dark tones which adds to the sinister appeal of this freshwater crocodile. In a dimly lit creek the exposure has been taken off the shaft of light using spot metering (as it was difficult to get too close!). This light has given a relief and texture to the reptile

Quality of light: Figure 75 above shows an example of *low key* photography. The freshwater crocodile was in a very dark pool of water in an Australian creek. Every so often it would rise up to the water surface and at one time a shaft of light to the left illuminated just a small part of the head, sufficient to give the texture of the skin. The solid blackness of the image gives a sinister edge to the picture with just a small amount of contrast on the crocodile to give enough detail so that we know what it is. By contrast the view across San Franscico Bay in the early morning mist is *high key*. The image is dominated by pale tones, the opposite of the crocodile and, likewise, so is the mood. The mist breaks up the dark objects to give them a pale softness but again there is enough small detail to realise what the subject is. The quality of light can be so important to get the mood of the picture. The full tonal range starts with white and passes through a series of shades of grey until it is black. High and low key are concentrated at one end of the range. See Figure 76 opposite.

Harsh (or hard) light falling directly on to a subject will produce a strong, dark shadow. The result is a very contrasting image with missing middle tones. On the computer later on it may be possible to reduce this but the harshness can detract from the subject, especially on skin tones. By scattering or diffusing the light the image can be improved,

Digital Image

Digital or Film

Camera Choice

Camera Controls

Accessories

Taking Photographs

Scanning

Viewing/Organising

Improving Images

Creativity

Archiving/Printing

E-mail/Web/Video

especially important with people. This is why you are likely to see a wedding photographer using a flash on the camera in brilliantly harsh sunshine to take the edge off the dark shadows. Diffusing the light will often improve the tones.

Finally, in this short section on light be aware of the differences in surface that exist such as reflective and matte finishes. Look out for reflections not just in water but in solid objects like buildings. In cities architects are using more glass to produce striking office blocks. Use reflections to put a different viewpoint on your subjects just like you should use mist and even rain to diffuse subjects. See Figures 71, 72, 73 and 74 on pages 100 and 101.

The Picture Elements

For many people photography is a way of recording events in their lives, of people and places they see. To do this they may just point and snap the shot without giving it another thought. But a snap can be made more interesting with just a few basic rules. Some structures we meet in our daily lives may be passed by as simple, not worth photographing. Yet these, apparently common placed items, can yield beautiful images, revealing fascinating colours, textures and form that had not been noticed. Like macro photography, we rarely get the chance to see our subject magnified but once magnified all kinds of amazing shapes can develop. A photograph

FIGURE 76. High key: The image is dominated by soft tones, taken with a telephoto to compress the landscape and misty atmosphere to give a bright but delicate image.

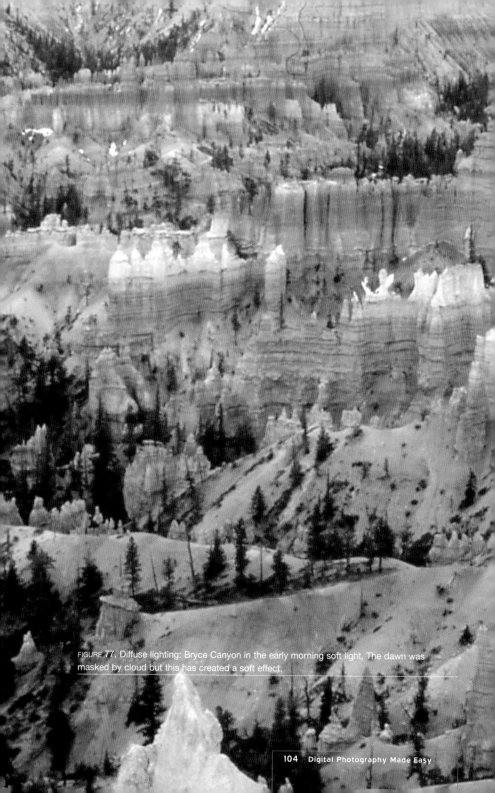

FIGURE 77. Diffuse lighting: Bryce Canyon in the early morning soft light. The dawn was masked by cloud but this has created a soft effect.

Digital Image

Digital or Film

Camera Choice

Camera Controls

Accessories

Taking Photographs

Scanning

Viewing/Organising

Importing Images

Creativity

Archiving/Printing

E-mail/Web/Video

rather than just a snap is beginning to happen. The photographer looks to make ordinary subjects special by searching for certain elements to make up that shot. Here are some.

Shape and Form: Sand dunes are one of my all-time landscape favourites. The flowing shape of their ever changing form. Taken early or late in the day the low angle of light provides a changing tone of curves across the landscape. Stark, naked trees show their distinct shape and form during winter and can be photographed against the sky to give austere and beautiful images. However, subjects can be abstract to produce weird and flowing shapes. Telephoto lenses can be good to crop out extraneous material so that the eye can concentrate on the form of shadows and reflections. Using a small degree of telephoto for the photo of San Franscico Bay allows us to concentrate on the various shapes in the landscape and compresses them together to give a series of counter points. A simple shape becomes the subject and it could be one shape across another. Macro photography is one way of getting in close to a subject so that the form and shape can be highlighted. Viewpoint is all important. Just a small shift in position will create a totally different shape and form, so always be prepared to move around objects to seek new ideas.

FIGURE 78. Aerial views can produce superb patterns and lines in the landscape. Initially the image will lack contrast and clarity. This can be enhanced at the computer stage.

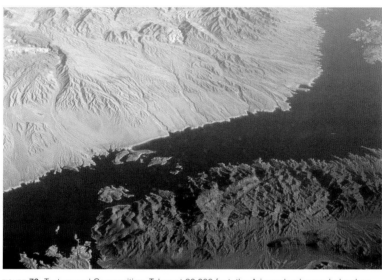

FIGURE 79. Texture and Composition. Taken at 30,000 feet, the Arizona landscape below has good texture as the sun at a low angle casts shadows. Watch for the right composition, here with the lake leading the eye in from the bottom left.

Patterns: Another time when viewpoint is critical is when looking for patterns. A stack of logs becomes a pattern when viewed from the end. Figure 78 opposite is an aerial shot looking out of an airliner window. It was photographed just because I liked the shape created by the rivers crossing the landscape. Photographed for itself rather than as a record in time. In this way look for either abstract or natural patterns of colour in your surroundings.

Texture: The texture of a photograph is about tangible qualities like roughness and smoothness of objects. With soft lighting the sand dunes look smooth and soft whilst the crocodile rough and scaly. Often you need to get in close to the texture, like the bark of trees. The direction of light is important creating texture. Side lighting will cast the shadows that show the relief or 3D effect. Early morning will have the sun low in the sky to cast shadow on a landscape. The wrinkles of skin on an aging face will need a light from the side rather than a flash on a camera. A picture could combine elements of rough and silky smooth to form a contrast between the two. See Figure 79 above.

Lines: The presence of lines, whether natural or man-made, will form a key element in a picture. Whether this is the flowing lines of a dune or the curved roots of a tree, lines can

FIGURE 80. Composition: Plan where the different elements of your image are located. Rarely should the main subject be in the centre. Here the vehicle is entering the water and needs plenty of space in front showing that it is going into the picture. Look for the rule of thirds in these pictures.

become the central theme of an image. They may determine the direction a person views an image. A road starting at the bottom of a picture and crossing it to the horizon will lead the eye. This means that the way lines are laid down in your image are crucial to keeping the viewer within the picture rather than taking them away. The art of composition. See Figure 80 opposite.

Composition

When people look through the viewfinder they naturally look into the middle of the scene. Temptation is then to place the main subject there and ignore other areas of the image. The first rule of composition is to look in the corners not in the middle. Look for unwanted material, car aerial, your thumb, etc. Looking at the edges will help to get your horizons straight. Sloping horizons are a very common problem with holiday snaps. Looking at the corners, eye up the two top ones and gauge that the distance between the horizon and the corners are even. Many cameras have lines or markers in the viewfinder to help you with this.

Composition help-lines are often best seen on the LCD display. Check in your camera manual to see if they are available. These can be useful in the early stages to help train you to improve composition. You will notice that they are like the lines set out to play noughts and crosses, dividing the screen into 9 equal segments. This is the classic photographic Rule of Thirds. It is a good general rule to go by although sometimes it is necessary to break it!

The basis of this rule is that the elements of your picture should approximate to thirds. As an example, a landscape would not have the horizon going through the middle to create half sky half land. Divide into thirds, either two thirds land and one third sky or one third land and two thirds sky. This produces a better pattern for the eye and brain. Splitting an image into two halves leaves the brain unsure which half to look and is not so pleasing. The thirds may be colour, form or shapes. Composition is where you place these elements. If possible leave the middle uncluttered and free. The face of a person should never be there, more in the top third. Photographing a car would place it just to one side of the centre not absolutely central. When taking any object that has a front and back, such as a vehicle, person or animal, try to place a little more space in the front rather than the back. This gives the impression of it coming into the picture. This is more pleasing to the eye than the reverse which is taking both the subject and your eye out and away from the picture. See Figures 81, 82, 83, and 84 on pages 110 and 111.

Some composition can be improved latter on at the computer stage. Cropping will allow you to remove a section behind a subject to increase the amount in front. Bear in mind that this will reduce the number of pixels and therefore reduce the size of the picture. This is why it is best to get it right if you can at the camera stage. Be prepared to move around to get the

Digital Image

Digital or Film

Camera Choice

Camera Controls

Accessories

Taking Photographs

Scanning

Viewing/Organising

Improving Images

Creativity

Archiving/Printing

E-mail/Web/Video

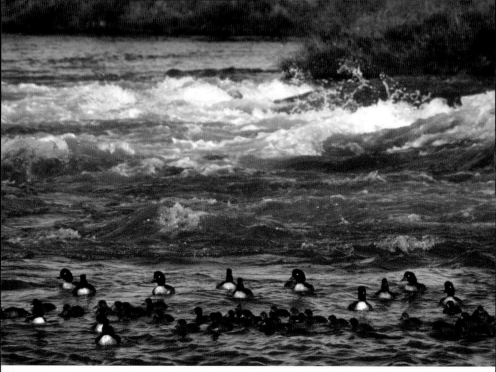

FIGURE 81. Composition. Plan the picture before taking it. The Goldeneye ducks are clearly forming a barrier to stop the chicks drifting into the turbulent water. The bottom third is made up of the ducks and then two layers of water.

FIGURE 82. Composition: Frames in the landscape. Whether a gap in a wall or a group of trees.

FIGURE 83. Composition: Vanishing points like the main subject should be off centre.

FIGURE 84. Composition: The curve of the body produces a good frame for the photo with the snake's head off centre.

Digital Image
Digital or Film
Camera Choice
Camera Controls
Accessories
Taking Photographs
Scanning
Viewing/Organising
Improving Images
Creativity
Archiving/Printing
E-mail/Web/Video

FIGURE 85. Composition. A classic holiday shot with a person in the foreground. In the left third and off centre positioning is good but how should the person stand? By facing into the shot the person is keeping the viewer's eye in the picture. When looking out of the photo it is natural to follow the gaze of the person. See inset.

composition right. If you have one third sky the land will be dominant. Look for something to lead the eye into the picture. For right-handed people something in the bottom left third is best for this. It could be a rock or flower. This is where most peoples eyes rest first and if there is a road or river running into the picture then starting this in the bottom left is good. Look for potential frames which will fit these side thirds. It could be a tree with a branch running across the edge of the top two or three thirds. Remember that these are just guides and you may have only a few or none of these present.

Viewpoint is crucial and this is why you need to look around you and decide how best to effect the composition. It takes very little time to train your eye and once you practice this it soon becomes a habit. Getting down low and shooting through vegetation can yield good frames and easy creation of thirds. See Figure 85 above. Besides getting down low is not how most people view the world and that in itself makes for more interesting images. Aerial images look down on the subject. A rather boring image of a room could be improved by getting down low and shooting up from a corner. Or the reverse, standing on a chair looking down. Look for the unusual

angle, frames to enclose the image, something to lead the eye into the picture and nothing dominating the very centre. Alternatively, on occasions do something completely different!

Specific Subjects - Portraits

Many people just want a picture as a record of family, at home or on holiday. If this is to show the landscape as well put them to one side (left third) to lead the eye into the landscape. Have them facing inwards slightly to further give this illusion of them bringing the viewer into the photo and not away from it. In this way, they are being used as one of the elements to lead the viewer and frame the image.

If the emphasis is on the person themselves we need to think differently. What follows is applicable to any "animal" subject whether human, pet or wild beast. To start with eliminate distracting backgrounds by zooming in, using a telephoto. This and by using a medium to wide aperture, such as f5.6 the background will be thrown out of focus or at the very least softened. This can further be improved by making sure that the back ground is fairly plain and at a distance, for example a grassy slope. Concentrate on the head and shoulders with the person turned slightly so they are facing 45 degrees to the camera. More space in front of them than behind. Focus sharply on the eyes. Even if the rest of the photograph is out of focus eye contact

FIGURE 86. Always focus on the eyes: This picture was taken in dim light with a telephoto. The aperture was wide and so depth of field very limited. By focusing on the eye, despite the rest being out of focus, it works.

Digital Image

Digital or Film

Camera Choice

Camera Controls

Accessories

Taking Photographs

Scanning

Viewing/Organising

Improving Images

Creativity

Archiving/Printing

E-mail/Web/Video

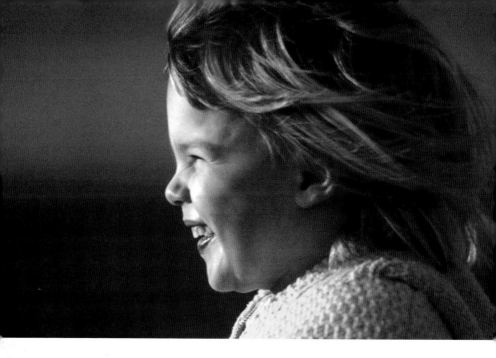

FIGURE **87, 88** AND **89**. Portraits of Children: By using a telephoto lens there is a greater chance of the child not seeing the camera and behaving naturally. The back grounds will be blurred by the shallow depth of field. Soft, directional lighting helps.

between the viewer and the subject can be made. The koala bear in Figure 86 below is an example.

Ideally, the light needs to be slightly softened coming in from a slight angle to the camera. This is easier to arrange outside but indoors needs careful consideration. A flash on the camera can be harsh, washing out detail, eliminating shadow and being very close to the axis of the camera lens will give red eye. An external flash held to the photographers left and with the subject's body pointing in that direction would be better. However, the light will still be a little harsh and using a using a diffuser (e.g. Sto-Fen or Lumiquest)it will be softened or also by bouncing the light off a white reflector. This need only be a small white card angled such that the flat of the card is facing the subject. If a flash is unavailable try a bright beam of light from what ever sources you have, even such things as a powerful torch or flashlight, bounced off the card. If the shadow still looks too strong a second larger reflector should be added to the right of the photographer to reflect some of the light back on to the subject. This can be a good idea outdoors as well to take the edge of bright sun. Although proper photographic reflectors can be bought a cheap alternative is a high quality A1 size card purchased from a hobby craft shop. If you are looking to use a reflector on a regular basis the Lastolite range is

Digital Image

Digital or Film

Camera Choice

Camera Controls

Accessories

Taking Photographs

Scanning

Viewing/Organising

Improving Images

Creativity

Archiving/Printing

E-mail/Web/Video

good and folds away neatly. I use a small one for photographing flowers in the field, acting as a good reflector and wind-shield.

Getting good photographs of people with a reflector and a separate flash can be surprisingly straightforward. Check the results as you go along. If the shadows are too harsh move the flash further away and reflect it more. If they are still too harsh break up the light with paper tissue over the flash or, better still, add a commercial diffuser such as the Sto-Fen "Softie" to diffuse the light. See Figures 87, 88 and 89 above.

Close-up & Macro

With the small focal lengths found on digital camera lenses they have the ability to focus much closer than traditional film cameras. Also, the depth of field is better. A macro switch is typical of even the cheapest point and shoot digital camera. However, most of these are for close-up not true macro. By definition true macro means that the size of subject is the size of the resulting photograph. This is easy to work out with film. Photograph a coin in macro and the resulting negative will have a picture of the coin exactly the same size on it. The size ratio of coin to negative is 1:1. It is much more difficult with digital cameras as it is dependent upon the size of the CCD or CMOS sensor. However, the digital camera will not be true macro just close-up. Good photos of flowers and butterflies are within easy reach. However, there are some important considerations.

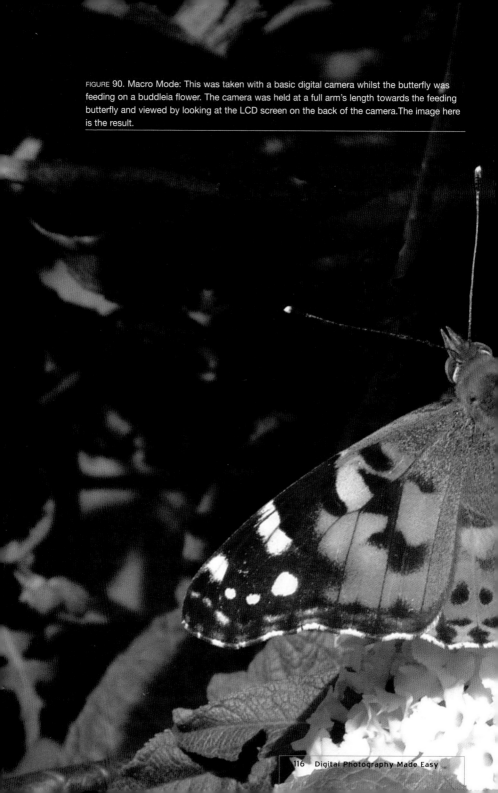

FIGURE 90. Macro Mode: This was taken with a basic digital camera whilst the butterfly was feeding on a buddleia flower. The camera was held at a full arm's length towards the feeding butterfly and viewed by looking at the LCD screen on the back of the camera. The image here is the result.

Digital Image

Digital or Film

Camera Choice

Camera Controls

Accessories

Taking Photographs

Scanning

Viewing/Organising

Improving Images

Creativity

Archiving/Printing

E-mail/Web/Video

Invariably, when the macro setting is used the digital camera achieves the best close-up with the lens set at wide angle. Wide angles give the best depth of field and therefore it is easier to achieve an image in focus. The only problem with using it in wide angle is the working distance between the camera and the subject. You may find that the subject almost touches the lens. A telephoto will give a greater distance but is not always available. Whilst working distance is not a problem with flowers, butterflies will be frightened away. The parallax problem of point and shoot cameras is over come by the use of the LCD panel which displays what the lens sees. Many cameras automatically switch this on when you switch into macro. As long as you can see the panel in the sunshine it is possible to take the photograph of a butterfly at arms length. Set the camera on auto-focus and use the panel to frame the subject. The camera may still be very close to the subject but your body will be well back from the insect and less likely to disturb it. See Figure 90 on page 116.

Depth of field is the biggest problem with macro. The closer to the subject the less will come into focus. This can only be overcome with a small aperture. Always try for the minimum aperture available on the camera (if you have the choice of selecting apertures).

FIGURE **91** Macro – an external flash was used to provide sufficient light so that a small aperture could be selected to gain maximum depth of field. By being held to one side of the flower a slight shadow has yielded good texture. Using a flash will invariably generate a black background. Compare this with the moss close-up on page 46.

FIGURE 92 Action: This shot was taken with fast shutter speed, 1/500th of a second. The vehicle is coming straight towards the camera but by using a telephoto it both compresses the dust to make it dramatic but also avoids hitting me. The camera has been pre-focused on a spot in front so that when the vehicle reaches that spot you do not have to wait for the camera to autofocus. If you have to do that the delay could be too much and you will have lost the opportunity. Digital cameras can be slow to focus!

Unfortunately, this can only be achieved if there is plenty of light as the camera reciprocates by compensating the small aperture with a slower shutter speed to maintain the light levels reaching the sensor. If possible use a tripod to hold the camera steady at these slow speeds although if there is any breeze blowing a flower, for example, may well be moving. A reflector can be used to shield the flower but if you are really serious about attaining the perfect shot of a flower on a breezy day a small housing of Perspex going over the flower with an opening for the camera is the only option.

A good option for when a tripod cannot be used is to go for an external flash as this is a bright, portable light source. In Figure 91 opposite, Macro – an external flash was used to provide sufficient light so that a small aperture could be selected to gain maximum depth of field. By being held to one side of the flower a slight shadow has yielded good texture. Using a flash will invariably generate a black background. Compare this with the moss close-up on page 46. Set up some tests using the smallest aperture, positioning the flash at different distances from the subject. If it is too bright place, always place a diffuser over the front of the light to diffuse it.

Light is easier to control when working indoors. If you are photographing still life

FIGURE 93. Action in landscape: Fast shutter speed to freeze the action of the waves.

objects close-up, try to get the subject as flat to the camera lens as possible and with the minimum aperture the maximum amount will be in focus. For something like a coin, if you are directly over the coin it will be all in focus. By working at an angle the centre will be in focus but either side will be soft.

When finishing your macro work don't forget to switch back to normal. Otherwise you will find all subsequent shots will be out of focus. If you cannot find a switch the macro is reached by calling up a menu which you need to scroll through and highlight.

Speed and Action

Digital cameras are ideally placed for close-ups but, for some people, action photography is where a digital camera can fall down. They can be slower to react than film cameras, especially to focus. Maybe the subject you want to shoot is a car coming towards you. See Figure 92 on page 119. Before the car arrives predict where you think you are likely to take the photograph. Focus on that point and take the light reading. If you can set the focus manually, do so. Likewise set the exposure. If you can do neither of these it will be necessary to push the shutter release down the first stage and hold it having locked the focus and exposure on that predicted spot. You then have to hold that while you wait for the vehicle! If the key is to freeze the action then try to set a fast shutter speed (more than 1/500th second) if you can. Now, as the car appears

Digital Image

Digital or Film

Camera Choice

Camera Controls

Accessories

Taking Photographs

Scanning

Viewing/Organising

Improving Images

Creativity

Archiving/Printing

E-mail/Web/Video

hold it in the viewfinder, composing your shot, and follow it until it reaches the predicted spot when you take the photo. Keep the car in the viewfinder and as you take the photo keep with the car. Remember to keep more space in front of the car than behind for good composition.

This predictive method of shooting is the same for anything moving and is the way to take good images of birds flying past, although they are more difficult to predict. In all cases watch first to see where the subject goes. The more information you have about your subject the better. In the case of birds or planes, where they have the sky for a back drop, the exposure may be fooled by the bright light. It may well be necessary to adjust the exposure by adding a stop or two of light (open the aperture more) otherwise the subject will come out dark.

Freezing action can result in a rather static subject. The car may appear parked. A helicopter will have rotor blades frozen in mid area. Check out panning on page 67.

FIGURE 94. Slow shutter: Photographing lightning can be achieved by trial and error and using slow shutter speeds. With digital cameras unwanted shots can be deleted easily. The camera was set on a tripod at night and aimed at a region above the city where lightning had been seen. Repeatedly the shutter was released using the slowest shutter speed possible, eventually a burst of lightning occurred while the shutter was open. If required crop afterwards.

Low Light Conditions

It is possible to achieve a great deal by using a tripod with your camera. If the priority for your picture is the maximum in focus a tripod is often essential as the smallest aperture can then be set and it does not matter how slow the shutter speed is. A flash needs care and practice before the photo is good and not too harsh. In many indoor public places flash and tripods are banned.

FIGURE 95. An almost impossible shot of Tutankhamen's Death Mask! Taken in the Egyptian Museum, Cairo, where no flash or tripods are allowed. The mask is in a very dark room with a spot light. ISO was set to 800 and the lens of the camera rested on the glass for stability. The shutter speed was 1/15th second. Taken on a Fuji compact.

If the camera has the facility to change the ISO sensitive you have a good option. Increase the sensitivity so that a shutter speed can be used without shake. In museums there is inevitably glass panels between you and the subject. Use this to your advantage. Place the front of the lens on the glass for support. This will also help to reduce reflection. See Figure 95 opposite.

Very early in the morning or after sunset can produce some beautiful pictures but rely on slow shutter speeds. Avoid increasing the ISO level as they will become grainy with excessive "noise". Landscapes with low light and people in the foreground can have a slow shutter speed for the landscape but a flash switched on to illuminate the people in the foreground. For this use either the slow sync setting or manual.

Trial and error is often the best thing to investigate taking shots in dim light. To get a sense of movement actually move the camera in a controlled way by either rotating the camera on a tripod or zooming the lens. On manual zoom lenses this is easy enough but the majority of medium to low priced digital cameras have an electronic zoom which prevents zooming and firing the shutter at the same time.

Scanners

If you, like many millions of people around the world have photographic prints, negatives or transparencies, do not ignore a scanner. When digital photography was first talked about digital cameras were still serious luxuries. If you had a scanner you were a digital photographer. Photographs could be scanned and saved to the computer hard disk: the process of digitisation. Like cameras, scanners have plummeted in price. They even "give" them away with computers. Scanners do vary enormously in quality both build and the results they can achieve.

There are two main types:

- Flatbed scanner, normally with an A4 scan size and used for scanning paper-based photographs or text.
- Film or transparency scanner

The first is the cheaper and most versatile type. If you have photographic prints, magazines and books to scan this is the one to go for. On the other hand if the bulk of the photos you have are transparencies or film negatives it is better to get the second type. Some of the better flatbed scanners do come with a transparency adapter built-in and so if you have a real mix of material this could be the best option. A flatbed scanner is like a small photocopier, with a A4 sized sheet of glass above what appears to be an empty box. The photo is put face down on the glass and as the scan progresses a light unit moves under the glass to illuminate

Digital Image

Digital or Film

Camera Choice

Camera Controls

Accessories

Taking Photographs

Scanning

Viewing/Organising

Improving Images

Creativity

Archiving/Printing

E-mail/Web/Video

FIGURE 96. Scanner: this is a dual-purpose flatbed scanner which deals superbly with all types of photograph, including prints, negatives and transparencies. Connecting by USB or Firewire it is a very capable setup."

FIGURE 97. Nikon Coolscan IV for scanning transparencies. This model has a USB connection whilst other models available may use Firewire.

the photo. See Figure 96 on page 124. Also in this unit is the CCD, just like a camera, that pick up the image, line by line. Transparencies or slides can be placed on the glass but of course the light goes through them and so the image produced is useless. Current transparency adapters are built into the lid over the transparencies and as it scans, the adapter houses the light instead of the unit underneath. The adapter light shines through the slide on to the photosites to create the image. Four slides can be dealt with at a time and the quality is good. This may tempt you to go for the flatbed even if you have many slides to scan. A dedicated film scanner, however, does produces superior results if quality is a major concern and they usually come with specialist software. There are only a few film scanners in most people's price range made primarily by the professional camera manufacturers, namely Nikon, Minolta and Canon. See Figure 97 opposite.

Scanners are sold on the level of resolution they produce in a similar way to cameras. The scanner resolution is normally expressed in dots per inch (dpi) rather than pixels. This can be misleading as some use interpolation to boost the pixels. If you are likely to use your flatbed scanner on a regular basis it is well worth investing in a medium priced model. The mechanism

FIGURE 98. Epson Twain Driver. Example of a flatbed scanner's advanced scanning software. Typically, the software to first appear when scanning is a simple screen to scan for e-mail, printing etc. This advanced screen allows a controlled scan by setting the pixel dimensions, dpi, etc. Note the scaling is at 100% and so the physical size of the scanned image will be the same as the original.

Digital Image

Digital or Film

Camera Choice

Camera Controls

Accessories

Taking Photographs

Scanning

Viewing/Organising

Improving Images

Creativity

Archiving/Printing

E-mail/Web/Video

that moves the light unit and photosites needs to be precision made and accurate. It is this which tends to be of reduced quality to save money as well as limited software. When moving a scanner between locations make sure you lock the mechanism in place as even the slightest damage will affect the scanning quality.

The scanner connects to the computer through either USB or Firewire. USB is most typical whilst expensive scanners may use Firewire. These connections will determine the speed of scanning as well as the computer processor and RAM. Unlike the camera which has to do everything from scanning, to processing and storage the scanner just does the first of these. This is why the software that comes with the model is so important. Everything is controlled from the computer screen. Other than an on/off switch, buttons on a scanner are rare. As your scanner ages consider upgrading the software which came with it. Usually it is just a case of going to the appropriate web site and downloading the new software.

The most important piece of software to come with the scanner is the TWAIN driver. This contains the instructions to link the scanner and computer so they can talk to each other.

FIGURE 99. Scanning Screen: This is the screen for scanning with the Nikon. Up-dates for all scanners are available from manufacturer websites. Three windows display a preview of the slide being scanned with the settings, a tool palette which sets those settings and a progress window.

The driver is often up-dated by the manufacturer and it is easy enough to go to their web site and download the latest driver. Another reason to buy a reputable scanner. When the driver is activated on the computer it wakes up the scanner and a window appears on the monitor. These vary enormously although the principles are the same. Figure 98 on page 125 shows a typical screen for the Epson scanners. One way in which the manufacturers vary is they way they try to simplify matters. The screen in Figure 99 opposite may take a while to find and is usually classified as Advanced Options. This is why we see scanners appearing with a coloured button which can be pressed to do everything for you. After a few questions are asked the software takes over and determines everything. The following looks at making a scan based on a TWAIN driver where you make the decisions.

In our example we see the scanning controls on the left of the window and a preview of what is lying on the scanner glass. This preview scan should happen when the driver is started. If not there is a button to preview and will need to be clicked every time you put new material in the scanner. Use the mouse to drag a cropping rectangle around what part of the preview you wish to scan. As you do this there are figures on the controls which change. The most important control to set is the resolution of the eventual digitised image. You may have a choice of setting the units as either PPI or DPI. The latter is more important when printing out. See printing resolution page 173.

The resolution you set is really down to the size of the original and how large you want an eventual printout to be. If the image is one inch by one inch and the scanner resolution is set at 1 dpi and the result will be a picture made from one pixel. If the scale is at 100% a printout of this image will also be one inch by one inch. A picture ten inches by eight would best be scanned at a resolution of 200 or 300 with scaling at 100%. This would result in images of 2000 x 1600 or 3000 x 2400 pixel resolution, respectively. Large file sizes but respectable for printing. Hopefully you can see that for printing more pixels will result in a better image but it also depends on the printer resolution.

Set the resolution required and an indication of the uncompressed file size will appear. If the image is to be printed then check out the setting for image size. By default the scaling will be set so that the size remains the same as the original. If you intend printing at a different size the scaling can be adjusted accordingly. The resolution should remain constant but the file size will change. Don't be afraid to learn by trying different settings for different scans. After looking at the results they can be deleted and the settings returned to normal by clicking the default button. Make sure the glass of your scanner is cleaned regularly.

With the scanner will be bundled a variety of software including a bitmap editor.

Digital Image

Digital or Film

Camera Choice

Camera Controls

Accessories

Taking Photographs

Scanning

Viewing/Organising

Improving Images

Creativity

Archiving/Printing

E-mail/Web/Video

FIGURE 100 AND 101. The church is an old, faded colour slide that has fungus growing on it. It have been scanned twice but the one on the right has been scanned using Digital ICE, ROC and GEM software, bundled with some transparency scanners. Digital ICE works by adding a fourth channel called the 0 channel (defect channel) to the RGB channels. During scanning information on defects, surface dirt, and scratches is collected. ICE then applies a series of algorithms (formulas) to rebuild the missing information. The result is scans that are scratch free and dust free even if the original film has serious defects.
Continued on facing page

Either this one or a better one you already use on the computer can be used. TWAIN drivers are designed to be used within other software. To start the scanning begin by opening the editor and then under File, on the menu bar, click Acquire. This is the way to start the driver running. You might think the word scan is more appropriate but acquire is the word to look for. After scanning the image should be contained within the editor window for you to manipulate and change.

Note that if you scan published photographs, e.g. from magazines, ugly patterns appear. This is Moire, a type of noise that can usually be minimised in a bitmap editor. The function "remove moiré" is usually found under filters or effects. Some flatbed scanners offer a 'descreen' function.

Film scanners work in a similar way but have to work at higher resolutions due to the

Digital ROC (Reconstruction of Colour) reads the dye signature in the base layer of faded slides and negatives and rebuilds the original colour values based on data that it gathers during scanning. The resulting image is true to the original. Digital GEM (Grain Equalization and Management) gathers detail on image grain during the data collection portion of the scan. That information is then combined with information on colour and sharpness to attempt to remove the appearance of grain in the final image. These are all better than dealing with it in a programme like Photoshop when it would take hours to remove the dirt and fungus and restore colour.

small size of the original. The scanning software will be similar although extra optional controls will be available. The most useful extra to go for is the additional software called ICE, ROC and GEM. These are designed specifically with slides in mind. The first of these is a cunning method of eliminating scratches and marks on the slide whilst the others help restore poor images, especially those which have faded with time. See Figures 100 and 101 above. The scanning of slides will be slower than a flatbed, mainly due to the higher resolution required, and when the computer applies these extras such as ICE it can take up to five minutes for the complete process. Clean the slide well before placing it in the scanner. A blower brush or, better still, a can of compress air will help. Read the manual that comes with the scanner well. There is usually a setting for different film manufacturers. The setting for Kodachrome will produce a different colour scan compared with, say, Fujifilm.

Digital Image

Digital or Film

Camera Choice

Camera Controls

Accessories

Taking Photographs

Scanning

Viewing/Organising

Improving Images

Creativity

Archiving/Printing

E-mail/Web/Video

FIGURES 102,103 AND 104. Using the flatbed scanner as a camera. These flowers and embroidery were placed on the glass and scanned. Depth of field is remarkably good here but does vary between scanners.

Using scanners to take photos: If you have purchased a flatbed scanner you also have a very good camera. Whatever you can place on the glass can be photographed to a higher resolution than your camera as illustrated in Figures 102, 103 and 104 above. It is especially good at close-ups and you will be astounded at the tremendous depth of field achieved. High quality montages of grasses and flowers, each element being created separately on the scanner can be produced. If you want to take photos of jewellery for insurance reasons just lay them on the glass and start scanning. It is an extremely creative device that is easily overlooked. I have heard of people placing mirrors and a prism on the scanner glass to take photos of whole rooms not to mention portraits! If you are interested in craft and design ideas check out the book Creative Photocopying by Stewart and Sally Walton, published by Aurum.

Digital Image

Digital or Film

Camera Choice

Camera Controls

Accessories

Taking Photographs

Scanning

Viewing/Organising

Improving Images

Creativity

Archiving/Printing

E-mail/Web/Video

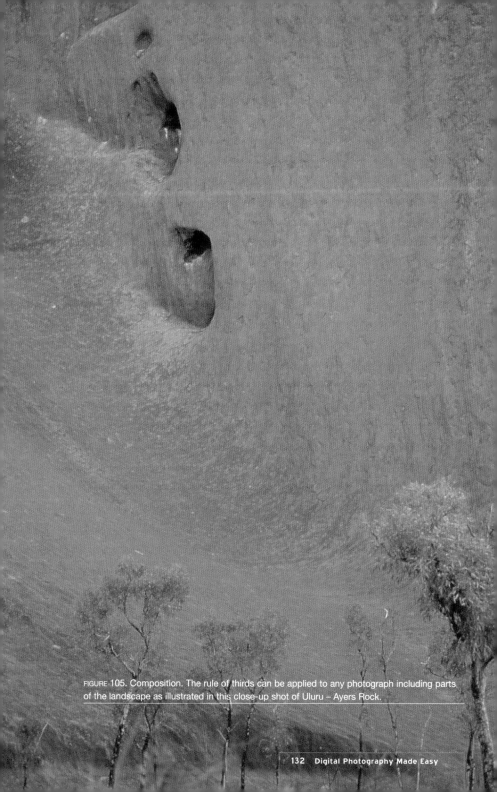

FIGURE 105. Composition. The rule of thirds can be applied to any photograph including parts of the landscape as illustrated in this close-up shot of Uluru – Ayers Rock.

The Computer

Computer Needs

It is quite possible to own a digital camera and not have to have a computer. However, you will be missing much of the fun as well as not making the most of your camera investment. The problem with any hobby is that the deeper you go the more ideas you have and the more money you spend. Other than the camera the computer could be the most expensive part of the whole set-up. If you were working with word processing or spreadsheets it is quite possible to get away with a fairly slow, old computer. The moment the word graphics is mentioned the people who love to talk about technical specifications have a field day because graphic files mean big files. Just one four-megapixel photograph will consume more space on a computer than all the text in this book put together. Take thirty six photos with your camera and there is some serious space disappearing on the hard disk. If you are buying a new computer go for the largest hard disk you can because the space will vanish in no time.

If photographs take up a good deal of hard disk space (the permanent storage) it follows that to work on a file needs as much RAM memory as possible. This memory is the working space into which the file goes when you open it up to view the data. Files cannot be worked on when they are on the hard disk, similar to a photograph filed away in a drawer, you cannot see it. RAM is like the table space you can put it on to view and manipulate. The more space you give it the easier and quicker it will be to manipulate and the more files you have open (on the table) the better big space will be. It will not just be the picture file that is using the RAM but many other software components as well. The processor, usually one from Intel or AMD, is the chip that directs operations and so the speed of this will determine the speed of your actions. Then there is the graphics card. This, too, contains RAM so that it can display the data on your monitor. Cropping an image means that the computer not only has to reorganise the file removing all those bytes of information in the memory but also it has to redisplay the new image. The more RAM there is on the graphics card the faster it can reorganise your display. This can be very annoying if there are lots of graphics to work on and you have to wait a minute or more for the computer to reset the display.

Finally, when viewing the pictures on the screen it helps if you have a good monitor.

Viewing your images on a good screen is important. Recently produced models are certain to be TFT or flat screen LCD monitors. These have improved and become very affordable

Digital Image

Digital or Film

Camera Choice

Camera Controls

Accessories

Taking Photographs

Scanning

Viewing/Organising

Improving Images

Creativity

Archiving/Printing

E-mail/Web/Video

in the last few years with 17 inch being most typical although 19 and 21 inch are becoming a good option. Try and get one with good contrast and a digital one (with a digital cable) will be better than analogue.

What about software? If you are buying a new Windows PC it will be using the Vista (either Home or Professional, basic or premium) operating system. In the last four or five years an earlier Windows version was used, called XP. Operating systems provide the computer hardware with instructions on how to work making it fundamental. Instructions differ slightly between versions but it just means that new software just provides more options. As the majority of users have Windows PCs we concentrate here on that operating system. Apple Computers have similar methods. In the photographic and computer press plenty of arguments occur over which is best, Apple or a PC. As fast as one produces reasons why theirs is best the other will counter with renewed argument. Apple Macs were traditionally used by publishing houses. I have used both and, in terms of functionality, they are both as good as each other and just down to personal preference.

Getting organised
Using Windows Explorer
You will soon start filling up the hard disk with photos and if you do not develop a good filing system from the start you will be lost in no time. The Windows operating system creates a folder (also known as a directory) on the hard disk called My Documents. Inside that you should find another called My Pictures. Note that in Vista the *My* has been removed. If you put all your photos in that folder at least you know where they are although once a few thousand are in there it will become confusing. Hence the need to set up a system of named folders so that you can file away your photos and that you can find them easily. It is very simple to change and amend this at any time. Fig 106 opposite shows a possible tree of folders created in Win98. To create your own system and to organise your files use Windows Explorer. This comes with all versions of Windows and can be found under Start/Programmes or to short cut this *right* click the start button and left click Explore.

The programme displays the contents of the computer down the left side of the screen, including the different drives and the folders they contain. Double clicking a folder or drive opens it and the contents appear on the right of the screen. The double click also expands the folder so that if it contains sub-folders they will also appear on the right side of the screen as well as beneath the one you have just clicked. There are also plus or minus symbols to the left of a folder. Clicking the former will expand the folder to show any sub-folders whilst the

minus contracts the folder. Note that it does not display the file content on the right. In this way by clicking the plus sign you can expand the folders to see the destination to where you can move your files (photos). Figure 108, overleaf, shows the equivalent screen for the Vista version of Windows Explorer. If you are moving files between folders or drives display the destination first, then click the folder or drive that contains the files to move. The files will then be displayed on the right side of the screen. Select the files to move by dragging across them or clicking on them. Click in the middle of the highlighted area, holding the mouse button down, and then drag the files to the destination. When this becomes highlighted let go and the files will move or be copied. By default, if the starting point and destination are on the same drive the files will be moved. If they are on different drives they will be copied.

The concept of a tree is used in computing terms such that the hard disk is referred to as the root. My Documents folder comes off this root. Within here generate the folders within which to store the files you create. My Pictures is a sub-folder. Click on this sub-folder and start building new folders within it. Click File on the menu at the top of the programme. Then New, followed by Folder. The new folder needs to be renamed so immediately type a suitable name.

FIGURE 106. Explorer in Windows XP, showing a potential, logical folder setup. Clicking a folder on the left displays the file content on the right. Hover the mouse over an image and the file details appear.

FIGURE 107. inset, shows the options when clicking the Views button on the toolbar.

At anytime rename a folder or a file by clicking it to highlight, followed by a short pause and then click again. If you click too quickly the file will try to open. The name will be highlighted but with a cursor at the end. Just type a new name and then click elsewhere. If all else fails highlight the file and then click File menu then Rename.

Remember that the folder is created in whatever folder is already highlighted. For example, in Figure 106 the folder Family has further sub-folders named after the year. To generate this system click My Pictures folder, click File, New, Folder. Type Family and click elsewhere or hit the return key. Then click the Family folder followed by File, New, Folder. Type the year 1998. With the Family folder still highlighted, repeat File, New, Folder but now type 1999, and so on. To produce the folder Holiday you need to click on My Pictures again and start creating folders there. At anytime folders can be moved by clicking and dragging them elsewhere or renaming them. By expanding the tree with the plus sign the entire structure can be displayed. See Figure 109.

FIGURE 108. Explorer in Windows Vista: The fundamentals are the same as XP but upon clicking a thumbnail notice that at the bottom of the screen details of the image can be added or changed, including the addition of tags, for easy searching in the future.

FIGURE 109. XP Explorer. Explorer in Windows XP. Click on the folder and the files are displayed to the right. Clicking the Views icon on the toolbar gives the options. Here the list is checked off and so just file names are listed.

You will notice in Figure 106 that I have included a folder called Temp Holding. I always download my photos into this folder. Afterwards I can go and check them out, manipulate them if necessary and eventually, when I have time, file them away in the correct folder.

Once downloaded, images have file names like Dscf2390. As mentioned before it is worth setting the camera on continuous numbering so that you never get files with the same number. It is also worth renaming files so that they can be recognised but this can be tedious. By keeping files catalogued in logical folders will help you find files even though Windows search facility is good. However, it does depend on having renamed the file to something you recognise.

The Picture folder may be found on the initial Windows Start menu as well as by going through Explorer. The above method of manually creating folders and moving files may seem unnecessary when auto downloading is available both in Windows and in purchased software, e.g. Adobe Elements. However, if you understand the above it provides a greater degree of control, not to mention the basics of backing up.

Digital Image

Digital or Film

Camera Choice

Camera Controls

Accessories

Taking Photographs

Scanning

Viewing/Organising

Improving Images

Creativity

Archiving/Printing

E-mail/Web/Video

Viewing Images - Different Operating Systems

Once downloaded viewing your pictures is the exciting bit except this will depend on what software is available. Let's start with the basics. If you have a very early version of Windows, e.g. Windows 98, viewing software is very limited. With the coming of Windows XP we see a raft of improvements. See Figure 110, below.

By clicking the View button not only are the usual options of List, Icon and Detail present but these have been joined by Thumbnail and Filmstrip. The former produces an array of thumbnails for all the files and double clicking the thumbnail will produce a larger image in a window. By clicking on Filmstrip the thumbnails appear as a row at the bottom of the screen and as you click on the file it appears as a larger image above. To create a slideshow is not straightforward and needs clicking the Folder button on the toolbar above to get rid of the folder view. Then there will be options for slideshow and printing and even saving to CD.

The Vista version of Explorer is significantly more versatile and when displaying folders even shows glimpses of the photos "stacked" inside. Using a slider under Views the

FIGURE 110. XP Explorer screen. Explorer in Windows XP. Click Filmstrip in the View list and at the base of the screen a "strip" of thumbnails appear and by clicking on one file it is displayed as a much larger image. Some simple image changes can be made here including lossless rotation.

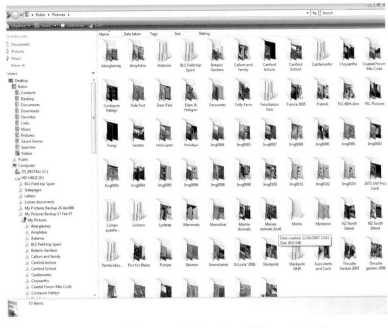

FIGURE 111. Windows Explorer Vista screen: Folders view, with View set to small.

thumbnails can be enlarged or made to shrink. Best of all the Slideshow button is on the toolbar at the top. See Figure 111.

Digital

Digital or Film

Camera Choice

Camera Controls

Accessories

Taking Photographs

Scanning

Viewing/Organising

Improving Images

Creativity

Archiving/Printing

E-mail/Web/Video

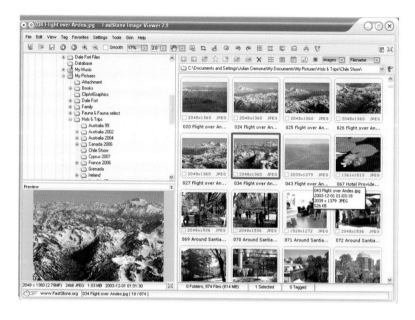

FIGURE 112 AND 113.
Faststone Viewer, a free download from the internet that provides excellent organization, viewing of images and simple enhancements. Inset is the accompanying Faststone Resizer for batch conversion for carrying out multiple actions.

Photo Viewers

Bundled with you camera will be varying amounts of software, much of which is not that brilliant. Downloading free software from the internet can be significantly better, e.g. Faststone above. Others include Picasa from Google and Irfan View. Those like Faststone behave in a similar fashion to Explorer. By clicking the folders displayed on the left the picture content is shown as thumbnails to the right. However, these do much more. They retain the software

settings so that going back into the programme you will see it exactly as you last left the screen. All the thumbnails are stored like a database and do not have to be recreated as in Explorer. Slideshows are easily configurable with transitions and custom positions. Double clicking a thumbnail allows a low level of enhancements and changes to be made. Remember that every time you save a change to a JPG degradation of the image will occur, so keep this to a minimum. As well as viewing the image they will allow access to all the information (called metadata) stored in the file. In these viewers conversions can be made to other formats, e.g. TIF. They will also allow batches of files (as many as you wish) to be renamed and rotated. Viewers are essential for organizing your pictures.

For those with poor eyesight the thumbnails can be made larger and the screen customised. It maybe that the viewer you have is adequate for your needs but there is some great software out there. Just try it!

FIGURE 114. Compupic screen. The screen of the excellent viewing software, Compupic version 6.1 Like Explorer the folders are on the left and the files displayed as thumbnails on the right. Clicking on a thumbnail previews it in the bottom left. Favourites can be located at the top left. Unlike Explorer it has many more options and is very versatile.

Digital Image

Digital or Film

Camera Choice

Camera Controls

Accessories

Taking Photographs

Scanning

Viewing/Organising

Improving Images

Creativity

Archiving/Printing

E-mail/Web/Video

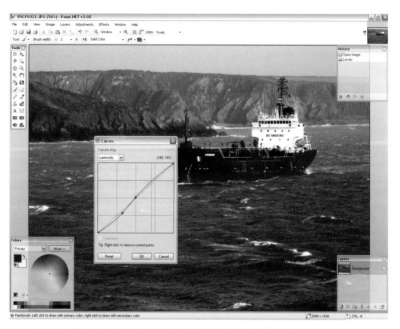

FIGURE 115. The Paint.Net free software. Available as a free download (see Resources) this is an excellent bitmap editor along with others like GIMP.

Software on the web

Pick up any photographic magazine and book, for that matter, and you would be forgiven to believe that if you take digital photographs you must have Adobe Photoshop. Now badged as a Creative Suite CS3 with new versions coming out regularly to encourage you to keep up-grading you could easily pay as much for the software as you do for the camera. This is definitely not necessary. Certainly the software provided with the camera can be substantially improve upon. Mentioned above are just a few of the many software viewers and packages, both free and for low cost. Faststone Viewer (www.faststone.com) is a relative newcomer to the scene but Compupic (www.photodex.com) has been around for some years, now manifested as an advanced programme in the commercial software, ProShow Gold. Popular bitmap editing programmes commonly bought are those like Adobe Photoshop Elements, a reduced version of Photoshop, or Corel's Paint Shop Pro. Corel is a big name in graphics and their CorelDraw! suite has been around since the late 1980's. Within the package is the superb PhotoPaint programme. Buying all these products can be very expensive but in many cases old versions can be bought for peanuts. Instead of buying the latest version of CorelDraw! try version 8 that arrived five years ago. It is still a superb programme but maybe newer ones will be easier to use. Almost

given away it is very cheap to buy. Better still download the amazing bitmap editor the GIMP. You can even get the GIMPshop, designed to be very similar to Photoshop. Both are completely free. Just type the name into your search engine like Google and it will send you to the best download page.

Workflow and Finding Images

Workflow is the word most banded about in the photographic world. Specialised software like Aperture, DxO and Lightroom will have you believe that taking the photograph is just the beginning and using their software will speed up the processing of your images once downloaded. Just about all images need some post-camera work. RAW files for certain.

A typical workflow could be as follows:

- Download the files into a holding folder (Windows Explorer)
- View pictures full screen and delete the rejects (Viewing software)
- Rename and backup original copies before enhancing (Viewing software)
- Enhance the photograph to improve features like composition, contrast, colour, sharpness and remove blemishes (Bitmap Editing software)
- Convert files to suitable format and size for storage, viewing, projection and printing (Viewer or Bitmap Editor)

In the latter case, RAW file formats need to be converted to JPGs to be viewed in any viewer on any computer. Another reason for conversion is that high resolution JPG files will not be needed for viewing on a computer. For efficiency they could be reduced to just 2 megapixel files whilst for emailing they could be resized to 640x480 pixels. Extra sharpening is often needed for projected images.

This idea of workflow could just put the novice off but persevere as it can be as complex or simple as you like. After all, even with traditional methods a workflow was required to organize and optimize your collection. If anything digital is easier to control as it is all in one place. You can even create contact sheets. A good organization of the photographs is essential to be able to find specific ones in the future. This can be done with a viewer and involves one or all of the following.

- Renaming the image from unintelligible (e.g. DSC001673) to a logical one (London Day Trip May 2007)
- Create a logical tree of folders to store the files (see Figure 106)
- Set up a database file of the photographs (see below)
- Add Tags or Keywords to images in software like Photoshop Elements or Vista (Figure 108)

Digital Image
Digital or Film
Camera Choice
Camera Controls
Accessories
Taking Photographs
Scanning
Viewing/Organising
Improving Images
Creativity
Archiving/Printing
E-mail/Web/Video

CompuPic supports a huge array of formats and is unaffected by changes in files. Any changes in a photo will have the thumbnail instantly up dated when switching back to the viewer. Different formats will show up as a different colour around the thumbnail and even video clips or sound are supported. This means that in a slideshow the video is played in sequence with the stills. If you regularly run slideshows to friends or for business this is an excellent tool. Not only can you sort by name, date, etc., there is a custom feature that allows you to use the thumbnails like traditional slides on a light box. Just grab the thumbnail and then drag it to where you want to show it in the slide sequence. In this way you can set up a slide show to run in the exact sequence you wish with what ever transition you feel is best.

Viewers will provide simple changes like crops, colour adjustments and rotations. However, JPGs will be recompressed when saved. If you want to make simple changes and not to recompress select the images and use Lossless Image Modifications (under Tools in Compupic). This allows certain changes like rotation without having to resave the image. A great advantage.

There a many other good features. Renaming files can be tedious. Under tools, there is a batch rename facility. This will rename as many files as you wish with the same name but ending with a sequential numbering system of your choice. Select the files which you want to give group names to, then Tools, Batch Rename. Type in the name in the text area leaving the three hash signs. These create the numbers at the end of the name and can involve several options. This is a very useful facility. Another batch facility is for converting files to other formats. If you have a good JPG or two that need working on it is always advisable to save them first as a TIFF file and work on these so that you do not have to keep compressing (and therefore degrading) the image. Batch conversion will change as many as you like in one go to TIFF leaving the JPGs unaffected. It has simple duplication facilities which automatically renumbers the copy or you can add security systems.

As part of your system for getting organized you might decide to set up a database of information about the photographs. This is referred to as Digital Asset Management and some professional programmes like Extensis do all of this very well. For simplicity you probably have everything you need including a viewer and office software (word processor and spreadsheet). Most viewers allow the printing of a picture index ("contact" sheets) or a text file of photo names. By default the file will be set up as simple strings of text, each photo with data stored on one line. Although a basic text file it can be opened in MS Word, the text selected and then converted to a table (under the Table menu, click Convert Text to Table). As it stands the table works as a searchable file but for more sophistication it can be pasted or imported into Excel or

Access. For completely free software use the free download OpenOffice. In addition to the above there are free shareware programmes, like ExpPrint, that allow you to print folder contents to a file. Tags and keywords can be added to files so that they can be searched for easily wherever they are located on the computer.

This section has tried to show that viewers are there to help you get organised with your files. Structure your folders logically and as the collection grows consider setting up a database of information around your photos.

Projectors

Whilst thinking about viewers and viewing your work we should consider that with more than a few people in the audience projecting the images is the only way. The price of data or multimedia projectors is low enough for home cinemas to become common place. Set-up the slide show with all the transitions you need, merging sound and video clips together and you won't even have to be there. Most viewers can be set to auto-run. There is a plethora of models on the market with manufacturers like Sony, Sanyo, Toshiba, Canon and Epson. The cheaper models will have a resolution of 800x600 pixels (SVGA) and around 1000 lumens of brightness. You may have to reduce stray light from windows but complete black-out should not be necessary. Pay a little more and the resolution climbs to XGA with 1024x768 or more pixels. 2000 lumens or more will be useful in a large hall. To project photographs set the colour palette on

FIGURE 117. Sanyo LCD multimedia projector.

Digital Image

Digital or Film

Camera Choice

Camera Controls

Accessories

Taking Photographs

Scanning

Viewing/Organising

Improving Images

Creativity

Archiving/Printing

E-mail/Web/Video

the projector menu to True Colour although this may need some trial and error to achieve the best result. Projectors need to be allowed to cool properly after use as the bulbs are expensive. This means not switching off the power but using the correct cooling cycle as per the instructions. This may only take a minute and try not to switch on again for up to thirty minutes. With S-video and composite inputs these projectors can be used for quite major home entertainment systems, projecting DVD, video, console game playing or even just the TV. The projector usually has a timer device so the number of hours use can be checked.

Changing the Image

Bitmap Editors

The photographs have been downloaded on to the hard disk and have been viewed. You may be pleased with them but certainly there will be occasions when they are not quite up to scratch: red eye on your main subject, unwanted detail on one side, uneven horizon or distracting reflection and flare. This is when digital imaging really comes into its own because these can easily be amended. The more expensive cameras often minimse the application of in-camera software. Typically, contrast, brightness and the saturation of colour will need to be

FIGURE 118. Screen shots of Corel PhotoPaint.

FIGURE 119. Screen shots of Adobe Photoshop.

improved. To do this requires a bitmap editor programme. Photoshop is the industry standard with PhotoPaint a close second. See Figures 118 opposite and 119 above. Both do some amazing things with digital images but may be beyond your needs. Adobe produce an affordable version of Photoshop called Elements that does more than enough to keep most digital photographers happy. The question is, which programme to buy? Help may come with the camera as software is increasingly being bundled with the equipment although this will be rather limited.

Personally, unless the bundled software is a well known, good quality programme I would not waste time with the installation but use a better alternative. Some excellent ones like GIMP and Paint.Net are completely free (see the Appendix on free downloads) and will be substantially better. Another good strategy is to buy software that is an earlier version than the current package. This may be difficult with Adobe products as they try to remove all but the current version. Corel, however, allow any of their versions to be purchased through suitable online outlets. My personal favourite is PhotoPaint which comes as part of a suite called CorelDraw. Version 8 is a powerful application and although five or more years old is a top notch

Digital Image

Digital or Film

Camera Choice

Camera Controls

Accessories

Taking Photographs

Scanning

Viewing/Organising

Improving Images

Creativity

Archiving/Printing

E-mail/Web/Video

FIGURE 120. Cropping images. The original you take always has a set shape. This means that detail you do not want can appear in the shot. Cropping can be used to remove unwanted material and improve the composition. Here the crop has been used to suit the shape of the animal, a guanaco.

bitmap editor. It will be a fraction of the cost of other packages. The Draw part refers to the industry standard vector map editor, for powerful drawing. There are additional small applications as well.

When you first look at a bitmap editor on the screen they can look very daunting. This is due to the wide array of tools to help you manipulate the image. Some like PhotoPaint and Photoshop have excellent tutorials to teach you the basics whilst others can be quite limited. The GIMP has a wide range of photo-editing tools although the interface can be confusing with many windows (called palettes) appearing and disappearing. However, online help is quite extensive as it is a popular free programme. It is powerful but needs time to learn. Corel also produce the famous and well established Paint Shop Pro software.

It may seem like splitting hairs but some applications refer to being Image Correction programmes rather than Bitmap Editors. The later can be used to create images from scratch, for scanning film or making substantial changes to digital photos. But for those using RAW files (particularly DSLR users) and wishing to tweak a good photograph to gain the maximum quality there are the new correction-type applications like Adobe's Lightroom and Apple's Aperture. They allow very controlled adjustments in white balance, contrast and sharpness to be made. Designed around the workflow concept they are not cheap. DxO Optics Pro take this further by adjusting specific lens distortion like that occurring in wide angle lenses (see page 71). Unfortunately, most of these correction applications lack tools like Clone and so you may still need several programmes. In addition, there are numerous plug-ins that help enhance applications like Photoshop. A plug-in is a small piece of software which works with a larger editor. For example, AlienSkin mimics the characteristics of different film types.

Whatever you do, beware, bitmap editing can become addictive after awhile and you will soon be looking to upgrade to a more powerful editor!

Digital Image

Digital or Film

Camera Choice

Camera Controls

Accessories

Taking Photographs

Scanning

Viewing/Organising

Improving Images

Creativity

Archiving/Printing

E-mail/Web/Video

The first thing you will want to do is to correct it by rotating the image through ninety degrees. This can often be done *lossless*. It is very easy to have a wonky horizon. If this is very noticeable you can select the angle of rotation if your editor will allow custom rotation. The chances are you will not get it right the first time but keep adding a little more rotation each time until it appears level. If you can get a grid to appear on the screen (check under View menu) the horizon can be rotated to be level with the horizontal line. The downside to this comes when you then need to crop the image to bring it back to a rectangle so that the background colour is not visible. See Figures123 and 124 opposite. Flipping an image is different to rotation in that a mirror image is created. Why would you want to do that? Composition. Figures 125 and 126 on page 152 shows a classic rule of thirds except the rock leading the eye into the picture is on the right. Most people feel more comfortable with that on the left. You are the one that must feel right with the image so if it helps, flip it.

Contrast & Brightness: Shooting towards the sun may well reduce contrast in a photo. Likewise, the exposure may be thrown by being too light or dark. This can be adjusted by using

FIGURE 121 AND 122. Cropping to get in close – digital zoom. The original seal shot is as close as I could get with the telephoto. To get closer I set the camera at the highest resolution (2400 x 1800 pixels) and took the photo. It can then be cropped to the composition of my choice. 795 x 605 pixels maybe a bit short on pixels but as long as you don't want a large blow-up it will be more than acceptable on the computer. This is the same principal as a digital zoom on the camera but here you control the process.

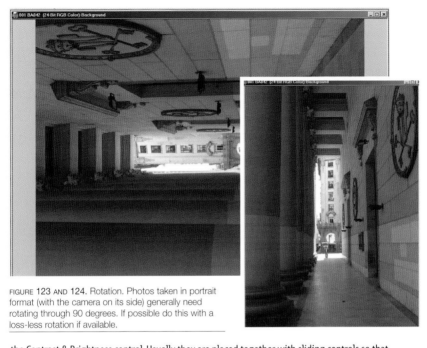

FIGURE 123 AND 124. Rotation. Photos taken in portrait format (with the camera on its side) generally need rotating through 90 degrees. If possible do this with a loss-less rotation if available.

the Contrast & Brightness control. Usually they are placed together with sliding controls so that you can easily preview the result. Even the most basic bitmap editor has this. What may not be available in the very cheap software is pixel level equalisation. The name varies somewhat between programmes but is generally under the menu of Image/levels. If you have this, forget the Contrast & Brightness control. The problem with the latter is that once saved it is virtually impossible to go back as the control completely changes the data in the photo, effectively destroying the original information. Levels is a powerful tool which looks at the distribution of pixels across the whole tonal range. It can then search for similarities, redistribute the data and so create more contrast. This can be done either automatically or manually but the key is that it does not destroy the original data. Even if saved it can still be restored to the original state. To me this is nothing short of a miracle. A situation when a rather poor photograph lacking in detail and contrast can be levelled. The result can be totally astounding as colours and contrast will appear that you never even saw in the original. Likewise, take a perfect picture and switch to auto level and nothing happens. Occasionally the result you see is not what you want and so just undo. Most programmes will allow you to undo a number of steps, even a hundred steps or more. So, there is no need to worry that you are destroying your precious images.

Digital Image

Digital or Film

Camera Choice

Camera Controls

Accessories

Taking Photographs

Scanning

Viewing/Organising

Improving Images

Creativity

Archiving/Printing

E-mail/Web/Video

FIGURE 125 AND 126. Flip for Composition. Rotation is often needed but the flip command may appear a strange one. This is for composition. Right-handed people view an image starting in the bottom left and then into the picture. A good composition needs something in this bottom third. Look at the two pictures and see which one is best for you. The main image should be for right-handed audience, the inset image for those which are not. The Flip command can improve an image if you have had to take it initially with a subject in the bottom right third.

Level adjustment can be important in most circumstance but the times when it can be a major bonus is in aerial photographs. Images from a plane at thirty thousand feet can be amazing but the drawback is the reduced contrast produced by the window and haziness caused by the distances involved. See Figure 127 opposite. Most of the time it is not worth photographing but take the low contrast image and adjust the pixel levels automatically and the chances are amazing detail appears. Figure 129 opposite shows the levels control for the image in Figure 128 opposite. Note the histogram showing the original distribution of the pixels as a pale grey in the background and the new adjustment as a series of peaks and troughs that generate the contrast. The RGB channels stands for the three colours red, green and blue that make up a picture. By clicking this it is possible to readjust individual colours separately. If there is a colour cast, for example bluish on a winter's afternoon, then within this window it is possible to drag the small triangles at either end of the histogram base to change them. Alternatively, see the next paragraph. Some programmes will have all that is present in

Digital Image

Digital or Film

Camera Choice

Camera Controls

Accessories

Taking Photographs

Scanning

Viewing/Organising

Improving Images

Creativity

Archiving/Printing

E-mail/Web/Video

Figure 129 as separate sections. The Gamma slider will allow a change in brightness. If there is a choice always use levels adjustment.

Colour saturation: Like the previous control there is a simple colour balance slider for the different colours so that permanent change be affected. Better still look for a way of altering pixel colour distribution through the levels control. An easier control can be one called Tone Curves. When the former was a histogram this uses a line graph. Choose the RGB channel to change and then start grabbing the curve, anywhere on the line, and start moving this to check the effect on a colour cast. Like the levels, tones can be restored at a later date if need be by coming back in to the curves and moving the line. See Figures 130,131 and 132 on page 154.

Red-eye: some software achieves red eye elimination better than others. The red area needs to be selected. This maybe using a lasso tool. Once selected there may be a red eye slider control

FIGURES 127, 128 AND 129. This photo was taken out of the window of an airliner. It lacked contrast and colour. The left side is the original and right side has been corrected by autolevels. With Auto-adjust checked on the re-distribution of pixels can be seen creating colour and tone. Also there are gaps between the bars generating contrast. The histogram shows the distribution of pixels in Figure128. There are no real blacks or white but the pixels are in two basic clumps.

FIGURES 130, 131 AND 132. Tone Curves: Tone curve controls are a useful way of adjusting the saturation of colour and contrast in an image. The starting point is a straight line.
If the line is reversed the image becomes a negative. Here the line has been adjusted a little at a time by grabbing the dots so that the result can be seen. The original image, on the left, is washed out and over exposed.Using the tone curve control the colour has been brought back. Instead of altering the RGB (all three colours) separate channels can be controlled.

which adjusts the colour. If this is not available use the tonal curves or colour saturation control to reduce the red. Alternatively, zoom in close so that the eye fills the screen and you can see individual pixels. Then using a paint brush, actually paint out the pixels one by one to the colour of your choice. By changing the colour of the paint every so often the eye can look more realistic. To change the colour of paint for the brush look for an eye-dropper or pipette tool. This allows you to click on a colour in the picture for you to use. Alternatively, there will be a palette of colours to go for. See Figures 133 and 134 opposite.

Brushing & Cloning: Like the red eye, parts of the image may contain details and areas that you really do not want and find distracting. It could be a sign, litter on the ground, a house on the

Digital Image

Digital or Film

Camera Choice

Camera Controls

Accessories

Taking Photographs

Scanning

Viewing/Organising

Improving Images

Creativity

Archiving/Printing

E-mail/Web/Video

horizon upsetting your "wilderness" or maybe a person that accidentally came into the frame. It may be easy enough to use the paint brush again to paint them out. Zoom in close so you can see the pixels and then by using the eye-dropper to gather up a pixel colour you want paint **small** groups of pixels at a time. The drawback to this is that unless you keep changing the colour your painted area will be too uniform. Even a brilliant blue sky will have subtle differences. After all, bitmaps can have up to sixteen million colours!

This is where the clone tool comes into its own. Sometimes referred to as the Stamp or Stamp Clone tool they all do the same thing. The idea is that you copy one part of the image to another. If the area to cover is in the sky then use some similar sky near by to copy. To do this, click on an area whose colours are about the same as the area to paint out. A cross may appear to indicate the cloning area. Next click the area to brush and a different shaped tool (e.g. circle) should appear. It is possible to change the size of this brush to suit the size of the area. On a tool bar at the top there should be a method of changing the size so that you can brush in a delicate fashion rather than swamping colour over the area. As you click and drag (paint) the

FIGURE 133 AND 134. Red Eye. A quick snap can easily result in red eye, where the flash has illuminated the retina blood vessels. To amend this, software may use a special filter or individual pixels can be painted. Here the eyes have been selected and the red channel adjusted with Tone Curves.

colours from the cloned area are painted on to your photo. This does require some practice to get it right but once you discover how it will become one of the most used tool. See Figures 135, 136 and 137 below.

Think carefully about what to use to clone out an area. Bushes, flowers and trees can be used to hide a myriad of "blemishes". It is also possible to have two images on the screen (use Tile or Arrange Vertically, found under the Window menu) and clone from one to the other. Click on one first to set the cloning area and then click on the second window twice, the first being to activate that window. This is particularly useful if you need a variety of bushes, etc, as it may appear strange with similar shaped bushes on the same image.

Sometimes the cloned area still does not have a perfect edge to it as the shade of blue, say, for the sky is subtly different. If there is a slight edge you can try "smearing" the edge to blend the two sides. This may come as a smear or effect tool. There will then be a number of possible smears from soft to heavy.

FIGURE 135, 136 AND 137. Cloning or Stamp Tool: This is the most useful tool for quick amendments. The red burglar alarm is distracting and can be easily removed. This is going to have some stonework cloned over the top of the alarm. To begin with there is a circle and a cross. By clicking on the stone the cross stays there and the circle is moved over the top of the alarm and clicked. Stone work from the cross area is cloned over the top of the alarm. Click and drag the circle until the alarm has disappeared.

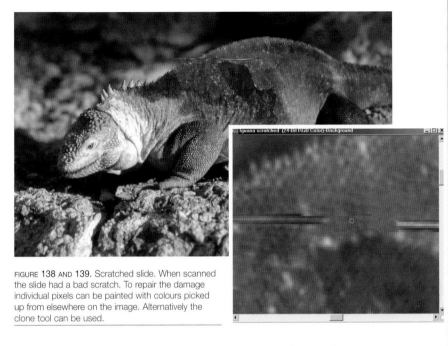

FIGURE 138 AND 139. Scratched slide. When scanned the slide had a bad scratch. To repair the damage individual pixels can be painted with colours picked up from elsewhere on the image. Alternatively the clone tool can be used.

Using an air-brush: Figures 138 and 139 above shows an image of a scanned transparency. Unfortunately the original had a scratch through the emulsion which has also scanned. Software such as ICE[3], found with some scanner software, will help to minimise this problem with slides. If not available the photograph could be rescued with the clone tool by cloning some pixels from nearby on to the scratch. However, it is very uneven and this was restored with the air-brush tool. Brush tools are available in many forms and the air-brush is one of the most delicate, placing the colour on subtly and slowly so the effect can be seen more easily. It takes patience and some experience to use carefully. First enlarge the area so that the image becomes heavily pixelated. Then load the brush with a Paint colour, determined by picking up specific pixel colour with the eyedropper tool. Use good pixels that are very near to the scratch. Click and spray a few pixels of the scratch and then change the colour of the paint. Spray a few more pixels and work your way along changing colour and spraying. Once enlarged the colours should blend without seeing the scratch.

Selecting and Masks: The problem with much of the above is that you have to apply the control to the entire picture. If it is to be limited to a specific area it needs to be selected. As well as

Digital Image

Digital or Film

Camera Choice

Camera Controls

Accessories

Taking Photographs

Scanning

Viewing/Organising

Improving Images

Creativity

Archiving/Printing

E-mail/Web/Video

FIGURE 140, 141 AND 142 Bit-map Fill. To expose the building correctly the sky has over-exposed. No end of tweaking will bring colour into the sky. It needs to be replaced by another photo of sky. The sky area needs to be masked and here it is easiest to use the 'magic wand'. By loading the fill command with a bit-map of sky this is then applied to the masked area. This also has to be applied to the windows and frames. The top left window area has been cloned with cloud. Take a stock of images so that you have a wide variety of skies to choose from.

words like Selection, some programmes refer to this as Masks and/or Marquee. As this name suggests, there is a set of tools giving you the opportunity to mask off areas so that you apply the control to just part of the image. Masks can be applied in different ways and depends on the size and shape of the area to change. Masking can be such a complex topic and Corel sell a programme specifically as a way of masking intricate objects. For example, imagine a photo of someone twirling their long hair. It would be necessary to mask individual hairs! The quality of a bitmap editor could be judged on the quality of its masking or selecting ability.

If the object to be selected is straight then a rectangular selecting tool is fine. Likewise a circular area can be done with an ellipse tool. If the area has a very complex outline with numerous colours and shades try brushing a mask or selection in place. If the pixels in the complex area are relatively similar there may be a magic wand tool. The options for this

FIGURE 143. Feathered and Blurred: As this photo was cropped the image was feathered to give a graduated edge. The waterfall was rather frozen in its action and so a directional blur was added to give a greater degree of movement.

Digital Image

Digital or Film

Camera Choice

Camera Controls

Accessories

Taking Photographs

Scanning

Viewing/Organising

Improving Images

Creativity

Archiving/Printing

E-mail/Web/Video

FIGURE 144. Sharpen filter. A telephoto of these mountain peaks was lacking contrast and colour due to the distance and the weather. Autolevels brought back the colour but to achieve a sharper image parts of the image were selectively sharpened with the sharpen filter.

can be changed to expand or contract the range of pixels to pick up. Take for example a scene where the sky has been over-exposed. By selecting the sky it could be adjusted or replaced with something more interesting. See the image in Figures 140, 141 and 142 on page 158. As the sky is quite uniform with just a small bluish area the wand was clicked into this area with an allowance of fifteen percent. All the sky becomes selected except for a small area to the right where there is a tiny windmill. This does not come within the fifteen percent tolerance. If it did then the selection could be removed and the tolerance reduced. Selections and masks can also be inverted, useful when the area to work on is large. In this case select the small area and then invert. For example, if it was the land needing to be masked then with the sky selected it could have been inverted.

Selection can also be done by drawing around the area very carefully. This freehand or lasso tool can be applied best when zoomed right in on the image so that pixels can be

identified. There are times it is beneficial to produce a gradual edge to a selection rather than a sharp one. This is called feathering but may cause some blurring at the edge. This can be used if a soft edge is needed as a border to a photo. See Figure 143 on page 159.

Finally, masks can be so important that having spent a great deal of time creating one on a complex selection it may be possible to save the mask as a JPG. Then if you need to work on the image again the mask can be reloaded.

Re-sampling and Resizing: This is the process of changing the resolution and size of an image to alter the number of pixels it contains. Upsampling increases the resolution, increasing the number of pixels; downsampling reduces the resolution, decreasing the number of pixels in an image. The latter can usually be done in the camera but is a way of controlling the size of files and also the size for printing. The reason for downsampling is to create a smaller file for e-mailing. Resizing is needed when printing. See page 174.

Exporting: this is similar to the Save As command found in other programmes but with a subtle different. Save as leaves you with the new file, closing the original one. When editing bitmaps it is more likely that an important original file, especially if it is a JPG, will not be saved after changes have been made. Instead, as changes are made and you like them export a copy and then carry on editing the original. At the end you may have a series of copies at different phases of change but the original is never saved. This way the important originals can be archived and the ones to view are those with improvements. Files can be exported in any format and uncompressed versions such as TIFFs may be best so that no more compression is applied.

Sharpening Photographs: There are occasions when a whole or part of an image will look soft and out of focus. If it is heavily blurred then there is very little you can do. It may be that parts of the photo are in focus but the depth of field was not brilliant as the aperture was too wide. Alternatively, a telephoto shot of a very distant subject is soft due to the atmosphere. In the first instance, try adjusting the levels. See Figure 144 opposite. When equalised the subject may develop more contrast. If not or the subject looks flat and needs a few highlights try the Unsharpen mask. This seems a strange thing to use as it appears to be the opposite of what you want. However, The Unsharp Mask filter accentuates edge detail as well as focusing some blurred areas in the image. Other sharpening tools include Adaptive Unsharp Filter and High Pass Filter. The latter creates an ethereal glow to the image.

Digital Image

Digital or Film

Camera Choice

Camera Controls

Accessories

Taking Photographs

Scanning

Viewing/Organising

Improving Images

Creativity

Archiving/Printing

E-mail/Web/Video

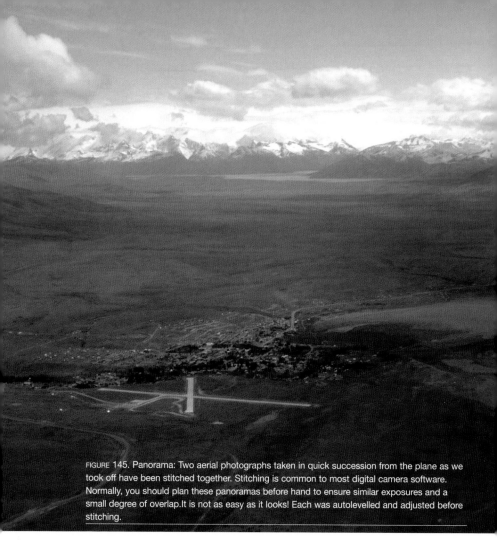

FIGURE 145. Panorama: Two aerial photographs taken in quick succession from the plane as we took off have been stitched together. Stitching is common to most digital camera software. Normally, you should plan these panoramas before hand to ensure similar exposures and a small degree of overlap. It is not as easy as it looks! Each was autolevelled and adjusted before stitching.

White Balance

On page 56 we considered how to ensure the colour could be kept as true as possible by using the Custom White Balance. Certainly, it is easiest and best to try and get this right in the camera. For all the care taken this may still go disastrously wrong. A photograph snapped in doors without a flash may have a strong yellowish-brown tone. Some correction programmes allow readjustment of this white balance, especially if you recorded the image in a RAW file format. This does retain all information and can be modified easily. Otherwise it will be necessary to use the tone curves as shown on page 154. If the colour caste is very strong the three different RGB channels may need tweaking.

Advance Changes

These may be classified as manipulation of the image rather than enhancements. There are any number of possible changes which can be made is is just down to the imagination.

Digital Image

Digital or Film

Camera Choice

Camera Controls

Accessories

Taking Photographs

Scanning

Viewing/Organising

Improving Images

Creativity

Archiving/Printing

E-mail/Web/Video

Adding Blur for Emphasis: This is the opposite to sharpen. You have a photograph and need to emphasise just part of it. It may be possible to do this with a telephoto lens and a wide aperture to restrict the depth of field. This would blur the background. If you already have the image and need to make something stand out mask/select the object and then invert it so that the applied blur will be to everything but the object. The object could be sharpened along the way but we want to make the rest out of focus. In Figure 27 on page 48 I wanted to emphasise the camera and tripod and so this was left alone while the back ground had added to it a Gaussian Blur. The foreground was slightly Diffused, as you would expect areas near to the object in focus would be less blurred. This style can often be seen in cookery books where photos of the food show part in focus with other areas blurred or diffused for emphasis. Like all things, a little in moderation.

Adding motion: When photographing action there is a chance that by freezing the movement with a fast shutter speed the sense of action is lost. A speeding car may look as if it is parked. Likewise some scenes are so dead they cry out for some kind of motion to be added to create the illusion of action. This is achieved once again by using blur but in a directional or radial form as if the lack of detail was due to motion. If this is a car you would expect the wheels to be spinning. First select the wheels, perhaps by painting on a mask. Depending on the software you might have to do this individually or by multiple selections. However, try to add a similar blur to all wheels. Once selected you are looking to apply a radial blur maybe found on either the Effects or Filter menu, under Blur. There maybe several options as to the degree of blur so try different ones, previewing to see the result.

If the illusion is to suggest the object is moving the background should be burred while the main object stays focussed. This will require carefully masking the background. The blur to apply here is a directional or motion one. In the blur dialogue box will be a control for the angle or direction of the blur as well as the level of blur required. Try different options, again with the preview on so that the action can be seen.

Panoramas: some of the disappointing shots from holidays can be the great open vistas that needed a wide angle to fit everything in. The results tend to be flat, as a wide angle changes the perspective such that mountains become small hills. Next time instead take the panorama with a normal lens and with several photos. On the computer these photos can be stitched together to create one image. See Figure 145 on page 162.

One of the reasons it is best not to use too wide an angle for this is that any horizons

can be curved and joining curves together produce a strange result. Also photograph the scene with a similar exposure. The problem being that as you move the camera across the scene the light may vary and when stitched together produce a dramatic contrast of colour and light. Ideally, take an exposure reading that best suits the whole panorama and then set this on manual. As the images are taken make sure there is a small overlap of up to twenty percent between them. The software needs to find similarities which it can overlap so you cannot see the join. Try not to over do the number of images or the panorama will become too long and narrow. Three is fine. If the vista is especially large, put the camera in portrait (on its side) and take five in that format. A tripod is good for panoramas as the camera can be swivelled around level and in a controlled way.

Software varies on how they actually stitch together. Some will try to do all images together. I prefer to start on the left and add photo by photo to the right. Once stitched, expect to crop the resulting image for recomposition as the top and bottom are very likely to be jagged. Also the image will have substantially increased the number of pixels. However, you could use this to an advantage. Let's say the best resolution of your camera is 1.3 megapixels. However, the photo you want to take is to be printed 10x8 inches. The result is likely to be on the poor side. Photographing the subject in portrait with several images and then stitching together could generate a 4 megapixel image which could easily be printed at those dimensions.

If the resolution is too high, for example it takes too long for the image to appear on the screen, resample at a lower resolution and export a copy for general use.

Objects and Layers: Even the most basic bitmap editor will allow an area to be selected, copied and pasted from the clipboard on that or another photograph. More complex editors deal with this in different ways calling them objects and layers. For the majority of cases when dealing with your photographs this is not an area to call on but there may be times when you wish to build a composite image from many others. For example, the back garden needs landscaping and to design how it will look a picture can be made up of the different elements. Take a photo of the area and use this as the background layer. Go round garden centres and gardens photographing a great stock of photos of the elements you might consider putting in your garden. Quite easily you could select bushes, trees, ornaments, etc, in these stock photos, copy them and paste them on top of your background image. When pasting there will be an opportunity to resize this *object* as it is now called and move it to the required position. In software like PhotoPaint and Photoshop these can be built up in layers over the background, with a number of objects being grouped together and merged with the background using

FIGURE 146 and 147. Filter effects. Motion blur, like the waterfall in Figure 87 images can some-times be enhanced by adding motion blur. Bas relief with texturing applied to a windswept beach.

different degrees of transparency. There is an incredible range of tools to make the image very authentic so that an impression of what you hope to produce in the garden can be created.

Save the original file that you are working on in the format of the software. It will be a large file as each layer and object will be saved separately in case at a later date they need to be changed. At any stage in the process copies can be exported into recognisable formats for showing. Files like JPG will merge all objects and layers together. Creating images in bitmaps is beyond the detail here being a topic in its own right. See the appendix for good resources on how to develop this area.

Replacing large sections: Landscape photography can be difficult. If the sky is very bright but the foreground is dark the exposure will bias towards one of them. If the camera is tilted down slightly and the reading taken and used for the photograph almost certainly the foreground will be just right and the sky washed out as it overexposes. Using the magic wand selecting the sky and then adjusting the pixel levels might improve the sky but the chances are there is no detail to develop. Using the Fill tool (often an icon that looks like a slightly tipped over bucket) the selected area can be filled with a colour such as blue. There may be options to graduate the blue so that it is not too uniform and create a slightly darker blue at the top grading to a pale blue at the base. The best option is to Bitmap Fill as it is called. Instead of filling with colour find another image that has a good sky. This can then be loaded into the Fill tool and when clicked in the masked sky fills the sky with the sky from the second image. See Figure 140 on page 158.

This is a reason to collect good stock photos of areas like blue sky with clouds, grassland and forests. Take them with differing degrees of scale and resolution. Filling the sky of a 1.3 megapixel image with a bitmap a fraction of that size will cause problems. Likewise

Digital Image

Digital or Film

Camera Controls

Accessories

Taking Photographs

Scanning

Viewing/Organising

Improving Images

Creativity

Archiving/Printing

E-mail/Web/Video

FIGURE 148 and 149. Filter Effects: Dry brush filter applied to a stream bordered by tree ferns. Patchwork filter applied to lichen encrusted rocks.

take the stock photos from different angles as the perspectives need to be similar to the one to be filled. Stock photos are also useful when you are cloning bushes and trees from one image to another. Keep these in a suitably named folder so that you can easily call on these at a moments notice.

Other Filters and Special effects: these come in abundance in most bitmap editors and it is as if they are vying for the most bizarre and extreme case. Yet this is the one area which has limited value in editing your images. To have most of your holiday snaps set to look like an oil painting would become tedious for the viewer and over used affects soon lose their individuality. It takes real creativity to apply some of these special effects and create a masterpiece. A few examples are shown in Figures 146,147, 148 and 149 above, but it is not really within the realm of this book. For you, the best plan is to take a good image and apply systematically all the special effects on the menu, clicking undo after each one. In this way you can see the range of what your specific software can do. If there is something you like then use the Export command to create a copy rather than saving it on the original. Vignette can be a useful effect. The vignette filter keeps the centre in focus but fades the edge into a shape and colour of your choice. Typically it is used for portraits but it is ideal for any situation where the main subject needs emphasis and will be the only area sharp. People are best with a black or white edge frame although the eyedropper tool can be used to pick a dominant colour from the main image to create a vignette frame.

Some of the effects, e.g. embossing and edge detect, are good at creating texture bitmaps that can be used as backgrounds or frames for other photographs. If you use presentation programmes like PowerPoint they can be used as backgrounds to the slides. Wallpaper, backgrounds and buttons in website can be produced in this way.

FIGURE 150 AND 151. **Filter effects.** Photocopy filter applied to a small village. Watercolour filter applied to a small waterfall.

Archiving images and making Video Disks to share

The one feature of digital photography you can be sure of is that the hard disk of your computer will be full in no time. This is not good for the computer or for you. For the operating system to function efficiently there needs to be space on the hard disk for what is called the swap file, a way of organising memory. As the hard disk fills up files can be moved on to other devices. If you load and move large chunks of data, particularly on a regular basis, defragment the hard drive every month. The Disk Defragmenter programme can be found by clicking Start, Programs, then Accessories, and System Tools. When a file is laid down on the hard disk it does not all get saved in the same place. Fragments are placed on the disk as it spins at 5000 rpm or more. As the hard disk fills up these fragments become more and more disparate and the disk has to work overtime to pick up the whole file. It takes longer to load photographs. After moving great chunks of data defragmentation brings these bits of file closer together and makes the system more efficient. Be prepared for it to take a long time. Twenty gigabyte drives could take up to six or more hours to defragment and should be left alone to do this. Make sure that you back up your data files first as it is essential that the defrag process does not get interrupted. A sudden power failure in the middle could be disastrous. Downloading video on a regular basis to the hard disk makes regular defragmentation essential.

The least expensive back-up method at the moment is to CD and DVD. Drives that write to these are cheap as is the media and now they are very quick. Files can just be dropped on to the drive and when prompted to write will fill the CD (700MB) or DVD (4.7GB or more) in no time. Keep the disks in the dark and suitably labelled. Viewers like CompuPic will playback slideshows from disks almost as fast as the hard disk and will remember the disk name so that thumbnails are filed to be used in the future. Archiving means that you will leave these copies somewhere safe and rarely use them. Several copies could therefore be made, one to archive

Figure 152 and 153 Filter Effects: Water colour daubs applied to a rocky coastline.Water colour effect added to daisies.

Digital Image

Digital Org...

Camera...ice

Camera Controls

Accessories

Taking Photographs

Scanning

Viewing/Organising

Improving Images

Creativity

Archiving/Printing

E-mail/Web/Video

one to use on a regular basis. Then delete the files on the hard disk. There is different quality CD material for sale. Some people would suggest that for archiving important data use only the best, e.g. Kodak Gold CDs. Possibly they have a longer life expectancy. The problem is that we are still in the infancy of the medium. Some film manufacturers have for a while now stated the length of time they believe film will survive before the emulsion starts to degrade, up to twenty years. CDs and DVDs are an unknown.

CD-R and DVD R disks are record once only disks. In theory if the disk is not full more data can be added but as always in practice this is not necessarily the case. They are cheap enough to make this the best option especially when bought in bulk on spindles rather than in jewel cases. CD-RW and DVD RW is when the disk can be written to repeated and data removed so that they can be used again and again. They are much more expensive, store the same amount of data but cannot always be read on other drives. They can be specific to the drive that laid down the data. Good for back up but not so much for archiving.

The common DVD formats are shown overleaf in a table. It should be noted however that there are higher capacity drives now available. These can be purchased as external drives connected by USB. Just like the DVD "war" between + and − format there is the battle for the next optical disk generation, between the two options of Blu-Ray and HD-DVD. The former has a theoretical limit of 200GB with 60GB for the second. Currently they are well below these. More manufacturers have come down on the side of Blu-Ray but like the common DVD formats we may well find one drive will run both types.

As well as back-up, software may be bundled with both CD and DVD drives to enable disks to be "burnt" so that your albums and slideshows can be shared with others to run automatically on either a PC or a home DVD player connected to a TV. This is a potentially complex area due to different formats and DVD compatibilities. The website

DVD Formats at a glance

Perhaps by learning from the past more and more drives are appearing which can use more than one format.

DVD-R: write-once, ideal for archiving images and recording home movies. Inexpensive and compatible with 85% of drives and players

DVD+R: write-once, ideal for archiving images and recording home movies. Compatible with 85% of drives and players

DVD-RW: DVD Forum's 1000-times rewritable format. Good for back-up, DVRs and movies. Most burners write at half the speed of DVD+RW. Compatible with around 65% of drives and players

DVD+RW: DVD Alliance's fast 1000-times rewritable format. Very good for back-up, movies and DVRs. Compatible with around 65% of drives and players

DVD-RAM: DVD Forum's 100,000-times rewritable format. Fine for back-up and DVRs but slow and far less compatible that other rewritables.

www.vcdhelp.com is very useful to explain as well as providing free software which may work on your computer. Often the software with your CD or DVD drive is a cut down version and needs up-grading, e.g. Roxio Easy CD Creator version 5 to Platinum version. Try trial versions before you buy if you are unsure of compatibility For example, Proshow (downloaded from www.photodex.com) is a good programme but may not work with your system!

The process varies with software but in essence what most do is to take your JPG images and convert them to a video format, MPEG. Options such as transitions between the images are made and then it is burnt to a CD or DVD as a SVCD (Super VideoCD) format. This is better than VCD, which is a more basic format, and has the ability to store between 35-60 minutes of very good quality full-motion video or simple photo album/slide shows with background audio on a CD. This can be played on many standalone DVD Players and a computer with a DVD-ROM or CD-ROM drive with the help of a software based decoder / player. The software you need depends on how complex you want the outcome to be. Some, like Ulead Moviefactory, will generate full multimedia type presentations using video clips and sound that can be played on a home DVD player. If the album is just to be played out on another PC some software packages generate an EXE file that just need clicking on to make slide show. This is a growing area and really needs you to experiment.

If passing your albums to friends is important and yet the above is too complicated, perhaps you have a video camcorder with a DV In/Out socket and capable of taking stills on a memory card. The images are transferred from the PC to the card and recorded on to tape. For this consult the camcorder manual. Once on the tape copies can be made and even recorded on to VHS tape.

Although CD and DVD may be cheap by far the easiest, and to my mind the best method of backup, is an external hard disk. Attached by USB or Firewire the chances are that your entire photographic collection could be backed up in one click. The size of a small paperback or even less between 250 and 500 gigabytes of extra storage could be sitting next to your computer. They are relatively inexpensive and appear on the computer's operating system as an extra drive letter or name. With increasing popularity the variety is increasing all the time. There is absolutely no reason to loose your images. As fast as you download the files to the computer from the camera copy them immediately to the external drive. I actually have two external back-up drives: one which stays next to the computer and a second that is kept off site. Burglary or fire could result in the loss of all your on-site files. Copying to the drive is easier than making DVDs and is just a matter of using Windows Explorer (see pages 32 and 139).

Who said digital photography was going to be cheap but at least you can easily back up and make copies of your precious photographs. How would you do this with film negatives or transparencies?

Printing

Collections of photographic prints can take up huge bookshelves, cupboards and even rooms just to store them. The sheer beauty of digital photography is the ability to store many thousands of photographs on the computer and if this happens to be a laptop you have a fully portable album. Wherever you are in the world as long as the laptop is there you have all of your photographs as well. Having a wad of photos still seems to be many peoples idea of looking at their holiday pictures. Whatever, at sometime everyone will want to print out their images. After all you have the entire digital darkroom at your disposal. Instead of standing in the dark with a red-orange glow, smelling noxious chemicals for hours you can sit in the comfort of a chair in front of the computer. Just like using different types of photographic darkroom paper the modern printer uses a wealth of different paper types to exploit the best of your printer.

Types of printer

For photographic purposes there are essentially three types of printer. The laser printer is largely discounted as high quality colour versions are expensive. For general use they are the cheapest printer to run as they use a fine toner like photocopiers. This toner will last for many thousands of sheets and as the cartridge containing the toner has the main moving parts these are replaced at the same time as the toner so lasers are often more reliable. The least

Digital Image

Digital or Film

Camera Choice

Camera Controls

Accessories

Taking Photographs

Scanning

Viewing/Organising

Improving Images

Creativity

Archiving/Printing

E-mail/Web/Video

expensive colour lasers, around £350/$500, are slow and can have expensive consumables including oil cartridges and four separate toner cartridges.

For those who wish to regularly print out batches of prints a dye-sublimation printer is worth a look. Produced by camera manufacturers like Olympus and Fuji, they are a small box not attached to the computer but to the camera. Alternatively, they take the flash memory cards direct. Sublimation actually means "a change in state". There is no liquid ink but a ribbon containing the three layers of dye present as a dry solid. As the specialist paper moves through the printer so the ribbon moves within and heat behind changes the dye to a liquid form to transfer it to the paper. This is where settings on the camera, called DPOF, are useful. Dye-sub is the main way that photographic shops will supply prints if you take your digital camera in for a stack of prints. The cost of the printer is proportional to the size of prints it creates and can be seen as the downside. On the positive side they produce excellent prints without a dotted appearance as the dyes are absorbed by the paper. As a consequence they do not look digital. They are specific to photographs and unsuitable for text but inkjets are cheap and so a second printer could be used for general printing.

By far the most common printer type for digital photography is the inkjet or bubblejet. As a microscopic wire in the print head heats up so it expels a tiny spray of colour on to the paper. This paper is passed through in a jerky, stepped fashion as specified increments. The printer head, containing the head and ink moves in synchronised increments with the paper. These increments require less memory than other printers and with few parts make inkjet the cheaper end of the spectrum to purchase although one can still spend a considerable sum on the top end. The key manufacturers are Epson, Hewlett Packard, Lexmark and Canon and the range is vast including print sizes up to A3 for less than the cost of the other two types of printer. What makes these expensive to run is the cost of all the consumables. This has created a substantial market with specialist outlets, especially on the web, selling both proprietary brands of ink cartridges as well as those from the independent manufacturers at massive savings.

Inkjets generate tiny dots of cyan, magenta, yellow (called CMY) and also with black (called CMYK) on the paper which merge to create the image. The problem with inkjets is the way that the ink "bleeds" into the weave of the paper unless it is good quality paper. For photographs, this is where we see the specialist papers to make the best of your images. It is not just the paper quality which is important but ink quality, the precision of the motor setting the increments and the size of the dots.

There is an incredible range of inkjet printers so that even the cheapest ones can

produce good printouts of text. Consider getting a cheap one for general use but a more expensive photo-quality one for just producing good photographic prints. The resolution of the printer is important but speed is secondary. All printouts will be relatively slow with a typical time of around ten to fifteen minutes for a high quality image, A4 size. The inks present in the new printers have improved to provide a longer lasting ability. Manufacturers are starting to guarantee them but if the images are important to you placing them under glass may increase the longevity of colour saturation although leaving them out of the way of direct sunlight is the main help. If you printout photos regularly expect to get through ink cartridges frequently and buy replacements in bulk. This introduces another problem. Choose a well known, common printer for which spare cartridges are easily available. When the model goes out of fashion so will obtaining replacement cartridges, occasionally just a year or two later.

Due to the way they bleed on coarse finishes, paper for inkjets need to have a fine weave. Paper can be sold specifically as "inkjet paper" and may even have an ideal dpi rating or called high resolution paper. There are many different finishes, like glossy and matt, to choose from as well as varying thickness to produce superb photographic prints. Paper of this quality is made by all the inkjet manufacturers and although can be used in any inkjet may have the edge in the manufacturers own printer. The traditional photographic paper producers such as Ilford and Kodak also provide a good range of papers. Check reviews of different papers in the digital photography press and buy small quantities of selected types to try. Once you find one you like then consider buying in bulk. Certain brands can be bought in rolls. In fact just about any media is possible including printing directly on to a CD with an inkjet.

Software, Resolution and Printer Settings

Switch on the inkjet printer, click Print and there we go, a perfect print. Wrong! The chances are your 1.3 megapixel image will be pixelated ("blocky") and printed across numerous sheets of paper. There are several factors to upset quality.

It is only when printing out an image that we suddenly start referring to resolution in dots per inch (dpi) instead of pixels. The latter have to be converted into dots by the printer and the actual physical size of the image needs to be considered. On the computer a digital image does not have a size as it depends on the resolution of the monitor. Now you want to print out the image it depends on the resolution of the printer and how many dots it can print.

At this stage dpi and ppi can be considered in a same way. Photos taken with a digital camera normally have a default printing resolution of 72dpi. Lets say we have an image with pixel dimensions of 1280 x 1024. By dividing each of these by 72 the physical size will be 17.77

Digital Image
Digital or Film
Camera Choice
Camera Controls
Accessories
Taking Photographs
Scanning
Viewing/Organising
Improving Images
Creativity
Archiving/Printing
E-mail/Web/Video

(inches) across the top and 14.22 (inches) down the side. This is because each inch of print has 72 dots or pixels along the length. A print 17x14 inches sounds good from a 1.3 megapixel image and explains why just clicking print needs more than one sheet of paper. Also, back at the start of this book in Table 1 the suggested size for this resolution was 6x4 inches. How come? There are several ways of looking at the problem. Clearly the large size needs to be reduced so that it can be printed on one sheet of paper. Second, quality will improve if we increase the number of dots per inch. Printing at a resolution of 200dpi is better than 72dpi and is about typical for a good quality inkjet. In the printer specification it will give the maximum resolution possible, for example 1440 dots across the A4/Letter page. 1440 divided by 8 inches is 180 dpi, close to the ideal 200dpi. If you now divide your 1.3 megapixel image by this dpi resolution your image becomes 6.4 x 5.1 inches.

This may sound complicated but is not difficult in practice. Effectively, you are

FIGURE154 AND 155. Print preview. Always print preview before hitting the print button. Invariably the image is too large for the page and so it needs resizing. This may be done by grabbing a corner and dragging it to fit. Alternatively, use resizing/resampling commands.

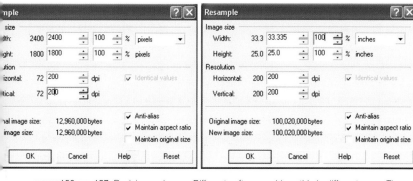

FIGURE156 AND 157. Resizing an image: Different software achieve this in different ways. These show a resample screen although it is going to resize the image. Make sure the units are pixels and then change the dpi to 200 this concentrates the existing pixel number into a smaller physical size when printing. The left screen shows no change in the new image file size, 12.96 megabytes. However, the screen on the right has the units in inches and by increasing to 200 dpi the file size has gone to 100 megabytes, almost ten times the file size. This is because the physical size of the image has remained the same and by increasing the dpi the number of pixels have had to be increased to compensate.

reducing the size of the image to create a better concentration of dots. To start with use the guide below for your suggested maximum print size. To achieve it, different software work in different ways but <u>always</u> check Print Preview in the programme being used. This is good practice for any application to save wasting paper. There is invariably something not quite right and as you can see in Fig 155 opposite only part of the image is showing. There will be a setting somewhere in this view to be able to display the entire image on the paper or you maybe able to click on the picture and drag the corner to resize to your requirements. Print preview is usually the quickest way to printout at a more suitable size. Alternatively, use the resizing option in the bitmap editor. It may be under different names but what you are trying to achieve is a change in the dpi to 200 but at a new, smaller size not retaining the original size. If you were to choose the latter the file size will rocket as the programme adds extra pixels, called upsampling. If you increase the dpi the file size will remain the same as no more

Suggested maximum print sizes of images with different printer resolutions

Pixel resolution	Original size (72dpi)	At 150dpi	At 200dpi
640 x 480	8.8 x 6.6 ins	4.3 x 3.2 ins	3.2 x 2.4 ins
1280 x 1024	17 x 14 ins	8.5 x 6.8 ins	6.4 x 5.1 ins
2400 x 1800	33.3 x 25 ins	16 x 12 ins	12 x 9 ins
3000 x 2000	41.6 x 27.7 ins	20 x 13 ins	15 x 10 ins

200dpi is best quality

FIGURE **158.** An example of a Word XP print screen. Clicking Print Properties brings up the set-up for the printer.

pixels (data) have been added but the size of the print will be reduced so that the pixels present are crammed into a shorter distance, 200 pixels per inch. See Figure 156 above.

If you do not have a bitmap editor insert the picture into a blank page of a word processor and then reduce the size of the image. Do this by clicking and dragging one of the corners. Do not drag the sides as this will distort the image. Print the page. For those using dye-sub printers it is important to get the dpi of the image the same as the printer.

All printers come with software to get the most out of it. This includes the driver, the most important feature. When about to print it is essential to go to the Print Properties of the printer to set the features required, especially the print resolution. This may be under Print or Printer Setup but you can be sure that they will vary according to the driver software that comes with the printer. The main change to be made is setting the paper type. Once selected the other controls needed are likely to change automatically. However, always check that once the high quality, photo paper is set the highest printer resolution is visible and high speed is switched off. Remember, go for the best resolution with speed being least important if you want the highest quality. See Figure 158 above.

Printing a number of pictures on the same page is a good way of saving expensive paper and may be a useful way of keeping track of your images just like contact prints of film. The latter can easily be achieved in software like Compupic or ArcSoft's Photo Printer Pro (see websites). Alternatively, use word processing software you might have like Word. Insert images into text boxes or frames on the page. Adjust the size of the image to suit and then place this exactly where you would like it on the page. The box can be formatted to have different colour borders or not. Then by creating another box and inserting an image in the same way a page can be built up with multiple images on it. Saving the file will generate a large file so avoid

Digital Image

Digital or Video

Camera Choice

Camera Controls

Accessories

Taking Photographs

Scanning

Viewing/Organising

Improving Images

Creativity

Archiving/Printing

E-mail/Web/Video

this if you can, just use it as a printing tool. Also, don't place the pictures too close to the edge unless your printer can print right to the paper edge.

Some printouts can still be very disappointing. The problem is that all the equipment such as monitors, cameras and printers, has different ways of displaying colours called the gamut. To begin to match these gamuts Windows uses a system called ICM (Image Colour Management). This tries to get all the devices to talk the same language over organising colour. Some devices like scanners and printers come with a specific colour profile which is installed with the system but most do not. They use a standard profile called scRGB. This is quite new as the older one, called sRGB was rather limited. ICM reads the profiles and manages the colour accordingly. ICM 2.0 is an application present in the Windows XP operating system. To see which system is running on your computer go to Start/Help and search for information on ICM. Help will also tell you more about how it handles colour on your computer. Experienced users can actually change the way the ICM works but it is best to let it work happily in the background choosing the correct profiles to work for your pictures.

To see whether your device has a specific profile use the properties button or tab to check this out. If you suspect that there is a printing fault caused by the printer, e.g. prints are consistently dark or with a colour cast, check this out in the driver properties and see how it is set to handle colour. If this is set to a default, see Figure 158 opposite ICM hosted by the computer it could be that you have not installed the correct driver and profile. Drivers for specific printers vary enormously and if necessary consider downloading an up-dated one from the manufacturers website. If matching colour in your printout with the monitor is vital to the work you do the only way forward is a calibration tool. Programmes like Adobe Photoshop come with a software calibration system but special hardware can be purchased. For the majority this is unnecessary.

Digital Imaging without a Computer

Inkjet and certainly dye-sub printers can be purchased that have a slot to take flash memory cards straight from the camera. This avoids having to have to print via a computer and in fact can get rid of the computer stage completely. Ideal for those who want to experience digital imaging without the need for a computer. Even easier, just take your camera to a high street photo store where they can remove the memory card and download the images for you to see on their computer so that you choose which ones you want printed. In no time you receive the prints. No different to dropping in the cassette of print film except it is now more environ-

mentally friendly with less resulting pollution and ability to reuse the card. By far the easiest way to deal with your photographic printing needs is to use a broadband connection to up-load your files to a printing website like Photobox. This can also be shared with friends and family who can select photos and have them printed to whatever size and condition needed. For example, giant posters, mugs, T-shirts or even super, stretched-canvas prints. Best of all are photobooks. Instead of the old-style photo albums, where the prints are stuck on to blank pages of shop-bought albums taking up vast acreage of bookshelves the photobook is like a published tome. Using online templates you create the pages of the book exactly how you want it including captions and titles. With up to 50 pages you position the photos to either fill the page or have multiples of images. Upon ordering they print and bind the book to look very professional and suitable to store on any bookshelf.

Viewing images on screen, of course, is quite possible on a TV without the need for using a computer. Most cameras come with the a suitable lead but to take this further a number of compact players are becoming increasingly popular. These, like the AVerMedia AVerFotoplayer connect to the TV or video and the memory card slots into it to display the images. The playback can set slideshows with timed transitions. They are relatively low priced and useful to display to a family audience in front of the TV. They may be limited by the resolutions they can handle, generally around 4 megapixels.

The Internet and Photographs

E-mailing pictures is one of the great things you can do with your pictures. If the photo to send is a large file consider resampling it with a smaller number of pixels. A resolution of 640x480 is fine on the computer and takes very little time to send. If you need to send a 1.3 megapixel image, apply a greater compression to it in the bitmap editor. Crop away surplus pixels around the edge and then when you export the file (rather than saving the changes to the original file) compress the file more than normal to make it smaller. Check the photo before you send to make sure it is still alright. Another potential way of e-mailing a group of photographs is to zip them together using the WinZip programme. This compresses all files together to create one file. Usually this is smaller than the total of all the files. It works very well with most files but does not make a substantial saving with graphics files.

Sending files is straightforward with e-mailing software like Eudora and Outlook Express, where the file is sent as an attachment to the message. Some free on-line email accounts e.g. Hotmail, limit the amount of space available for storing attachments and quickly fills up. Not all internet software provide attachment facilities and then you are stuck.

More and more people are now putting their photographs up on the web for people to see, either in galleries or on their own site. There are many operators who provide galleries and after you have set up an account with them they give you the information to upload your images to their gallery. Then it is just a case of giving the URL (address) to friends so that they can go and have a look at your photographs. Perhaps the most well known site is Flickr (**www.flickr.com**). Here your images can be displayed, organized and shared for the world to see. It is a superb way of allow a huge audience to look at your photographs anywhere in the world. The alternative is to set up your own website.

You do not have to be a web developer to set up your own site with galleries and it is surprisingly inexpensive to host. In fig 159 (overleaf) the practical sequence of setting up your own site is shown. Software like CompuPic and Word is all you need. The latter is a basic web editor. Setup a relatively simple page in Word as your home page and save not as a document but as HTML. This can be your introduction to the site and have a link to the photographic pages. Photographs need to be small, low resolution images resampled to around 400 pixels across and compressed JPG format so the files are small. JPGs can be saved as either Standard or Progressive. The latter means that the imaging progressively appears as the information comes down the line rather than waiting for all the data before displaying. Set these up in a folder ready for the web and then open CompuPic. Under the Internet menu is Web Page Generator. Follow the instructions for this and all the photos selected in the folder will be placed individually on web pages with the text you want. It generates a photo index by making a page of small thumbnails. Each of these is linked to the image page. The Home page just needs to have a link to the thumbnail index page. Now just about everything is ready. From the home page there is a link to the index. Clicking on a thumbnail opens a page with a larger image. Buttons will be placed on this page for you to go back to the Index or move to the next image page.

Design your web on paper first before you try to generate it. Keep the resolution low or it will take a long time for people to download the image. After you have set this up on your computer open up the home page in Internet Explorer or the browser you prefer to use. Check the links by clicking your way through it. If all is well it is time to publish to the web.

Stage 2 is finding a host for your site. Start with your own Internet Service Provider. They may give you some free space for personal use. If not search on the web for hosts checking out their conditions and price. These can also be found in the adverts of internet magazines. Sometimes to make them cheap banners will be present on your site but paying a fee gets rid of this. If you are buying space you will also get the chance to have your own

FIGURE 159. Creating a simple family web site. In Word the home page is written by saving the file as index.html. The background can be coloured and sections organized by making a table, here with three columns and two rows. The text and photographs can be clicked to link with another web page. Each web page is a separate file, again produced in Word, and to make the link select the text/photo and use the hyperlink command.

FIGURE 160. Once a folder has been setup with the correctly resized images you are ready to create a page of thumbnails and photo pages. This is simplified using a photo organizer, e.g. Compupic which has a web page generator.

FIGURE161

FIGURE 161. A typical thumbnail page in a browser. Clicking on the thumbnail expands to full size, achieved by a link to a new file, shown in Figure 162.

FIGURE162

FIGURE 163. The File Transfer Protocol (FTP) software. Once the web site is working fully on the home computer the site needs to be up-loaded to the hosting site. FTP software like this free version has all the settings added (given by the host) and once connected to the internet this screen shows. On the left is your computer and on the right is the hosting server. By highlighting your folders and files on the left, the middle, bottom green arrow is clicked to send the material to the host. In this instance the site should be placed in the html folder. The index is the home page and not placed in that folder but remains outside.

FIGURE163

domain name, that is a web address ending in dot com, etc. The host will provide details of user name and password.

Stage 3 is to use an FTP (File Transfer Protocol) programme to upload the pages to the site. These can be purchased, obtained free on magazine cover disks or from shareware. The programme needs to be setup with the user details and password. It then works a little like Windows Explorer except your computer folders are on one side of the screen and the folder of the host server is on the other. The files are then just dragged across from your side to the host. Finally, use your browser to visit the site and check all is well. In this way you have your own domain name for people to visit your site to view your images, from anywhere in the world.

There are many hundreds of gallery websites, some with free pictures and others retaining the copyright and asking that they are not used commercially. If you see pictures you would like to keep on your computer it is very simple to grab them. Put the mouse pointer on the picture and right click. There is a menu with the option of Save Image to Disk. Click this and set the folder where you wish to store the image.

Digital Video

There are two main areas to this subject. Low resolution, video clips that are stored and viewed as computer files on the computer screen and full screen digital video. Due to the enormous amount of storage space required on a hard disk for the latter the computer is really only used for full screen quality video as a film editor. In this case the video is taken by the camcorder and stored on a video cassette or DVD. The camcorder is then connected to the computer, video captured in a compressed form, edited and then put back to a new video tape in the camcorder to be shown on a television screen. The requirements vary with the camcorder as more are now available which record digitally to high speed memory card or hard disk. The easiest is a digital video recorder which is connected to the computer via a Firewire port. The software on the computer then uses three sequences: capturing the video, editing and putting the new sequences together and then returning the edited movie to the tape. Note that this can only be done if the camcorder has a DV In and Out socket. The basis of this sequence is seen in Figure 164 on page 184. If your camcorder is the analogue tape, i.e. VHS-C or Video eight, it requires a capture card to be fitted to the computer. These vary dramatically in price but essentially convert the analogue signal to a digital one. Then the sequence is fairly similar to the digital video.

Even if your interest does not lie with video editing short bursts of low resolution

computer clips maybe. In the case of the clips generated by digital stills cameras these will be as a file stored in a separate folder on the flash memory card and downloaded in the same way as the still images. The video file is typically either an AVI or MPG format and are supported in some photo viewers like Compupic. This means that as you have a slide show of stills if the video clip is within the album when it comes to the clip this is displayed. Hence, a true audio visual presentation! Due to the poor quality in the past this area has been overlooked. The better still cameras are coming out with 640x480 pixel resolution and up to 30 frames per second. Alternatively, generate them from camcorder video captures. The latter can be edited before the clip is made.

To generate computer files from camcorder videos the procedure starts as above for full screen video. That means the video has to be captured by the software as in Figure 164. As the video is stored on the computer the software identifies each separate clip as it was shot. A small still image is generated so that clip can be identified. These clips can then be reordered or even changed. The final step once the clips have been arranged is to save it as a file on the hard disk. We know from our deliberations on stills that each frame will have a great deal of information stored so at 25 or 30 frames a second just a minutes worth of video will be a considerable amount of data. AVI format (a Windows media video file) does compress the data but the better and smoothest format is one of the MPEG (Moving Picture Experts Group) formats.

Unlike the bitmap editor which is usually bundled with the camera, available free over the web or a wide choice from your local computer store video software is quite specific. Windows XP and Vista come with a basic piece of software, Windows Movie Maker. "As well as this software there are various applications often bundled with PCs and available as free downloads. These so-called lite versions will allow you simple editing and the ability to stitch clips taken with your stills camera together. Pinnacle, overleaf figures 164 – 168, produces a bundled SE version. Although Adobe Premiere one of the top video editors, and one of the most expensive, like Photoshop there is a reduced but excellent low-cost version, called Adobe Premiere Elements (see screenshot on page 186).

The mention of video here may seem unnecessary and yet it is yet another facet of photography. Some of the latest, digital stills compacts, e.g. Olympus SP 550, can take amazingly high quality videoclips and should not be ignored. Using the video editor like Premiere Elements they can be edited and several clips joined. Then slideshows, mixing still and moving images, can be put to DVD and played back on a home DVD player. Digital photography is an amazing and flexible medium allowing the sharing, distribution and archiving of images for the future

Digital Image

Digital or Film

Camera Choice

Camera Controls

Accessories

Taking Photographs

Scanning

Viewing/Organising

Improving Images

Creativity

Archiving/Printing

E-mail/Web/Video

FIGURE164

FIGURE165

FIGURES 164, 165, 167 AND 168. Pinnacle Studio SE: A good but simple programme for editing video on a computer or generating video clips to be shown on the computer. Attach the digital video camera via the Firewire port and the capture screen. The settings for the capture are set here. The camcorder can be control from this screen by clicking the buttons on the camera picture. 165, The software separates the individual clips as they are captured and identifies the these as a small picture in a "book" of galleries. Timings are given on the picture of the camera. 166, Edit Screen. This is where the movie is compiled by dragging the clips to the

FIGURE166

FIGURE167

timeline at the bottom and placing them in the required order. Each clip can be separately edited by shortening it. There are different transitions that can be set-up between clips. The movie can be previewed in the window before moving to the last stage. **167,** Movie Making Screen: First select the output required. Here it is set to MPEG, a compression method to produce a movie file. If Tape is selected the movie will be returned to tape in the camera. This can only be achieved if the camera has a DV In/Out socket. Share will create a highly

Digital Image

Digital or Film

Camera Choice

Camera Controls

Accessories

Taking Photographs

Scanning

Viewing/Organising

Improving Images

Creativity

Archiving/Printing

E-mail/Web/Video

FIGURE 169.
A screenshot of Adobe Premiere Elements in editing mode. There are options to export to any media including the creation of a DVD with menus.

Glossary

Digital Image

Digital or Film

Camera Choice

Camera Controls

Accessories

Taking Photographs

Scanning

Viewing/Organising

Improving Images

Creativity

Archiving/Printing

E-mail/Web/Video

A

Aperture - Variable opening that controls the amount of light that passes through the lens.

Anti-Aliasing - Smoothing out *jaggies* in digital images.

B

Backlight Control – when a camera's light meter exposes for the light behind something the result is a silhouette. This control will compensate for this

Bit - smallest unit of computer information, a binary digit represented by either a 1 or 0.

Bitmap - An image made up of pixels. Produced by digital cameras or scanners. The opposite of a vector maps which are drawings made from lines.

Bracketing Exposure – manually or by an automatic setting, several extras shots are taken on either side of the chosen exposure.

Buffer RAM – When taking pictures with a digital camera buffer RAM is used to store images whilst they are recorded on to the slower removable media card. Depending on the size it may allow a sequence of shots to be taken quickly before transfer to the card.

Byte - Standard computer measurement of file or data storage. A letter of the alphabet when typed on the keyboard is stored as eight bits of binary information, by-eight hence shortened to byte. Kilobyte, is a thousand bytes, Megabyte, a million bytes or a thousand kilobytes, Gigabyte, a thousand megabytes. Then, Terabyte.

C

CCD - A Charged Coupled Device (CCD) is the sensor unit in a digital camera that converts light into an electrical current.

CD-ROM – A read-only Compact Disk, usually carrying software from manufacturers.

CD-R - Recordable CD, that can only be written once and not erased. CD-RW can be reused with writing and erasing but is more limited to specific drives and is more expensive.

CMOS – a cheaper alternative to the CCD sensor unit in a digital camera that converts light into an electrical current.

CMY, CMYK - (Cyan, Magenta, Yellow) form used by dye-sublimation and low-end inkjet printers. CMYK adds black and is used for professional printing.

Colour Bit Depth - The number of bits used to represent each pixel in an image; the higher the bit depth the more colours appear in the image; 1-bit colour: black & white image with no greys or colours; 8-bit colour: 256 colours or greys; 24-bit colour: 16 Million colours, also known as photorealistic colour.

CompactFlash – see flash memory

Compression – method of reducing file size for storage. Lossy Compression can can squash more data but loss in quality. Lossless does not over compress but does retain quality.

CPU - Central Processing Unit or brain of the computer; containing many switches that organises instructions and commands.

Cropping tool - A tool found in bitmap editing software for removing unwanted areas on an image

D

Defragmentation – the process of moving the fragments making up a file closer together on the hard disk to improve efficiency. Done with a systems program.

Digital Zoom – a feature of some cameras where it crops the image to simulate a telephoto lens but reduces quality.

Dithering - A method used in software to simulate multiple colours or shades of grey with a limited amount of data.

Download - The transfer of files from one piece of digital equipment to another, e.g. from camera to a computer.

Dpi - Dots per inch, used as a measurement of printer resolution

DPOF - Digital Print Order Format, system found on digital camera to allow the photographer to select images for printing in-camera.

Driver - A piece of software installed on a computer so that it can "talk" to the device when connected, e.g. digital camera

E

Exposure Compensation - the facility change the automatic exposure set by the camera

F

Feathered Edge – creates a gradual edge to the selection or mask in a bitmap editor

File Format - The way that the information in a file is stored. Digital images are commonly stored as JPG and TIFF

Filter - Bitmap editing software feature, altering the appearance of the image being edited. From the idea of photographic filters used on lenses.

Firewire – a port for the rapid transfer of data, soon to be replaced by Firewire 2.

Focal Length - The characteristic of a lens that determines its magnification and field of view, e.g. 28mm is a wide angle.

Focus – The adjustment of a lens so that the subject is recorded as a sharp image.

Flash memory - A type of memory chip that does not require power for it to function and so used in portable devices to store data. This is removable media such as CompactFlash, Memory Stick, SD Multimedia and SmartMedia.

FlashPath Adapter - allows some types of flash memory cards to be read in a standard 3.5-inch floppy drive.

G

GEM – Grain Equalisation and Management

GIF -A graphic file format developed for the web but only supports 256 colours.Cf. JPG.

Graphics Card – the interface between a computer motherboard and the monitor. Its speed and the amount of RAM memory fixed to it determine the speed that graphics can be refreshed on the monitor.

H

Hard Disk (or Hard Drive) – a sealed unit used inside the computer for fast and cheap storage of digital information. External ones can be added via Firewire or USB ports.

Hue – this is the actual colour of an image, i.e. red, green, blue. An RGB image can be defined by Hue, Saturation and Brightness.

I

ICE – reduces the effect of dust and scratches

Icon - A small graphic symbol on a computer screen that can be pointed and clicked on with a mouse and represents a file, disk, application or command.

Image Manipulation - Once a digital image has been transferred into a computer, bitmap editing software allows the individual *pixels* to be altered by such ways as colour and brightness change.

Interpolation or upsampling - Increasing the number of pixels in an image largely by guesswork

J

Jaggy - The jagged stepped effect often seen in images whose resolutions are so low that individual pixels are visible.

JPEG -A bitmap file capable of high levels of lossy compression. 16 million colours.

L

LCD panel - A small colour screen found on the back of most digital cameras that allows the image to be previewed before taking and afterwards.

M

Macro - Description used to indicate a lens that can focus closer than normal strictly speaking at a 1:1 ratio of subject:photograph

Mask – also referred to as a selection it defines an area of an image to which an effect will be applied.

Megapixel - one million pixels-a measure of camera resolution.

Memory Stick – exclusively used by Sony; see flash memory

Marquee - Outline of dots created by image editing program to show area selected for manipulation or masking

Moire - unsightly patterns appearing in scans of printed materials. Cannot easily be remedied although most flatbed scanners offer a 'descreen' function,

Digital Image

Digital or Film

Camera Choice

Camera Controls

Accessories

Taking Photographs

Scanning

Viewing/Organising

Improving Images

Creativity

Archiving/Printing

E-mail/Web/Video

N

Noise - In bitmap images, random pixels on the surface of a bitmap, resembling static on a television screen. Most often occurs in low light areas in the form of pixels of the wrong colour appearing at random in the dark areas

O

Optical Viewfinder – Similar to point and shoot compact film cameras in that it gives a clear view with no power. It is not accurate and cause parallax and focus problems.

Optical Resolution - In scanners the maximum resolution possible without resort to interpolation. Applies to the camera's true CCD or CMOS resolution.

P

Parallax Problems – Problem with optical viewfinders giving a slightly different view to the lens. This is only a real problem for close-ups.

Parallel port –originally found on the first PCs as a method of transferring data. Still used mainly to connect printers. Fairly slow and being replaced by *USB*.

PC Card (also known as PCMCIA card) – Mainly for laptop computers. PC cards can contain hard disks, modems, network cards or flash memory. May fit some cameras. Adapters available to allow flash cards to be connected to laptop.

Peripheral – An external item connected to a computer, e.g. printer, camera.

Photosite - A single photosensitive element in a CCD or CMOS unit which translates to one pixel in the resulting image.

Pixel – a Picture Element. The smallest element of a digitised image and the small points of light that make up a picture on a computer monitor.

Plug in - A small piece of software that adds extra features or functions to a specific application.

Ppi – Pixels or points per inch. A measure of the resolution of scanners and digital images.

R

RAM - Random Access Memory. The workspace of the computers CPU. A large amount of RAM usually offers faster manipulation of images.

Red Eye – common problem on indoor photos of people caused by the wide open iris on the eye allows a bright flash from the top of the camera to reflect the blood vessels on the retina.

Refresh Rate - in digital camera terms how many times per second the display on the LCD preview monitor is updated. Especially noticeable in electronic viewfinders. Removable Media - memory chips which store the captured images. See flash memory.

Resample - To change the number of pixels in an image. Upsampling uses interpolation to increase the number of pixels. Downsampling throws away pixels to reduce the size.

Resize - Changing the resolution or physical size of an image without changing the number of pixels.

Resolution - Measure of the amount of information in an image expressed in terms of the number of pixels per unit length, i.e. ppi. Camera resolution is usually defined as the total number of pixels in the image, 1.3 megapixel.

RGB – the three channels of light used to generate images. Red, Green and Blue.

ROC – Restoration of Colour

S

Saturation - The purity or vividness of a colour, expressed as the absence of white. A colour that has 100% saturation contains no white whereas a colour with 0% saturation is a shade of grey.

SCSI – pronounced scuzzy, it is a fast method of attaching devices such as scanners.

SD Multimedia card – see flash memory

Shutter lag or delay - The brief delay between pressing the shutter and a picture being taken.

Serial Connection - Connecting a digital camera to a computer via the serial (COM) port. Slow to download images.

Slave Unit – a small photoelectric cell for triggering an external flash

SmartMedia - see flash memory

Swap File -

T

Telephoto lens - Lens that has the effect of making subjects seem closer than they actually are but will change perspectives in the process.

Thumbnail - A very small, low-resolution version of a larger image file that is use for quick identification of that image

TIFF –A bitmap file format for high-resolution images, uncompressed. Readable by both PC and Mac computers.

TWAIN - Protocol for linking computer software with devices such as scanners and digital cameras.

U

USB - Universal Serial Bus. Becoming the standard connection for attaching peripherals such as mice, printers, scanners and digital cameras. Provides fast data transfer soon to be superseded by USB2.

V

Video output - Digital camera can be connected directly to a TV to display images or to video to record on tape.

Vignetting – the darkening of the corners of an image possibly caused by a filter, supplementary lens or lens hood obscuring the light passing into the lens.

W

White Balance - Adjustment on digital cameras to ensure that colours captured are correct whatever the

Digital Image

Digital or Film

Camera Choice

Camera Controls

Accessories

Taking Photographs

Scanning

Viewing/Organising

Improving Images

Creativity

Archiving/Printing

E-mail/Web/Video

type of lighting present. Usually automatic but some cameras can be overridden. Tungsten light produces a warm, yellowish cast.

Wide angle lens - A lens of short focal length providing a wide angle of view, allowing more of a scene to be fitted into a photograph but will change perspectives in the process. Vertical lines will appear to converge

Z

Zoom Lens – Continuously variable focal length lens. The user can adjust the field of view by zooming rather than having to move.

Resources

Digital Image

Digital or Film

Camera Choice

Camera Controls

Accessories

Taking Photographs

Scanning

Viewing/Organising

Improving Images

Creativity

Archiving/Printing

E-mail/Web/Video

1. Free or Low cost Software downloads

Name	Description	URL
ACDSee 9 Photo Manager	Suite with enhancement Tools	www.acdsee.com
Adobe Photoshop Album Starter Edition	**Free** Viewer with management	www.adobe.com/products
Arcsoft Panorama Maker	Create seamless panoramas	www.arcsoft.com
Arcsoft Photo Impression Gold	Viewer and image management	www.arcsoft.com
Arcsoft Raw Thumbnail Viewer	**Free** Previews Raw images from within Explorer	www.arcsoft.com
Artplus Digital Photo Recovery	**Free** deleted images recovery programme	www.artplus.hr/adapps/ eng/dpr.htm
Ashampoo Photo Commander	Organising and editing	
Compupic	Good viewer, organizer and enhancer	www.photodex.com
Brush Strokes	**Free** Basic bitmap editor	www.pabird.supanet.com /~pabird/freesoftware
Corel Snapfire	**Free** organizer and enhancement	www.corel.com
Faststone Image Viewer	**Free** viewer, organizer and enhancement	www.faststone.org
Faststone Maxview	**Free** small veiwier	www.faststone.org
Faststone Photo Resizer	**Free** batch converter for files, sizes and names	www.faststone.org
Google Picasa	**Free** viewer and organiser	http://picasa.google.co.uk
Irfanview	**Free** easy to use viewer	www.irfanview.com
Kodak Easyshare	**Free** simple but powerful organizer enhancer	www.kodak.co.uk
Lexar image rescue	Data recovery	www.lexar.com/software
Microsoft Photo Story	**Free** creates photo album slideshows	www.microsoft.com /downloads
Naturpic High Quality Photo Resizer	**Free** Quick resizer and effects	www.naturpic.com/resizer
Opanda Digital Film	Recreates effect of different film types	www.opanda.com/en/df

Opanda IEXIF	**Free** metadata viewer	www.opanda.com/en/iexif
Opanda Photofilter	**Free** application of effects to images	www.opanda.com/en/pf
OpenOffice	**Free** powerful word processor, spreadsheet, database	www.openoffice.org
Photo Pos Pro	Powerful bitmap editor	www.photopos.com
Picget Magic Photo Editor	Blends photos and other effects	www.picget.net/magicphoto
Pixarra Twisted Brush	**Free** artworking of images	www.pixarra.com
Serif Montageplus	Creates stunning montages	www.serif.com/creativity
Studioline Photobasic	**Free** management software suite	www.studioline.biz
The GIMP	**Free** Comprehensive bitmap editor	http://gimp.org
The Little Calorie Picture2icon	**Free** image converter to Windows icons	www.picture2icon.com
Triscape Fxfoto	Automatic management and enhancement	www.fxfoto.com/fxhome.htm
Ulead Photo Express	Simple management and enhancer	www.ulead.co.uk/pe /runme.html

2. Firmware and Updating

Firmware is your camera's operating system and like everything in the world of digital it goes out of date almost as fast as it is produced. Updating is not essential but may cure a few simple problems, particularly useful for DSLRs. For example, updating the original firmware of the Canon EOS 350D allows it to work correctly with Canon's remote controller. Find the current version by checking the end of the camera menu. Check on the web site how to perform the update but often it is a case of downloading the file on to a memory card, inserting this into the camera and switching on. During the following automated update of the firmware do not touch any controls on the camera until it is complete. Make sure the battery is full before starting and it should go smoothly but updating is not without risk so do it after making sure you fully understand the procedure.

Here are the current update web sites for the principle manufacturers.
Canon:
www.canon.co.jp/imaging/news-f-e.html

Casio:
http://world.casio.com/qv/download/en

Fuji:

www.fujifilm.com/products/digital/download/index.html

Nikon:

http://tinyurl.com/2dce4l

Pentax:

www.pentaximaging.com/customer_care/software_firmware?sfFlag=f

Olympus DSLR:

www.olympus.co.jp/en/support/imsg/digicamera/download/software/firm/e1

Olympus compacts:

www.olympus.co.jp/en/support/imsg/digicamera/download/software

Sony DSLR:

http//tinyurl.com/2a9229

Sony compacts:

www.sonydigital-link.com/dime/firmware/firmware.asp?l=en

Note that it is not just cameras that can benefit from an update. Devices like scanners and printers can have their drivers and interface software easily updated and installed on the computer. Particularly useful if you mislay the CD that came with the product.

Digital Image

Digital or Film

Camera Choice

Camera Controls

Accessories

Taking Photographs

Scanning

Viewing/Organising

Improving Images

Creativity

Archiving/Printing

E-mail/Web/Video

INDEX

Digital Image

Digital or Film

Camera Choice

Camera Controls

Accessories

Taking Photographs

Scanning

Viewing/Organising

Improving Images

Creativity

Archiving/Printing

E-mail/Web/Video

Digital Image

Digital or Film

Camera Choice

Camera Controls

Accessories

Taking Photographs

Scanning

Viewing/Organising

Improving Images

Creativity

Archiving/Printing

E-mail/Web/Video